Underground Together

CHRONICLE BOOKS

Underground Together
The Art and Life
of Harvey Dinnerstein

Introduction by Raman Frey and Wendi Norris

Essays by Pete Hamill and Gabriel P. Weisberg

CHRONICLE BOOKS

SAN FRANCISCO

Library of Congress Cataloging-in-Publication Data available.

ISBN: 978-0-8118-6232-5

Manufactured in China
Design by Annabelle Gould

10 9 8 7 6 5 4 3 2 1

Chronicle Books LLC
680 Second Street
San Francisco, CA 94107

www.chroniclebooks.com

page 2
Detail of *Rainy Evening, Lower East Side*
oil on canvas, 35" x 41", 2001

Contents

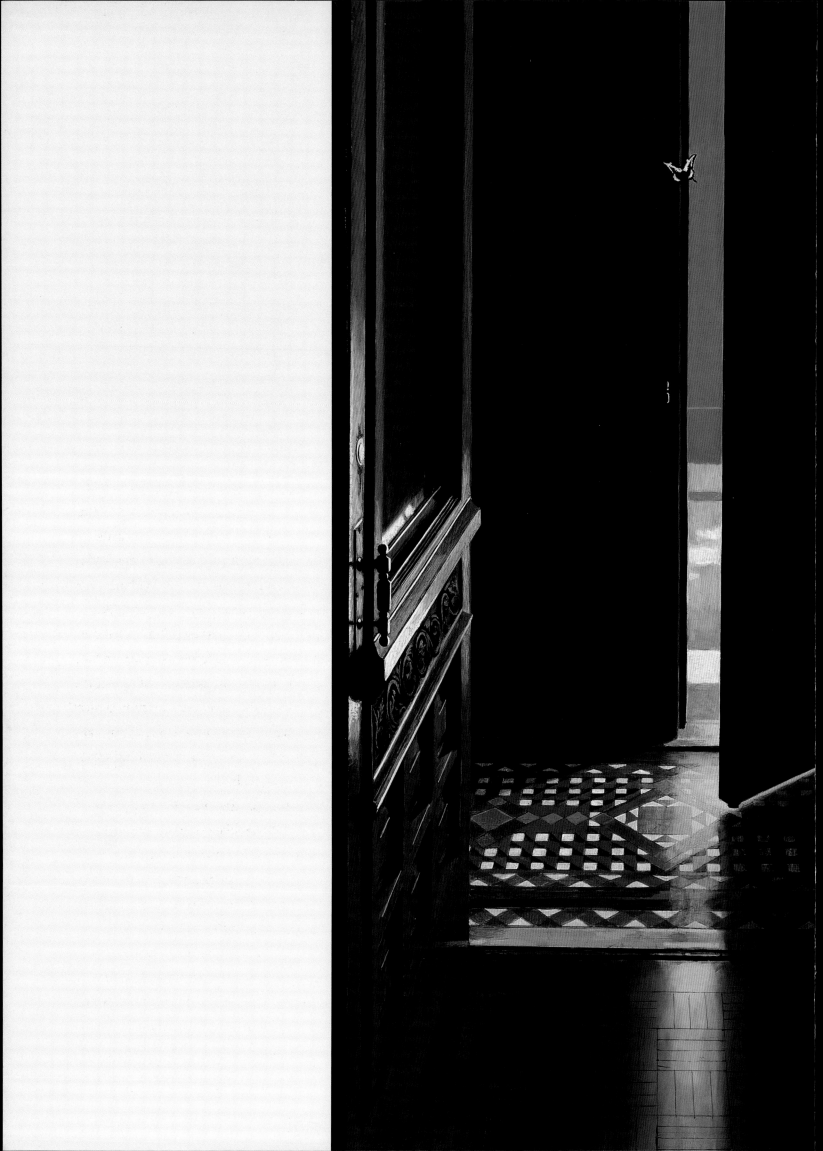

Park Slope Brownstone

Introduction by Raman Frey and Wendi Norris

We first met Harvey Dinnerstein at his large brownstone in Brooklyn's Park Slope neighborhood in the pouring rain on a late summer day in 2002. After coming inside and hanging up our coats, we found ourselves quickly engaged in an animated conversation not about art or the prospect of working together, but about American poetry. The discussion became an amicable debate on the highest aspirations of poets like Walt Whitman, Henry David Thoreau, and William Carlos Williams and writers as diverse as Henry James, Émile Zola, and Jack London. Our earlier talks had felt much like tug-of-war, with Harvey initially challenging and resisting two unproven and unfamiliar gallery owners from San Francisco, both of whom were eager to disturb the peace of his sanctum and studio with a visit. He was understandably wary and possibly cynical about the trustworthiness of gallery owners in general. Even as our cab approached his address, he begged us off via cell phone, insisting we'd have to reschedule, since he wasn't feeling well.

Once we'd talked our way inside and upstairs, we entered a giant *wunderkammer* of profound humanity. It was like entering a crowd in which every individual is confident in his or her own total emotional vulnerability. Around us were stacks of paintings, pastels, and drawings spanning decades. These were pictures of history: Harvey as a gawking young soldier and then again five decades later after cataract surgery, a family stay in Rome for a year in 1965, and other family histories, such as a treasured painting of Lois, pregnant with their son, in a kitchen interior, Vermeer-like light flooding onto the back of her profiled body. Long before we could articulate it for ourselves, we experienced the difference in impact between Harvey's art and that of many other accomplished draftsmen, often decried by him as "mere renderers,"

Hallway Entrance oil on board, 29" x 13¼", 2002

and with whom he is so often superficially grouped. Perhaps we bene-
fited from our disinclination to believe that this art was out of vogue,
art that the trendiest art lovers knew was not appropriate to appreciate,
since popular wisdom at the time still said we were looking at simple
"illustration."

The poetics of Harvey's empathetic insights into human character,
the suffering and joys that connect people, have become clearer over the
years. A recent visit to Muir Woods, just north of San Francisco, afforded
Harvey less an opportunity to appreciate the giant redwood trees than a
chance to sketch the infinitely diverse array of tourists from all over the
world, milling about the forest floor. A trip to the Metropolitan Museum
of Art in New York, with a few of Harvey's collectors, demonstrated
Harvey's razor-keen insights when viewing the acknowledged masters
of sixteenth- to nineteenth-century European oil painting. He impres-
sively dissected these late artists' varied strengths and weaknesses
(and how they compensated for or obscured those weaknesses) in an
impromptu lecture, explaining how he'd assimilated their strengths
in order to convey a deep connection to people in our own times. He'd
been looking closely at many of these paintings for seventy years. Our
small group visit to the Met quickly became a huge and conspicuous
tour of almost fifty people, many of whom recognized Harvey by his
telltale corduroy jacket and large gray beard. As reclusive as he has
often seemed, Dinnerstein is a hugely popular figure among painters,
collectors, and art students who appreciate his refined draftsmanship,
his understanding of color, and his ability to methodically construct
arresting compositions.

Now, after a six-year friendship, after meeting appreciative students
from Harvey's four decades as an instructor at the Art Students League
on West 57th Street and the School of Visual Arts and the National
Academy of Design, abstract questions about whether his art is impor-
tant seem remote and absurd. Clearly there are other methods for
exploring and expressing our shared humanity through art than what
Dinnerstein employs. A humanist agenda in making is just that, an

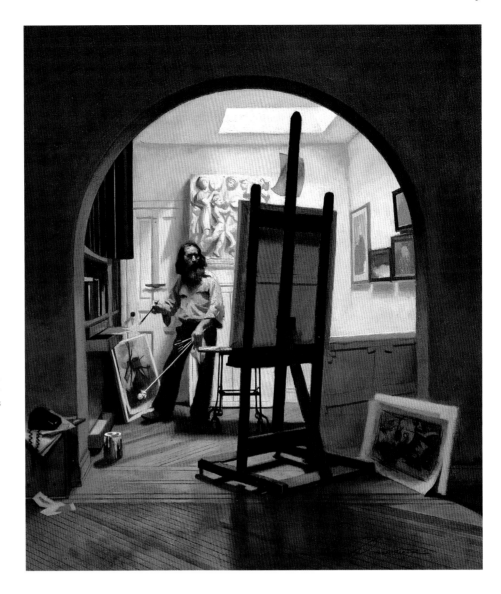

The Studio oil on board, 23½" x 20½", 1978
My studio is on the top floor of a brownstone in
Brooklyn. There are three sources of natural light that
illuminate the space. A skylight facing north, which
provides a steady cool light that I usually work under,
a bank of windows facing south, which offers a
warmer light, and another smaller skylight, domelike
in shape, which allows sunlight to enter an alcove of
the studio. I also have shades so that I can control the
light and fluorescent tubes, which are color-balanced
to supplement the north skylight. In this painting,
I am working in the alcove, where a Della Robbia cast
is mounted on the rear wall. I have painted this cast
many times over the years, and it has an interesting
history. When my wife, Lois, taught her first art his-
tory class at Vassar College in 1959, she came across a
collection of casts in the basement of the college cha-
pel that were about to be destroyed because the school
needed the storage space. There were exact-size repro-
ductions of Della Robbia's Cantoria reliefs, Donatello's
St. George Tabernacle, and Michelangelo's early Pietà,
among other casts.

They had been used in the school's art classes. But
years ago the administration had decided that they
were no longer relevant, and they had been in storage
since 1928, the year I was born. We rescued a half
dozen of the casts, which were eagerly acquired by
various painter and sculptor friends.

agenda only. Dinnerstein's approach is pictorial and representational,
a mixture of methods assimilated from painters as divergent as Ingres,
Rembrandt, and Eakins. These methods combine with the intense
human empathy of American poets like Walt Whitman (who is featured
prominently in a number of Dinnerstein's canvases). This is not a "how"
but a "why," and artists who differ from Dinnerstein (such as Alfredo
Jaar, who works in a variety of installation, video, and photographic
media) function from the same motivational principles: to open us to
a dialogue with the other.

Humanist Convictions

Dinnerstein began his artistic studies as a teenager, with a solid founda-
tion of drawing and painting as the crucial supports for the canopy he
saw himself developing years later. But this canopy was not a simplistic
ecosystem. Instead, Dinnerstein has embraced and extended a tradition

Brownstone Ornament pastel on paper,
3¾" x 10½", 1972

of representational painting, one that makes evident to the viewer that there continue to be possibilities for this tradition, possibilities that transcend the values of the merely pictorial and evoke the poetic experience of our shared humanity.

Dinnerstein came of age as an artist at the advent of abstract expressionism, in the 1940s. Given what he would choose to pursue as an artist, he had unfortunate timing. At first he struggled to find value in abstract modes of painting and eventually found them to be personally ungratifying. Dinnerstein responded to the turbulent passions in the country, starting with his revelatory trip (with artist and friend Burt Silverman) to Montgomery, where he made sketches during the bus boycott of 1956, and continuing through the countercultural movements of the 1960s and the anti-Vietnam "protest theater" of the late 1960s and 1970s. Such journalistic "speaking truth to power" was most effective when least sentimental and most complex, as in Dinnerstein's large masterpiece *Parade* (1970–72).

By the late 1950s, the art community in Europe and America seemed fed up with accurate handmade rendering. Altruism seemed naive and aesthetic humanism vanquished by the cynical aftermath of World War II and the terrifying birth of the Cold War. Nuclear annihilation became a tangible possibility in everyday life. A cold, theoretical art flourished, with an aesthetic agenda arduously divorced from the lives of everyday people. With few exceptions, intelligent artists of any persuasion were no longer interested in drawing people on the subway or in a public park or in constructing monumental scale paintings of convincing verisimilitude over the course of years or decades. Practicing this style of representational painting was tantamount to practicing Greek polytheism in a new Catholic Church, with the Church being the uncompromising orthodoxy of abstract expressionism and its formalist and postmodern derivatives, and its two popes being Harold Rosenberg and Clement Greenberg.

Rosenberg and Greenberg presented dynamic and highly seductive ideas about what art of the latter twentieth century should offer, and they

did so with convincing charisma, polymath erudition, and tremendous hubris. Perceptive art-world outsiders, such as Tom Wolfe in his now infamous essay "The Painted Word", would remark in retrospect that artists seemed to be painting to fit these two critics' theories, rather than the other way around. The slowly gained skills of Michelangelo or of the Dutch Masters were deemed irrelevant to a decidedly new human predicament, one that these two critics argued had changed dramatically from previous millennia, owing in large part to the advent of industrialism and the possibility of nuclear oblivion. The supposed apostates who practiced those Old World modes of art-making were for some time considered personae non grata by the arbiters of legitimacy, even as the notion of an "important American artist" transitioned from an oxymoron into the natural assumption of forward-thinking lovers of high culture.

Today, we in America and Europe live in a much more pluralistic art community, one that assimilates far more cultures and schools of thought than the Eurocentric model of a hundred years ago (as well as the mid-century American abstract expressionist lockstep). Art practice has exploded into digital, theoretical, and conceptual art; installation; assemblage; social practice; and abstraction. And yes, painting and drawing are more broadly acknowledged as having value. In other words, we seem to have abandoned purist orthodoxies, based either on ideas or materials. This opening up of possibilities for the artist is without doubt a good thing, both for artist and for audience. Representational painting and drawing are now acknowledged as significant elements in contemporary art in the 21st century. It is virtually impossible for a young artist to understand the toxicity and vitriol associated with the establishment of what was then the one true art-making orthodoxy of abstract expressionism, or the burden of those who defied these simplifying trends to effectively become the art world equivalent of "Invisible Men." Such was the birth of American artistic dignity; it could only afford the assertion of a single faith at first.

Pluralism and Recognition

Dinnerstein's artworks, usually rendered in pastel, graphite, or oil paints, depict an extraordinary diversity of people living in what is arguably the most cosmopolitan city on Earth, New York. As Pete Hamill's contribution to this book attests, Dinnerstein is Brooklyn in his blood and bones. The relationships and narratives he chooses, however, are powerfully ambiguous and therefore transcendent of such specificity of time and place. They are rooted in art historical precedent and study. This foundation is insightfully illuminated by Dr. Gabriel Weisberg in his essay on the evolution of Dinnerstein's specific aesthetic. What Dinnerstein's dramatis personae do have in common is a compassionate empathy implicit in their facial expressions and postures, as well as in the overall emotional tone and composition of the paintings. For those who appreciate the intimacy of bold eye contact with a stranger, these scenes catalyze and energize the viewer's own sense of what it means to be human. Harvey Dinnerstein's art implicitly asks us to face the other with empathy rather than fear.

In literature, film, music, and theater, indeed in almost every traditional format and many hybrids of art praxis, a vein of "deep humanism" persists, ebbing and flowing, but never blocked. Although the most knowledgeable critic often has the first word, it is the ability of an artwork to rivet the attention of a broad audience that is the final arbiter of that work's endurance in history. A deep humanism is not the only possible measure of an artwork's value, but Dinnerstein's art emphatically asserts that it must be one of them. The best art either succeeds in becoming populist or is inevitably forgotten. Critics and intellectuals may help or hinder this assimilation, but occasionally even informed opinions become irrelevant to the aesthetic experience; we do not need any instruction or interpretation to appreciate a poem by Edgar Allan Poe.

In 1991, populist poet Dana Gioia published a highly controversial essay entitled "Can Poetry Matter?" as a clarion call to redirect poets (particularly academic poets) to their connection, or lack thereof, with the general public. Now director of the National Endowment for the Arts,

in June of 2007, Gioia delivered a commencement address at Stanford University that focused on the American public's increasing disengagement from literacy and the arts in general. Many people increasingly feel they need a graduate degree to appreciate challenging contemporary art and are therefore often too intimidated or put off even to attempt an investigation. Gioia asked why this is, why we should care, and what the repercussions are for a society that finds itself increasingly alienated from its greatest artists and their creations. The art in this book is an almost a priori response to Gioia's challenge, since many of the barbs he has aimed at poets might often apply to visual artists as well.

For much of Dinnerstein's career, his art has been misperceived as the labor-intensive machinations of a living anachronism, an artist mired in the past and therefore too stubborn to engage with the questions at the forefront of contemporary art practice. This is the only option offered by thinkers who are uncritically enamored with the forever reinventive, who embrace the cult of innovation for its own sake. Innovative art, when not following theoretical rabbits down dead-end holes, offers the great promise of altering the viewer's worldview or of broadening and deepening or shifting his or her awareness. Such flexibility of consciousness and opinion is laudable. In contrast, Dinnerstein is one of the few artists to maintain a tradition of humanist art-making that contains completely different fundamental assumptions about what art should do and what it can achieve. He is a traditionalist, no doubt, but one who integrates traditional means with a postmodern appreciation for multiculturalism and an unflinching belief in the need for art that stimulates broad human empathy. •

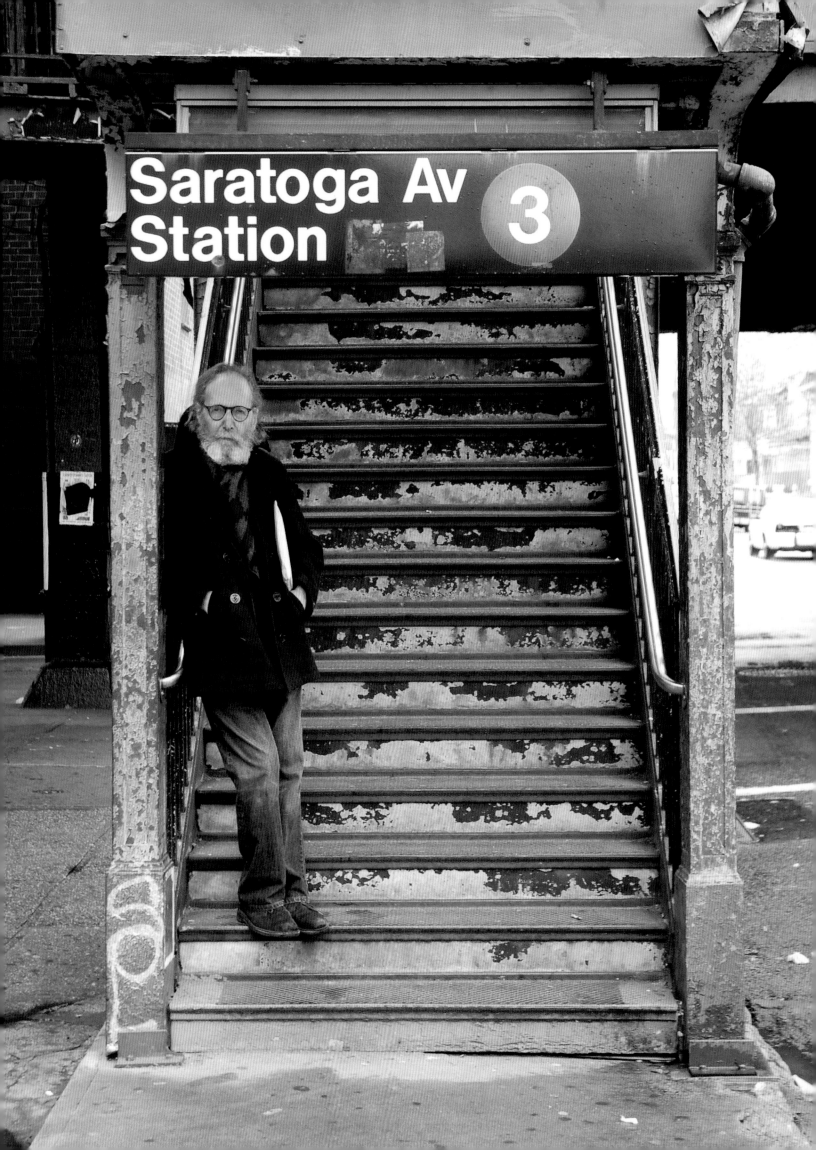

The Hand He Was Dealt

by Pete Hamill

Morning in Brownsville, under a luminous Brooklyn sky. I'm with Harvey Dinnerstein, who was a boy here before World War II, in a world now vanished. The 1939 WPA Guide to New York City described a Brownsville with more than seventy Orthodox synagogues, where the pushcarts jammed Belmont Avenue, and where Yiddish was frequently the language of trade and intimacy. That year, Harvey Dinnerstein was eleven. He had already acquired the template of Brownsville. Almost seventy years later, he still knows the neighborhood. That way is Ocean Hill, where his father, Lou, ran a drugstore. Not far away is Betsy Head Park, where kids played ball and old people sat in the warming sun. There was a library on Stone Avenue that helped the young create dreams of other worlds. In another direction, on the corner of Saratoga and Livonia, was Midnight Rose's, the twenty-four-hour candy store where the stone killers of Murder Incorporated accepted contracts that created corpses. The gangsters recruited their infantry from the packed tenements, where two hundred thousand human beings were jammed into an area of a little more than two square miles. After Pearl Harbor, many young men from the same mean streets went off to join the U.S. infantry.

On the streets of Brownsville during the Great Depression, the boy named Harvey Dinnerstein began to see, which is not the same as merely to look. There were so many things to observe, starting with people. Old men and women from the shtetls of Eastern Europe; cops and firemen; brazen young women; rabbis; young men dressed in sharp clothes; tradesmen; shoemakers; prizefighters from the gym on Georgia and Livonia; and the carpenters, masons, painters, and electricians who gathered on Sunday mornings at Stone and Pitkin Avenues. There were

above
Subway Sketch graphite on paper,
8½" x 6", 1986

opposite page, left
Chicken Market A graphite on paper,
8⅛" x 6", 1972

opposite page, right
Chicken Market B graphite on paper,
8⅛" x 6", 1972

socialists among them, and communists, and union firebrands, many driven by visions of utopia, others by matters more practical, such as finding a decent meal in a bad time. For a boy who was learning how to see, one major lesson of Brownsville was simple: there were many ways to be a New Yorker.

For a few children of Brownsville, including young Dinnerstein, there was still another choice: to be an artist. Not surprisingly, in a neighborhood with more than twenty movie houses, including the glorious palace called Loew's Pitkin, many found their way to the performing arts: Danny Kaye, Phil Silvers, and Joseph Papp among them. Some were inspired by teachers at PS 156 (which Dinnerstein also attended), or the shelves of the Stone Avenue Library, to literature: Alfred Kazin (who wrote extensively about Brownsville in his brilliant memoirs); Gerald Green; Norman Podhoretz, a splendid literary critic before moving into neoconservative polemics; and Irving Shulman, author of the 1947 novel *The Amboy Dukes,* the first account of young urban street gangs, set on Amboy Street, which many years later was home to heavyweight prizefighter Mike Tyson. Each found a way to do something he loved: making people laugh, or think, or read. Each made human beings more human.

Young Dinnerstein also had something he loved. He could draw. There were no graphic images on the walls of the Brownsville apartment, no examples to emulate. But Dinnerstein was always drawing. And when he was fourteen, while the war was raging, his drawing got him into the High School of Music and Art, far away in uptown Manhattan. Every morning he would leave on the subway, a journey of more than an hour. All the way to school, he would make sketches. All the way back, in late afternoon, he would do the same. His subjects, then as now, were human beings.

In the gloomy neo-Gothic building that his fellow students called The Castle, Dinnerstein met for the first time other youngsters from all over the city. Among them were Burt Silverman, Daniel Schwartz, Arnold Abramson, and Herbert Steinberg. They all became close friends. Silverman would later write that these friends "were incredibly talented and seemed full of unbounded confidence and exotic preoccupations such as going to museums

and galleries, making etchings, drawing in sketchbooks, and talking about art and politics with a kind of certitude that is only tolerable in the young."[1] Dinnerstein began to know the names and work of the great artists of the past, and because this was New York, he could actually stand in front of paintings as closely as their painters once did, examining brushstrokes, shadows, details. The branches of this artistic treasure-house were just a subway ride away. On one early trip with his friends to the Metropolitan Museum of Art, he saw a self-portrait by Rembrandt.

"I lit up with the possibility of doing something like that," Dinnerstein remembered decades later, as we talked in his Brooklyn studio. "In contemporary terms . . . in contrast to all the other images that were being offered to me."

His teachers at Music and Art treated the students with respect, demanding good work, while imparting some of the emerging doctrines of modernism. But the engine driving Dinnerstein was drawing. The first two art books he remembers buying (at a Manhattan bookstore named Weyhe's) were about the work of Käthe Kollwitz and George Grosz. Both could draw superbly.

"There was a linear quality to Grosz's work that fascinated me," Dinnerstein says. "But at a certain point, later, I began to realize all the sources that he derived from. These were northern Flemish traditions that had a great deal more that interested me."

In Kollwitz he saw other qualities. "The human qualities are so obvious. But even though there were innovative qualities in her etchings, basically her drawing abilities really derived from the nineteenth century. That's what I really related to."

Across four years in wartime New York, in a world of black-outs, rationing, scrap-metal drives, austerity, black marketeers, and war news flooding the newspapers and the radio (along with increasing information about what would later be called the Holocaust), Dinnerstein and his young friends were in pursuit of the secrets of the artistic past. But they did not entirely seal off the swirling currents of the present. He and a few others used to stop by the Hans Hofmann School of Fine Arts on 8th Street in Greenwich Village. An immigrant from Germany, Hofmann was one of the great prophets of an emerging New York school of modernism, sometimes called abstract expressionism. He was, Dinnerstein remembers, the "latest thing."

"There were some classes that Hofmann conducted that were open classes, where he would lecture in front of the students' work," he remembers. "Anybody could come in and listen to him. And he was a very charismatic lecturer and teacher. I could see that immediately. But it really didn't interest me. There were others of my contemporaries—Wolf Kahn, Paul Resika—who decided that was for them. But I made other decisions. And those little decisions you make along the way go to form what you eventually are."

One reason Dinnerstein rejected the siren song of fashion-able modernism was very simple: he loved to draw.

"I didn't want to give it up. Later on, I figured out more clearly why. But instinctively, intuitively, that was mostly why. Yes. I loved to draw." He pauses, thinking of old choices. "The point I'm trying to make is that other stuff was available. I'd had a kind of precocious introduction to all that as a kid growing up in

New York. And I saw that it just wasn't for me. And I turned my back and went on to other things."

After a few years at Music and Art, Dinnerstein and some of the others began to take Saturday and Sunday classes with Moses Soyer in his studio on 16th Street near Union Square. (In 1912, at age thirteen, Soyer, his twin brother, Raphael, and his younger brother, Isaac, arrived in New York from Russia with their parents. All three brothers would have careers as artists.) Dinnerstein remembers the studio of Moses Soyer as two rooms: one for students, one for Moses.

"It was the first artist's studio I ever walked into," he recalls, "and it was just a marvelous experience. I could wander into his studio and see what he was doing there. There was an ambience, a high seriousness about the place, and clearly his hand had touched everything."

Some of Soyer's friends would stop in, including an old man named Joseph Stella, who had painted his own urban vision of modernism in 1919. Many years later, Dinnerstein became familiar with the brilliant drawings of immigrants on Ellis Island that Stella had done in 1905. "They were more interesting to me," Dinnerstein remembers. So was the life of the Soyer studio. One Sunday morning, the students arrived to see the remains of a party for Paul Robeson, the African American singer and actor who was a hero of the Left. Some guests had left drawings and cartoons on the walls: a piece of Soyer's world.

"What he taught us was really minimal," Dinnerstein said of Soyer. "I can't remember anything in terms of craft that really lingered with me. But it was about what it meant to be an artist. That it was a way of living a life, and it was about other human values that he had, far beyond the craft. There were things he would say about being true to your perception. You know, picking up on something I was doing that was false or pretty . . . *that* I thought was more significant than any technical information he would have offered. Years later, that's what lingered on: the idea of being honest and true to your perceptions toward a subject."

There were other artists in the studios around Union Square: Reginald Marsh, Isabel Bishop, Yasuo Kuniyoshi, among many others. The teenage Dinnerstein didn't meet these artists, but their unseen presence provided a model for the

artist's life. On the square, fading numbers of utopian orators bellowed about the class struggle. But the Depression was over. There was a war on. Soldiers and sailors moved through the crowds, in pursuit of shopgirls. Swells emerged from taxis and swaggered into Luchow's Restaurant. Musicians played jazz under the trees. Artists could examine them all, then head for their studios, where they could turn these people into art. It was all part of Dinnerstein's education, although he did not know it then.

"My training was really very haphazard," he said many years later. "I'm mostly self-taught."

Along with painting at Moses Soyer's and studying at Music and Art, he continued to draw every day on the subway. He was building his visual memory (although he did not articulate it that way). He was training his hand in charcoal, pencil, and brush. I asked him about the hardest part of his education as an artist.

"Figuring out what I wanted to do," he said, "what I was good at, and how I was going to develop it." A pause. "When you first start out, you're offered all kinds of possibilities, and it's difficult and confusing. . . . Once I had a clear idea of what I wanted to do, then I could figure out enough of the craft to get me there."

The war ended in 1945, and Dinnerstein graduated from Music and Art the following year. The future looked bright. He had won a scholarship to the prestigious Carnegie Institute of Technology in Pittsburgh, a long way from Brownsville. But when he arrived as a freshman, he sensed that something was wrong. He found the atmosphere antiseptic. The faculty was interested in the icy certainties of the Bauhaus, with texts by György Kepes and László Moholy-Nagy. He missed the ambience of a painter's studio, the aroma of oil and turpentine. A few months later, he dropped out. "It wasn't for me." Dinnerstein transferred to the Tyler School of Art in Philadelphia, the city of Thomas Eakins, and stayed there for three years. The teaching methods were more traditional, the atmosphere more comfortable. During those years, he also took classes at the Art Students League in New York, with Kuniyoshi and Julien Levy. More important, he made some new friends, among them the artists David Levine and Aaron Shikler. He said of his artistic friendships,

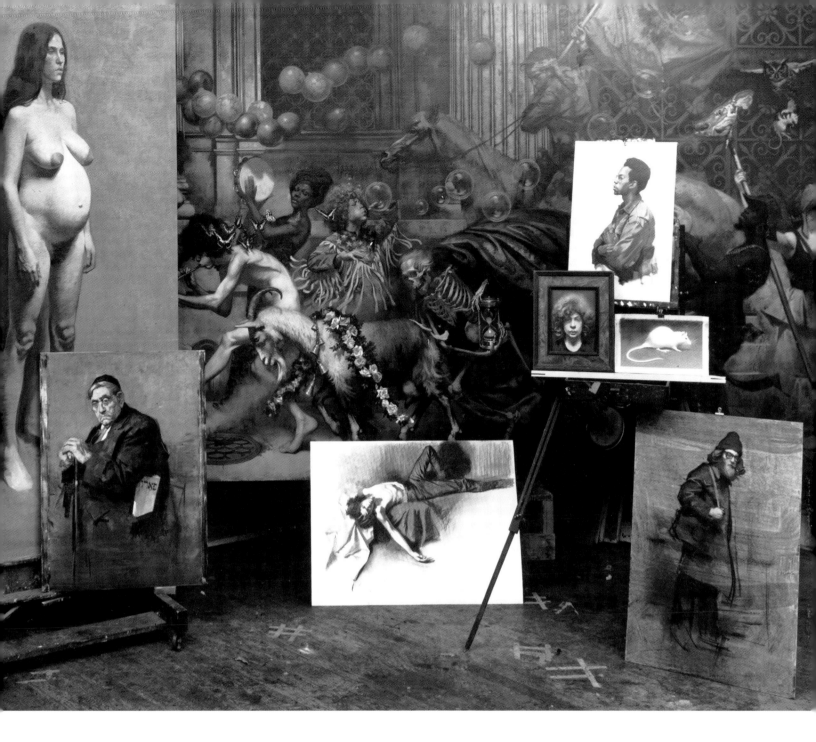

Studio photograph
Photograph by Geoffrey Clements, 1972

"I think we learned more from each other and from studying great paintings than we ever did from any institution."

Dinnerstein left Tyler in 1950, and for the first time had his own studio, shared with his friend Burt Silverman. The studio was on 14th Street, a few blocks from the studio of Moses Soyer, in an area of working painters. Some of the abstract expressionists had studios in the same area, but even established realist painters (such as Jack Levine) were having trouble getting the attention of critics. Meanwhile, in the summer of 1950, the Korean War erupted, and worries about critical attention soon became academic for the two young painters. In 1951, both were drafted. Dinnerstein has little to say about his army days, except to emphasize that the period was a waste of time. One self-portrait survives from the period, showing a young soldier looking sullen and wary (page 44).

There were difficult times after the army, and Dinnerstein did odd jobs just to pay the rent. But he kept painting, trying to refine and expand his vision, with moral support from his artist friends, who were engaged in the same project. In 1955, he began showing at the Davis Gallery on East 60th Street in Manhattan. The gallery was run by Roy Davis, a student from Tyler who had given up painting for the more hazardous vocation of dealing in art. Davis believed that he could go against the prevailing tides of fashionable modernism. He showed Dinnerstein and Silverman, David Levine and Shikler, among others.

External events were now forcing their way into the consciousness of all Americans. The Cold War had chilled many American lives, along with a punishing reaction called McCarthyism. Most important domestically was the modern civil rights movement, specifically the Montgomery Bus Boycott, when the world first heard of Martin Luther King Jr. In early 1956, Harvey was reading accounts by Murray Kempton, the superb columnist for the *New York Post,* and seeing images from Alabama on television and in the newspapers. He suggested to Silverman that they go to Montgomery together and draw the story: ordinary people doing extraordinary things, saving the honor of their country. Silverman agreed. In March, they headed south. Harvey's wife, Lois, went with them to interview the participants. It was almost exactly nine years after Jackie Robinson had stepped onto the grass of Ebbets Field to become the first black man to play major-league baseball. That event was momentous for every American, black or white, but particularly for people from Brooklyn, like Dinnerstein and Silverman.

In ten days, they made about ninety drawings, using art to show the determination of black people to end Jim Crow segregation on the city's buses. They visited courtrooms and black churches. They witnessed marches, one of which included a one-legged black man on crutches. Strong, proud black women were central to the movement, and Harvey made a quiet graphite and pastel portrait of Rosa Parks, the extraordinary woman who set off the protest with her refusal to surrender her bus seat to a white person. He and Silverman showed that classical tools, such as drawing, could provide insights into real-world events that went beyond those provided by photography. They could evoke the spirit of an event, not simply its surface. "In retrospect," Dinnerstein has written, "the drawings seem limited and anecdotal, with a few exceptions." But Käthe Kollwitz surely would have understood what the two Brooklyn artists were doing in Montgomery.

"It was so much larger than ourselves," the artists wrote in 2006, "and had a powerful impact on our understanding of how art could express the passions of contemporary life. It would lead to a lifetime dedication, as artists, to expressing a personal vision of our time."

In his own work, Dinnerstein was struggling to combine his roots in Brooklyn, his life in the present tense, and the creation of an art that went beyond simple reporting. In 1963, he made his first visit to the Louvre and saw Théodore Géricault's *The Raft of the Medusa*. This masterpiece was painted in 1819, when Géricault was twenty-eight, and was inspired by an actual shipwreck three years earlier in which an incompetent captain and a notoriously late rescue were widely seen as products of political bungling.

"It was one of the things," Dinnerstein said, "that just bowled me over."

Back in New York, his dealer said he thought the *Medusa* was an unsuccessful painting. "And if you went over it, inch by inch, it really didn't work. There were so many dead areas of brushwork, where the color, you know, was just a brown mess. But if you step back, and look at the whole bloody thing, it works on a certain level that just knocked me out. And the fact that Géricault took a contemporary incident and transformed it on some mythic level was astonishing. You can look at the painting, and not even know about the raft of the Medusa or the politics of the moment, but it reaches that other *epic* level. That's what I aspire to."

The '60s were erupting, and Harold Hayes of *Esquire* assigned Dinnerstein to cover many of the events: antiwar demonstrations, trials, the aftermaths of assassinations. "I tried to get beyond the incidental nature of various events," he wrote later. "I avoided representing well-known personalities, and instead of drawing the courtroom scene at the conspiracy trial in Chicago,

with its attorneys, defendants, and judge, I turned to the demonstrations in the streets. Above all, there was something more *visual* in those demonstrations that expressed deep rumblings going on throughout the country."

In 1961, Dinnerstein and his family moved to a house in Park Slope, Brooklyn, before that neighborhood of trees and brownstones became too expensive for most New Yorkers. David Levine lived a block away. Silverman was in Brooklyn Heights. The vast green acres of Prospect Park were a half block away.

"The most difficult thing was defining myself," Dinnerstein told me. "An artist is more than technique. It's also knowing who you are and how you relate to the world you live in. I realized that the Jewish provincial Brooklyn background was part of it. And the challenge was how to incorporate that with all the other things I had learned. I'm aware of the danger of being seduced by the knowledge I have of paintings from the past—Rembrandt, Géricault—and by the skill I've acquired, and forgetting about where I really come from."

Brownsville was deeper into central Brooklyn than Park Slope, reachable by subway, but by the 1970s it had changed. Dinnerstein's portraits of a model named Mr. Meltzer seem more rooted in the Brooklyn that he came from. Isidore Meltzer was an immigrant from Russia, who grew up on the Lower East Side. People who resembled him were all over Dinnerstein's Brownsville. Above all, his portraits (and drawings) of Meltzer are infused with a stubborn pride. During this time, Dinnerstein was becoming a superb portrait painter, using Brooklyn neighbors as subjects. He was finding layers in the human face and in the stance of a full-length subject that revealed character and life, suggesting the past and even some portents of the future. His portraits of Lois Dinnerstein (now a respected art historian) and their children, Rachel and Michael, are radiant with feeling without being sentimental.

Dinnerstein also had larger preoccupations, most of them about finding a way to capture the essence of the times. He wanted to serve as witness. The breakthrough came with *Parade,* which he worked on from 1970 to 1972. This huge painting (74" x 153") could be called a processional of the '60s: the era's sexual license, roaring music, ambience of death, illusive hopes, and the jagged irrelevance of newspapers. It seethes with symbol

and allegory but is not a simpleminded political cartoon. Instead, *Parade* requires a viewer to enter it, as if entering a book, and simultaneously to examine both the parts and the whole.

"In that painting," Dinnerstein told me, "I began to see that there was a way to take incidental narrative information and put it together in some epic form that would work."

In his major paintings since the 1970s, the ambition remains the same: to take the bits and pieces of the world as he sees it and make something grander, more universal, from them. His method remains the same, too. He begins with a sketch. Sometimes he makes photographs for incidental details: lettering on a wall, the exact position of a fire hydrant. Most of the time, when making photographs, he also does sketches, "because photographs are too full of meaningless detail." He begins to block out the compositions, feeling his way in, and then he seeks out models and does drawings. Later, these can be squared up and transferred to stretched canvas. At this stage, he can bring back his models.

Dinnerstein's mastery of craft is evident in the paintings of his maturity. In *Rainy Evening, Lower East Side* (2001) the sidewalk glistens in the rain exactly as it does on any lonesome New York sidewalk. Steam escapes from an unseen sewer. In the background, one browning store sign is in Yiddish, a relic from times past, while Chinese lettering adorns the side of a small delivery van and scraps of red graffiti are scribbled on the wall beyond, each defining the present. An old woman, probably Jewish, carrying flowers, uses an umbrella to navigate the steps of the bus and finds her way to the streets where she was once young. A young woman, carrying a bag, pushes into the driving rain with an umbrella that shields her and the child strapped to her back. A black woman strides hard in the opposite direction, trying to open her umbrella. A mysterious hatless blind man, as pale as death, dressed in a raincoat, umbrella furled beneath his arm, uses a red-tipped cane to tap his way in the same direction as the young woman. All are isolated, except mother and child. Each seems consumed with a separate destination. And in a bus window, observing them all, is Harvey Dinnerstein.

Dinnerstein is present, too, in *Underground, Together* (1996). While he was drawing on the subway a half-century earlier, he sketched the black woman who stares out of the open doors,

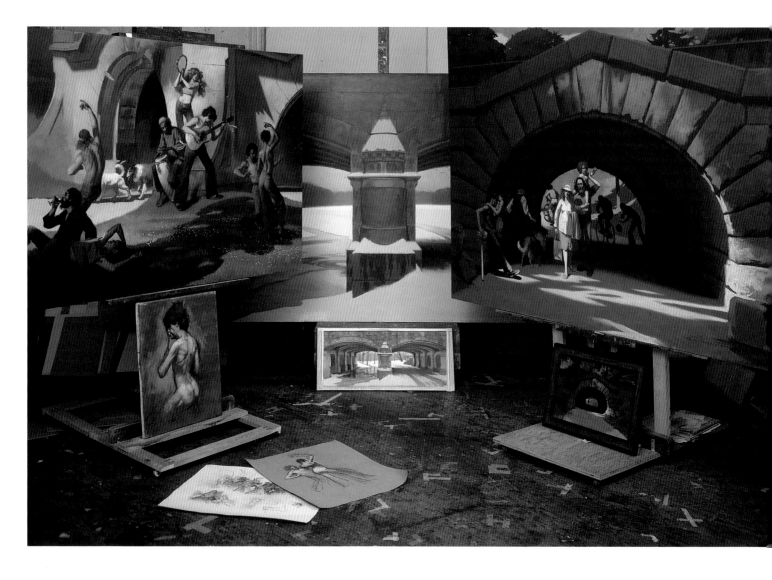

Studio photograph, *The Seasons*
Photograph by Tony Mysak, 1983

engaging the viewer. On the floor, a capped, legless beggar leans forward on his dolly, while a Japanese woman drops a coin into his cup. (Like Dinnerstein, I used to see this beggar almost every day for a few years, and then one day he was gone). There are other New Yorkers in the same car: a bearded hard hat; a young woman with a child; a veiled Muslim woman; a young man with a yarmulke; a businessman in hat and raincoat, reading a newspaper; a small elderly Chinese woman. They are crowded together in individual solitude. There is no melodramatic sense of menace, no tension. Just a varied group of New Yorkers heading somewhere, knowing they will never see each other again. And that is probably Dinnerstein's point. But during that brief instance, they are community.

Dinnerstein is present in other pictures: mourning the victims of September 11 in *Candlelight Procession* (2003), with

its candles and flowers, its fireman and its Muslim woman, its black construction worker, and a man in a Yankee watch cap with a boy on his shoulders. An older man in a wheelchair grieves over the changed world. A pregnant young woman seems wary. There is no rhetoric in the painting, no bullhorn polemics. But Dinnerstein has captured the deep, abiding sorrow of all who were there on that terrible day in September.

The painter is present, too, in the *Summer* part of his series called *The Seasons* (1982), which evokes the moods of Prospect Park. This is the great 526-acre park designed by Frederick Law Olmsted and Calvert Vaux in the 1860s, a place into which the visitor can move beyond the sight of any building, a green hilly refuge from the city. There is also a self-portrait of the painter at work in the park, poised at his easel, with stone arches and summer green behind him. At times, the park has been a dangerous place, but these paintings only suggest such sinister possibilities; the subjects insist on playing music, dancing, jogging, strolling in the light and shadow of Brooklyn.

"When I refer to Brooklyn," Dinnerstein has written, "or my neighborhood, the words themselves suggest the provincial and familiar, and it is just this aspect of everyday life that is the source of my work." Another self-portrait is part of *Della Robbia and Baseball* (1991). It shows Dinnerstein in his studio, moving a canvas against a background dominated by a cast of a Della Robbia Cantoria. The cast was saved from destruction by Lois, when she was teaching at Vassar. Harvey placed it under the skylight in his studio. "One day," he later explained, "I happened to notice the play of light on the sculpture and other props and materials in that alcove. I was intrigued with light enveloping the forms of the fifteenth-century Della Robbia and the round shape of the contemporary baseball."

That baseball is part of Brooklyn, too.

In his great ferry paintings, Dinnerstein has woven together many of the strands of his art and life. Figures from previous paintings are on deck in *Sundown, the Crossing* (1999). The ferry is called the *Brooklyn* and is heading home. There are the flutist and the *conguero,* with a medieval figure of death behind them holding a bloody scythe. There is a young man, with a monkey on his back. There is Harvey, with Lois. And many others as well who have found previous life in other Dinnerstein canvases.

They are like travelers out of Boccaccio or Chaucer. And on the steps above and behind them, in white beard and hat, is Walt Whitman, shaped by Brooklyn, great poet of the harbor crossing. Behind them all, immense dark blue clouds rise into the sky, while the horizon is shared by an old sailing ship and a tugboat.

One companion piece is called, simply, *Fallout* (2002). Again, we see a small group of Dinnerstein's travelers on a more modern ferry. Off to the left, an unseen blinding brightness is marked only by a few specks of red, some splintered objects, and a long dense trail of black smoke. The intense light reveals a man seated on the ferry in a business suit, a laptop on his knees, speaking intensely into a cell phone, while newspapers in several languages scatter at his feet. A black-gowned older woman, possibly Muslim, turns her back on the unseen calamity. A shocked young woman tries to shield a sleeping infant with a cream-colored shawl. She resembles an immigrant from the turn of the nineteenth century. A black man uses his hand to shield his eyes from the fierce blast of light, while his right leg lifts in shock. A man and woman in the shadows hug forlornly. And alone at the rail, gazing ahead, trying to see, is Dinnerstein. Gulls move against the greenish gray somber sky. Above them hangs a lifeboat marked "The Walt Whitman," an invention of the artist. Maybe poetry can save them all.

On our morning together in Brownsville, we started walking from the Saratoga elevated station. On the corner was a barber shop called Moor Cutz, which also sold CDs and DVDs, and a Chinese take-out place. We moved across the street under the El, with its scabby paint job, and the screeching sound of steel against steel as a train moved into the station. On the far sidewalk, we could see the way the El curved on its way to Manhattan, and Dinnerstein remembered that he used to worry as a boy that it would fly right off the tracks.

We passed an old, small movie house that was now the Morris Koppelman Early Childhood Academy, and Dinnerstein remembered the tough street gangs from Legion and Grafton Streets. He grew up in an apartment house at 219 Grafton, a few blocks away. But he doesn't sentimentalize Brownsville.

"In 1965, I was in Rome," he remembered, "and a letter arrived from my kid brother Simon [also a fine painter]. He told me, 'Mom and Dad are moving next week.' He explained that there had been some terrible incidents. They moved in a kind of panic. My mother was afraid to carry a purse; she used a brown paper bag. And all around them, the Jews were moving.

"Because of his left-wing politics, my father was reluctant to leave. But he'd been mugged four times in a month in the hallway at 219 Grafton. One time, they cut his pocket with a knife to grab the money. So they moved to Brighton Beach and lived there for the rest of their lives." A pause. "My father kept his illusions right to the end. All his friends lost the faith. But in a way, it was what sustained him.'"

The old building at 219 Grafton is gone now, replaced by a pair of two-story houses, with gardens in front and a cheerful sign announcing Fay's Day Care Center. Dinnerstein had last been on the street almost fifteen years earlier, accompanied by his brother Simon. That was a time when Brownsville had been reduced to a bleak urban tundra, full of burnt-out buildings, enrubbled lots, abandoned automobiles, crackheads, gangs of feral youths. I had been there in the 1970s as a reporter; Dinnerstein came as a native son. On this day, we were both astonished.

"This is amazing," he said, as we looked at rows of two-story houses, many of them erected by the Nehemiah Houses Project, a combination of citizens and civic leaders. Cars were parked in driveways. Small bicycles stood on lawns, awaiting the kids' return from school. The gardens were tended with obvious care. Dinnerstein looked around and mentioned places that existed now only in memory, like the bakery on Sutter Avenue that sold yellow cookies. After his father opened his first drugstore at Dumont and Rockaway Avenue, he started a second drugstore in Ocean Hill, where people came in after the war with concentration camp numbers tattooed on their arms.

We talked a while with a middle-aged black man from Guyana, who was working in a turbulent garden. He was cheerful and funny. And then we went toward Pitkin Avenue, and Dinnerstein remembered shops that were gone and movie houses. The huge bulk of Loew's Pitkin rose into the sky, long unused, once full of noisy kids who could dream through

tenement nights about the open spaces of the American West. Women sat on benches in Zion Park. Mothers wheeled baby carriages. Immigrants mixed with African Americans. Young men stood in front of fast-food joints. We hailed a taxi.

"I had a curious conversation with my son, Michael, the other day," Dinnerstein said later. "He's a law professor and has done various things in his career as a lawyer. He said to me, 'It's what you do with the hand you're dealt.' And I thought there was something very sharp about that. We're all born with certain intuitive abilities, and what we can do is limited by the world we live in. And it's what you do with the hand you're dealt, you know? I thought for a long time that Brooklyn was so provincial and I was really desperate to get out of it. But at one point, I began to realize: This is really, interesting. Unique. Special. And I know it." He paused. "I know the territory." •

1 Silverman, Burt. *Painting People* (New York: Watson-Guptill, 1977): 10.

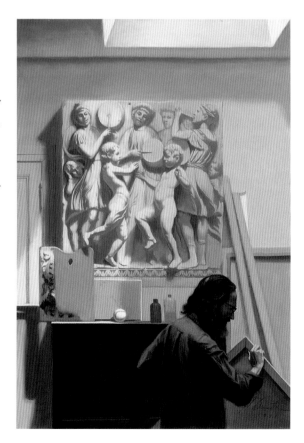

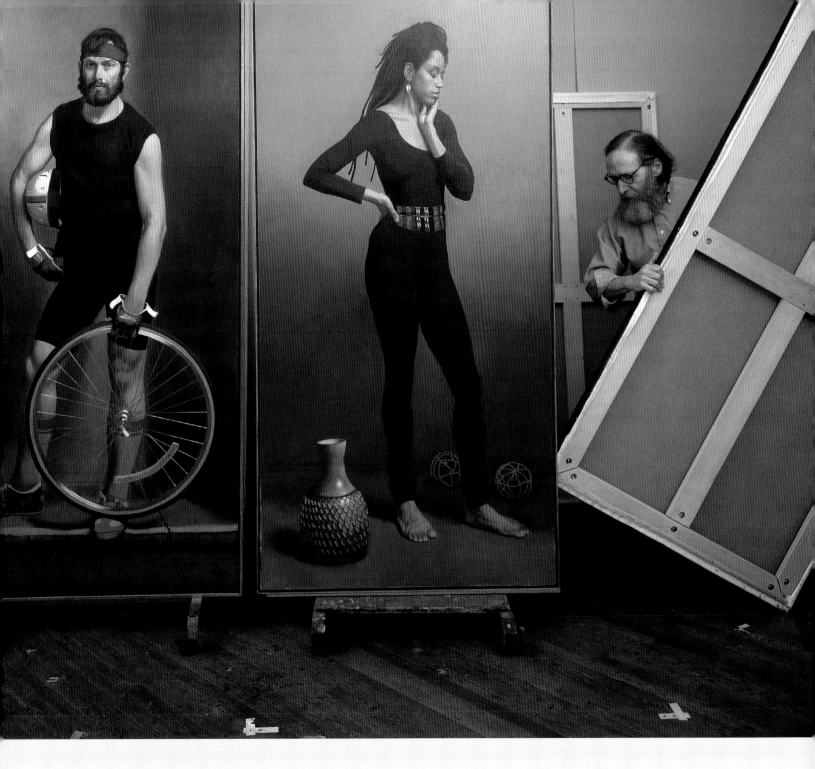

Studio photograph, *The Cyclist* and *The Dancer*
Photograph by Tony Mysak, 1991

opposite page
Self-Portrait, Della Robia and Baseball
oil on canvas, 31 ⅝" x 21 ⅝", 1991

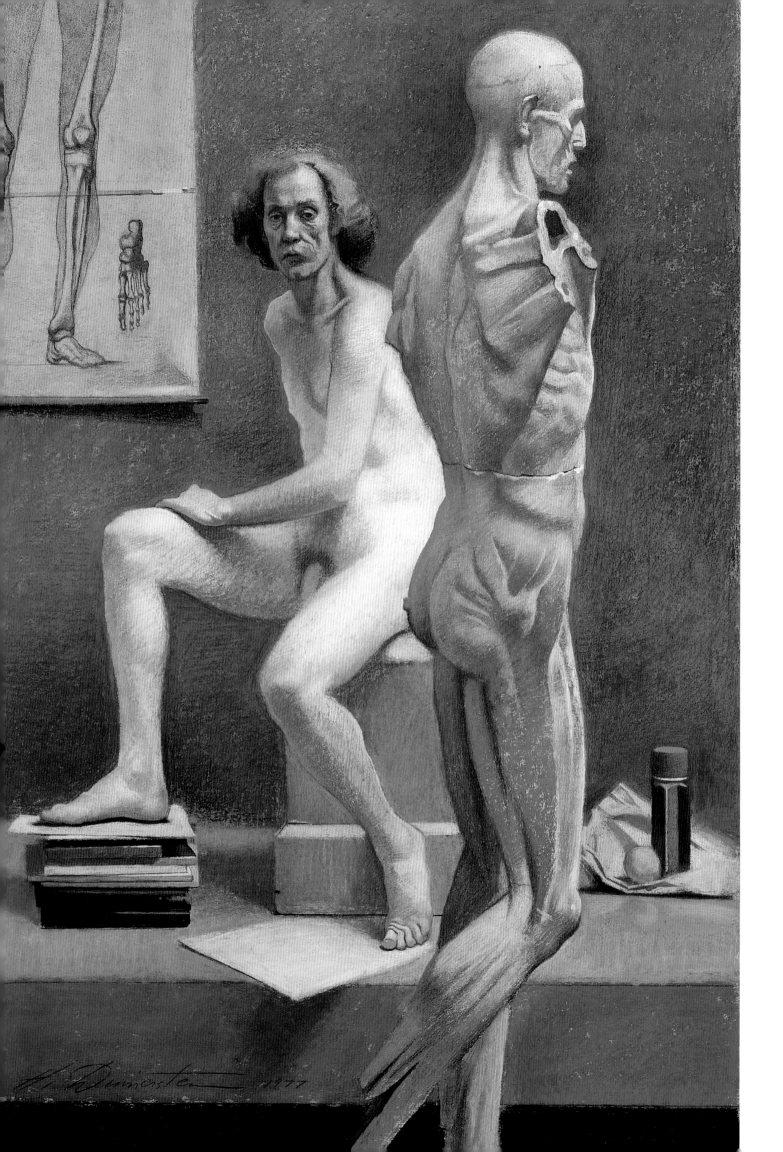

Harvey Dinnerstein:
A Traditionalist for the Future

by Gabriel P. Weisberg

Harvey Dinnerstein is a contemporary artist whose oeuvre spans the second half of the twentieth century and now moves into the twenty-first; his works recall academically trained painters from the nineteenth century or earlier. However, Dinnerstein is no mere copyist; instead, he uses traditional methods to express his connection to humanity, thoughtfully and insightfully capturing the inherent qualities of those he portrays.[1]

Capturing the vision of many realist and naturalist artists from the second half of the nineteenth century and earlier, Dinnerstein has positioned himself in the lineage of traditional master painters. He understands the humanity of Rembrandt, the earthy qualities of the Le Nain brothers, and the emotional truths of Spanish painters such as Ribera—painters who were concerned with the human condition. Dinnerstein belongs to a family of painters who drew a truthful representation of their world, expressed from their own unique humanistic perspective (fig. 1). The painters he admired in museums and discussed with young students or in occasional public lectures are those who have continually informed his work. He shows a deep reverence for artists from whom he learned and a desire to keep the links alive. When we read Dinnerstein's words about his dedication to representing his environment and the people he knows, we are reminded of the writings of nineteenth-century art critics and art historians who encouraged artists to paint their own era, who felt that a painter born at a certain period should record and interpret the life of that period—that the artist should be of his own time. (For example, Champfleury in his writing on realism, and his defense of the painter Gustave Courbet.)

fig. 1 *At the Louvre* charcoal on paper, 12" x 15", 1976

opposite page
Figure Studio, National Academy pastel on board, 27½" x 18", 1977

Knowledge of the great humanitarian artists of the past has led Dinnerstein to admire the paintings and prints of Honoré Daumier, the prints and drawings of Théophile Steinlen, the Swiss humanist, and the powerful graphic art of Käthe Kollwitz. Yet Dinnerstein's art is not so overtly political. While his work is not devoid of the political undertones related to his own era (witness earlier drawings and later images inspired by 9/11), his painting is more detached, more intuitive and inspirational. He lets his art speak for itself. Drawing on themes from the street, from the people in New York City and Brooklyn, Dinnerstein has remained humbled by his themes and truthful to his inclinations. As a traditional realist, he follows no whims or fads, relying instead on history and his ability to carefully construct a composition to make his own aesthetic and intellectual mark.

Early Training and Realist Work: 1942–1970

After training at the High School of Music and Art (1942–46), where he was undoubtedly introduced to the history of art and to the importance of studying art in museums, Dinnerstein continued his education at the venerable Art Students League (where he later became a teacher) and in the studio of Moses Soyer. A scholarship took him to the Carnegie Institute of Technology in Pittsburgh, but he found the courses there dull and uninspiring. The tradition of the Carnegie Internationals, established in the 1890s, were not enough to keep him in the city, and he left to attend the Tyler School of Art in Philadelphia (1947–50), where the curriculum provided an opportunity to engage his painterly aspirations. But none of the schools, he mentions, "imparted a method or training that seemed meaningful." Brushing aside courses, Dinnerstein set out to establish his own sense of tradition, "both by studying paintings in museums and by working from life."[2] That he was finding his own answers—moving away from formulaic responses—allowed the vitality of his work to blossom. This has remained a constant quality from his earliest images until now.

In 1950, he left Philadelphia to return permanently to New York City, where he shared a studio with his friend and closest artistic colleague, Burt Silverman (fig. 2). This studio, located off Union Square, provided an opportunity to study the people of

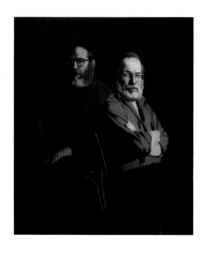

fig. 2 *Self-Portrait with Burt Silverman*
oil on canvas, 38½" x 31½", 1987

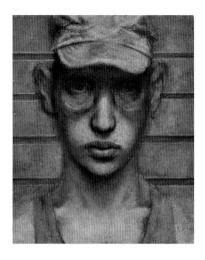

fig. 3 ***G.I. Self-Portrait*** oil on wood, 4¼" x 3½", 1952

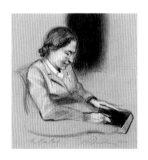
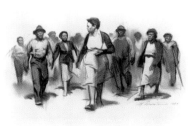

figs. 4, 5
Rosa Parks, Montgomery graphite and pastel
on paper, 15⅛" x 12⅜", 1956

Walking Together, Montgomery charcoal on paper,
17¾" x 25⅞", 1956

the city, to develop themes that he has never forsaken. He "wasted two years" in the army, where he was unable to devote himself fully to painting, although an occasional self-portrait anticipates his later work (fig. 3). He continued to sketch in the army barracks, and later on the subways in New York City while going to and from odd jobs. Sketching, which provided a foundation for later pastel studies or for large-scale paintings, became deeply ingrained in his creative process and has remained another constant in his work.

The 1950s saw momentous social changes in American life, and some artists could not remain detached. In March 1956, Dinnerstein, along with Silverman, left for Montgomery, Alabama, where they witnessed a significant event in American history— the bus boycott, a symbolic turning point for the nascent civil rights movement. In Montgomery, both artists recorded what they saw, much as artist reporters would have done in the nineteenth century, instilling their sketches with immediacy, while also selecting moments that captured the drama unfolding around them. These studies of people marching together, striving to gain equality, demonstrated the effectiveness of his ability to sketch what he saw and convey the essence of contemporary events (figs. 4, 5). Putting into practice what he began in the streets and subways of New York allowed him to achieve a rare moment: the revival of American realism at the service of social justice, qualities he maintained in drawings linked with the urban issues of the 1960s. In these vignettes sketched from life, Dinnerstein became the true heir of John Sloan and the everyday realism of the Ash Can School. His roots were now firmly planted in American art history.

At the same time, he focused on his personal life. His family was growing. Sketches in pen, charcoal, or pastel of his wife, Lois, and children, Rachel and Michael (figs. 6, 7), reveal that his studio (no matter where it was located) was a living organism, providing the artist with unending subjects. Since everyday life was to be the artist's main source of inspiration, he didn't shut himself off but let life enter his studio. His children entered his working space at will and brought a vitality that permeated his creative environment. With the death of his mother, Sarah, in 1967, Dinnerstein's work deepened; a terrible sense of loss and pathos dominates a powerful charcoal drawing of his

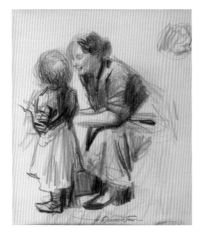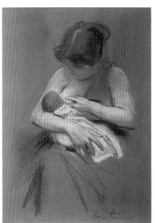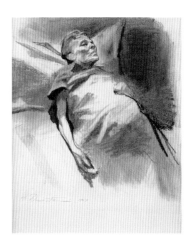

figs. 6, 7, 8
Rachel and Lois graphite on paper, 7⅛" x 6⅛", 1957

Newborn (Michael) graphite and pastel on paper, 9¾" x 7", 1960

Sarah (My Mother on Her Deathbed) charcoal on paper, 14⅜" x 12⅛", 1967

fig. 9
Clinton Square, Newburgh oil on canvas, 16" x 20", 1962

mother on her deathbed (fig. 8). This image further links Dinnerstein with artists, such as Käthe Kollwitz, who were able to use a moment of intense anguish and suffering to heighten the intensity of their work.

As Dinnerstein began to show his oil paintings at the Davis Galleries, and later, in 1964, at the Kenmore Galleries in Philadelphia, he found a growing audience responding to works such as *Clinton Square, Newburgh* (fig. 9). His spare compositions, often of partially deserted streets, reflected a sense of loss, while also suggesting that the real life of American cities was not to be found in its empty public places, but with its people. These were soon to become the major leitmotifs of Dinnerstein's compositions as he put into practice what he had been training himself to do from the start: to be a humanitarian artist of the people, to understand the inhabitants of the urban environment and, specifically, his own living space in Brooklyn. In retrospect, he commented: "Even though I have aspirations beyond genre painting, the image is always rooted to a specific place with a vision that embraces provincial and universal aspects of the subject."[3]

Toward Universal Truths: The 1970s

With *Parade* (fig. 10), Dinnerstein openly questioned the validity of the realist view that excluded symbolic and spiritual levels of perception; his own work now entered a critical phase. His travels through Europe brought him into direct visual conversation with the masters of former times, including Peter Paul Rubens, with his massive paintings, and Georges de la Tour, and his more intimate statements. Inspired by artists working on a grand scale and their commitment to examining heroic, even epic, themes of life and death (Théodore Géricault's *Raft of the Medusa*, for

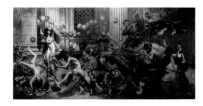

figs. 10, 11
Parade oil on canvas, 74" x 153", 1970–72

Studies for *Parade*

example) led Dinnerstein to broaden his vision so that he could construct an epic confrontation with life, based on his familiar Brooklyn surroundings, for contemporary times. *Parade* was to be the first of these large-scale paintings.

Inspired by street theater and recognizing that many of the figures suggested deeper allegorical meanings, Dinnerstein developed a complex composition. As *Parade* evolved, he commented that "he had in mind a processional image, somewhat like the reliefs of Roman sarcophagi, related to Rubens' development of similar themes."[4] The painting grew from numerous charcoal studies drawn from memory and imagination (fig. 11). As it coalesced, Dinnerstein employed the traditional method of completing numerous pastel studies for various figures, allowing him to think in coloristic terms. In the back of his mind was the creation of an allegory based on a street demonstration where music, movement, performance, and the eerie presence of death—holding an hourglass—conveyed the turbulence of the period and its increasing emphasis on change. In contrast, the young boy blowing bubbles in the center of the composition, seemingly immune to the commotion, creates his own world in order to escape the tumult. The bubbles also serve as a symbol of the fleeting nature of human life, underscoring the fragility of the moment. Dinnerstein's work was moving in a new direction, in which he would examine universal themes inspired by contemporary events.

At the same time, Dinnerstein was creating other images that were equally fraught with the emotional turbulence of the era, particularly the increasing opposition to the Vietnam War. He kept a written journal of what he witnessed and the places he visited; one work depicts a candlelight procession outside St. Patrick's Cathedral, where "a moratorium vigil . . . presents aspects of ritual and reminds me of paintings by Georges de la Tour."[5] Pastels for the composition reveal that he included himself in the group of participants, reflecting the deeper emotional ties that Dinnerstein was bringing to his work at a moment when America was trying to comprehend the tragedy befalling it. A spiritual light illuminates his figures, a cross section of society trying to understand the moment. The effect, as in the work of de la Tour that Dinnerstein noticed, is hallucinatory and deeply moving.

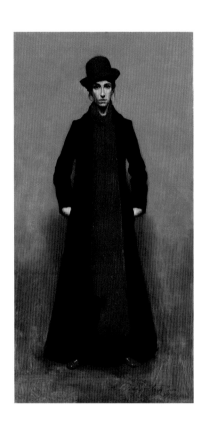

fig. 12 **Michelene** oil on panel, 28" x 12", 1970

The Portraits of the 1970s

As a true heir to the figurative traditions of the past, Dinnerstein knew that portraiture was an area he wanted to master. During the 1970s he painted members of his family, such as *Lois and Rachel* (1971); *Ladino Song* (1975) is a study of Noe Dinnerstein, Harvey's cousin. In each case, the sparseness of his composition, where models are posed against a flat studio wall, let him concentrate on the intensity of expression and the close rapport that the artist established with his sitters. Suggestive of the ways in which James McNeill Whistler or Thomas Eakins simplified shapes into patterns, as well as of their often-limited tonal color range, Dinnerstein's portraits further revealed the debt he had to painters from the past.

As the decade evolved, the artist moved toward completing a series of smaller portraits in which he stressed an intimacy of scale that allowed him to think much as a miniaturist might have. Drawing his own comparisons with paintings by the sixteenth-century artist Jean Clouet, among others whom he studied in the Louvre, allowed other relationships to emerge with painters of the Northern tradition. The clarity of the representations and the love of intricate detail help project the personalities of the figures through pose and dress. *Michelene*'s oversized scarf (fig. 12), cascading down her front, directs attention back to the quietly determined appearance of her facial features; *Michael S*'s casual dress, direct gaze, and sullen expression speak of the attitude of a young man emerging from adolescence. As the decade matured, Dinnerstein's portraits became larger and more complex.

In *Shaka* (fig. 13), the subject is portrayed in a dashiki reflecting his heritage, and leaning on a ledge in the foreground that suggests the structure of Renaissance portraits by Bellini and Titian. With *Stay Amazed* (fig. 14), Dinnerstein's portraiture became both intuitive and deeply resonant with personal symbols. Here his son, Michael, is shown looking up from his work at his father, the painter, who is interested in showing not only the young boy's features but also the child's world and interests. The details in the room—the globe, the books, and the small constructions on the shelf—remind one as well that Dinnerstein's interest in portraiture had been informed by the symbolic allegories of the leading sixteenth- and seventeenth-century German

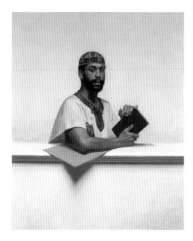 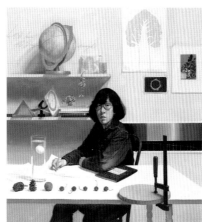

figs. 13, 14
Shaka oil on canvas, 44" x 36", 1976

Stay Amazed oil on canvas, 48" x 44", 1976

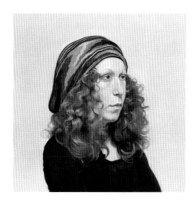

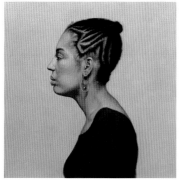

figs. 15, 16
Linda oil on board, 14" x 13¾", 1977

Mercedes (detail of triptych's left panel)
oil on board, 15½" x 15½", 1977

and Dutch painters, including Hans Holbein and Jan Vermeer, artists with whom this detailed work could be compared.

With the interest in new realism gaining adherents in the 1970s, Dinnerstein's work took on an added resonance. Whether he worked with photographs is a disputable point; the artist might have used photography in the same manner as nineteenth-century artists who used the medium as a starting point for a composition or simply as an aid in remembering a particular gesture. But it is important to state that Dinnerstein is not a hyperrealist concerned with reproducing the look of a photograph, and he has clearly stated his dislike of this particular mode of painting. In a review of a Thomas Eakins exhibition, writing about Eakins's use of photographs, Dinnerstein stated that with the photo-realists, "there is a deliberate attempt to imitate the so-called objectivity of the camera on the smooth surface of the painting."[6] By the end of the 1970s, Dinnerstein's portraits became even more particular and more detailed as he concentrated on bust-length studies. These works are suggestive of Renaissance portrait busts, once again reflecting his awareness of past masters; Dinnerstein now focused on facial features and on sitters observed from three-quarter poses or from the side. In *Linda* (fig. 15), the 1977 portrait of a young woman with a transfixed expression, the headdress is the only note of strong color in this otherwise muted painting. In *Mercedes* (fig. 16), also from 1977, the hair pattern and earring accentuate the gracefulness of the design. The startling use of a blue background reinforces Dinnerstein's masterly handling of the designed surface, even as he worked with three-dimensional space and deepened psychological resonance.

Another aspect of Dinnerstein's portraits is their psychological depth; we sense that he tries to understand the models' feelings in order to lend weight to his drawings and paintings.

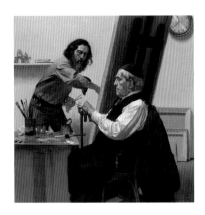

fig. 17 **Self-Portrait with Mr. Meltzer**
oil on canvas, 42¼" x 42¾", 1975

This can be seen especially in his portraits of Isidore Meltzer. Dinnerstein recounts the time when Meltzer came as a model to one of his classes at the School of Visual Arts in New York City. His strength of character, forged by years of travail while he tried to make a living, is what attracted Dinnerstein. The artist established a lasting relationship with Meltzer, drawing and painting him over a long period of time. In a double portrait dated 1975 (fig. 17), artist and model have been united in a work that transcends time. This painting suggests a beaten-down Jew, trampled on by years of struggle but holding steadfast with a determined eye and a religious bearing, symbolically hinted at by the black yarmulke on his head. Dinnerstein found something universal in his sitter by getting to know how this man thought and lived, and by using his dress and demeanor to characterize a person rather than to create a stereotype. By making an effort to empathize with his model, he reveals the timeless philosophical truths of the portrait genre.

Reflective Moments: The 1980s

With the 1980s came a period of decisive urban change. Many of the old haunts that Dinnerstein had known since childhood were torn down to make way for new developments. As he wandered the streets of his city, whether in Brooklyn or lower Manhattan, he remembered what the places had been like. The vivacity of their tradition, their place in urban existence, lingered on in Dinnerstein's memory, as is evident in *Rainy Evening, Union Square* (fig. 18), where he documented the scaffolding covering the S. Klein department store in preparation for demolition. In painting after painting, he suggests America's disappearing vernacular "monuments," as seen earlier in *The Eight* and maintained by Edward Hopper. Here was a city in transition; Dinnerstein saw the buildings as architectural ruins much as if he were recalling the etchings of Charles Méryon, a nineteenth-century printmaker he revered, who often recorded the buildings of medieval Paris about to be destroyed.[7] *Demolition, Union Square* (fig. 19) shows the same effects of erosion: the howling of a solitary dog seen in the window of a soon-to-be demolished building suggests that time is erasing the past. The ruins of former times, as if they were already part

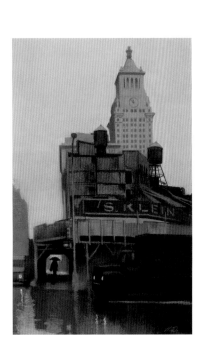

fig. 18 **Rainy Evening, Union Square**
pastel on board, 20" x 13", 1986

fig. 19 **Demolition, Union Square** pastel on board,
17½" x 20¼", 1984

of the picturesque tradition, led Dinnerstein to show a shuttered building on Atlantic Avenue, *Morning Light, Brooklyn* (fig. 20), with a solitary African American biker streaming past, unaware of what had once been; the building remained significant only in the eye and mind of the painter, who had known the site. In later works from the 1990s, Dinnerstein reconnected with his past, observing that urban landscape painting remained a viable subject. In *Triumph of Time* (fig. 21), the figures of a welder and another worker on the roof are strongly contrasted with the symbolic figural presence of time or death. Coming to grips with the passage of time and with his own mortality, by showing the decayed ruins in the city, helped Dinnerstein refocus at a time when he had started redefining his own creativity. In *Triumph of Time,* he realized that workers were not demolishing but adding to the Guggenheim Museum, suggesting allegorically the "ephemeral quality of contemporary culture."[8]

Living close to Prospect Park in Brooklyn led Dinnerstein back to nature. Beginning in the mid-1970s, and continuing for about ten years, he worked on a series of studies and finished oil paintings that defined the seasons. Whether he saw *Spring* as a moment of rejuvenation, or *Summer* when others, including himself and his family, strolled through the tunnels seeking shade on a hot summer's day, or when the change of colors

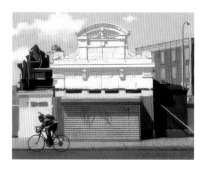
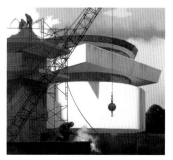

figs. 20, 21
Morning Light, Brooklyn pastel on board,
17½" x 22⅜", 1991

Triumph of Time oil on canvas, 59" x 67",
1991

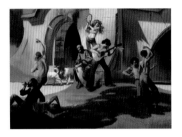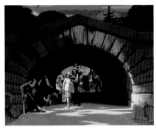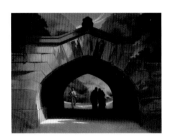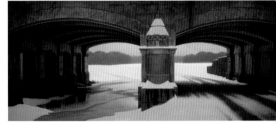

figs. 22, 23, 24, 25
Spring oil on canvas, 40"x 64", 1982

Summer oil on canvas, 60" x 78", 1982

Autumn oil on canvas, 60" x 78", 1982

Winter oil on canvas, 60" x 144", 1982

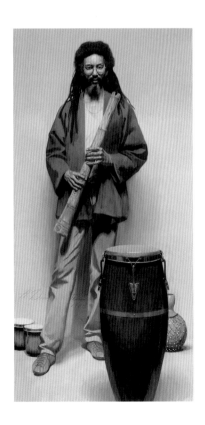

fig. 26 **Bamboo Flute (Ralph McAden)** oil on canvas, 76" x 37¾", 1988

brought on an autumnal air of romanticism, Dinnerstein used the park and its landscape as a means of creating a symbolic allegory of the transitory (figs. 22, 23, 24). In *Winter* (fig. 25), the people are gone, and ice and snow reign supreme; it is all about the solitariness of the environment when the stillness and peace of the early morning hours dominate. As Monet would have done in his series paintings of the late nineteenth and early twentieth centuries, Dinnerstein used a single motif observed at changing times of the day or year, finding that the park provided him with the necessary stationary locations. The tunnels and bridges were the framework of his compositions; once in his studio, he was able to redirect his energies to modify light and atmosphere for further effect. The series, and the studies for it, including one example in which he is shown working in the park, recalls the works of the Barbizon painters, who worked in front of the subject before returning to the studio to perfect their subjects. Dinnerstein continues the tradition of working before a motif and later changing the compositions in his studio so that the finished canvases become more personal and poetic.

Other works in pastel are concerned with the human element integrated with the architecture and landscape of the park. In *The Passage,* Dinnerstein focused on a tender, reflective moment when he and Lois enjoyed the park together. Their love is visually expressed in a painting that reaffirms the romantic idyll that has been a strong part of Dinnerstein's personal life. But the studio was his domain. It was here, amid other paintings and drawings, and in front of his easel, that the painter pondered and worked. As if inspired by Jan Vermeer's *Portrait of an Artist in his Studio,* Dinnerstein patiently reiterated the importance of the artistic environment in his own life. This is an artist who is fully engaged, attacking his canvas while thoughtfully developing his next move. With paintbrush in hand, there is no better example of the intense commitment that led him to do studies of individuals such as *Earthbound (William Preston)* or *Bamboo Flute (Ralph McAden)* (fig. 26).

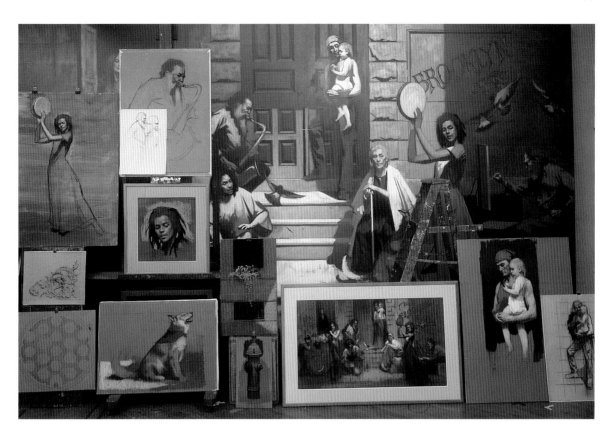

above
above
Studio photograph, Underpainting and studies for *Past and Present*
Photograph by Tony Mysak, 1994

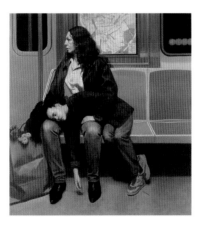

fig. 27 ***Linda and Alicia*** oil on canvas, 48¼" x 44", 1992

Between the Past and the Present: Autobiography at Center Stage

At the dawn of the 1990s, the intense commitment to abstract art lessened. Disinterested as always in changing art fashions, Dinnerstein maintained his dedication to working directly from the model. He was determined not to become distracted by the continued ascendancy of modernism, and Dinnerstein's inherent toughness led him to recommit his connection to traditions of the past that he revered in order to express his perceptions of contemporary life. He must have had in mind two of his most important paintings of this decade—*Past and Present* (pages 160–161) and *Underground, Together* (pages 176–177)—when he completed another subway scene, *Linda and Alicia* (fig. 27). Throughout his life, sketching in the subway has provided Dinnerstein with a huge reservoir of images that he can draw on to show real people: their exhaustion, their resolve to move ahead, and the toughness of their daily lives. It is this type of thoughtfulness that led him to complete *Underground Reflections* (fig. 28), in which attention is focused on his own presence as he rides the subway, a silent, albeit haunted, observer of humanity. The sketchbook he holds provides a telling picture of the way that Dinnerstein captures the world as it passes before him.

Since autobiography has always been a staple of Dinnerstein's work, it is significant that *Past and Present* (1994) weaves together many strands of his life. To the right, in semidarkness, and to the side of the Brooklyn brownstone, Dinnerstein patiently works at his easel. In his mind, and before him, unfolds his narrative and his vision. The old brownstone, marked 933 for his own address in Brooklyn, provides a theater where various types have

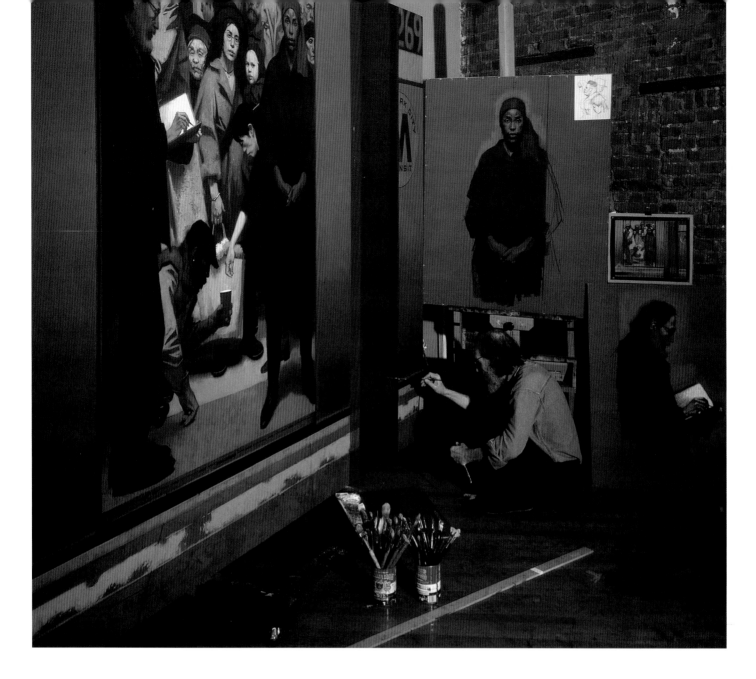

above
Studio photograph, Working on
Underground, Together
Photograph by Tony Mysak, 1996

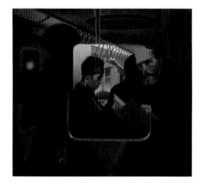

fig. 28 ***Underground Reflections*** oil on canvas,
39" x 42", 1995

been brought together: the old musician, the young flutist, the player of bongo drums, the tambourine player, and the young father and child on the steps. All reminders of what Dinnerstein has seen on the steps of his own brownstone and elsewhere in Brooklyn. Just as Gustave Courbet shifted from reality to dream in canvases such as the *Burial at Ornans* or *The Painter's Studio,* Dinnerstein has included the image of his dead mother as she might have appeared on the steps.[9] With a cane for support and a light glowing shawl over her shoulders, this venerable woman gazes at the viewer pensively. She is the person who directly connects with the audience. To the left, in an open window, is Lois—Dinnerstein's muse—who looks down at the group in front where the painter constructs his visionary canvas of life. Both the past, personified by the brownstone and its traditions, as well as the presence of Dinnerstein's mother, are brought to bear on the present. He unites both in a daring painting that brings together the personal, recurring themes of his career, using studies and ideas that he had been working on for decades. In effect, this is Dinnerstein's personal vision of Brooklyn, where he has lived for most of his life.

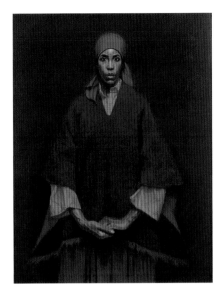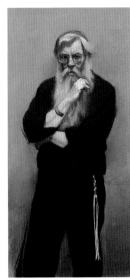

figs. 29, 30
Elaine Shipman oil on wood, 46" x 35", 1979

Izzi pastel on board, 51½" x 25", 1998

In *Underground, Together* (1996), Dinnerstein allows his audience to see how he worked as he composed his subway scene. He is the patient observer who stands at the doorway with sketchbook in hand quietly drawing. Early study-book notations, including the drawing of the beggar in the doorway, and Elaine, the elegant African American female wearing a head scarf, also enter his crowded train composition. Both figures have had another life in Dinnerstein's studio, Elaine in a portrait dated 1979 (fig. 29). She is the counterweight to Dinnerstein in *Underground, Together;* it is through her gaze that the audience establishes contact with the participants. The remainder of the composition, which Dinnerstein began as a triptych that included other sections of the train, coalesces around these foreground figures. The artist has created a symbolic visualization of underground subway life.[10] The massive girder at the right accentuates the feeling of enclosed space where people are brought together for a brief moment.

When *Underground, Together* was first exhibited in New York in 1997, Dinnerstein contributed to the exhibition brochure by commenting on what the subway meant to him: "When I began my art studies 50 years ago, the subway enabled me to travel from a provincial neighborhood in Brooklyn to art classes across the river on the island of Manhattan. . . . The subway also revealed a view of the great diversity of life in the city that shaped my artistic vision over the years."[11] Similar to Honoré Daumier, whose series of prints, drawings, and paintings are dedicated to the theme of mid-nineteenth-century travel, culminating in the famous *Third Class Carriage* (1860s), Dinnerstein had found the location where he could witness ever-changing city life, and where models were continuously at his disposal. It was here that he found the clues for his symbolic vision of New York, here where he could show the out-of-work alongside the worker, the old with the very young, in a fragmentary moment before the doors closed and the train left the station: "Though the trains have been redesigned numerous times over the years, the cars are often crowded and unpleasant as ever, and the problems of contemporary life—poverty and homelessness—are always present."[12] What is vividly apparent in this large canvas is the ability of the subjects, all involved in their own worlds, to mesmerize Dinnerstein, and the genius of the

artist to capture their personalities. This is what makes the painting a primary example of the artist's conception of urban life; the subway remains a staple ready for his creativity.

The New Century

With the start of the new century, Dinnerstein, now in his late seventies, shows no loss of energy. He is just as involved in contemporary issues, just as committed to painting portraits, as he was earlier in his career. What is different now is that his portraits are more imposing, larger, often life-size. Dinnerstein wants his portraits to rival those of Thomas Eakins, John Singer Sargent, or other late-nineteenth-century painters, whose large-scale portraits often dominated the exhibition spaces of the golden age of the 1890s. With both artists, it appears that they hoped to immortalize the sitters, not just show them as static figures of another age but as lively participants in their own world, among their peers, or holding props that speak of their professions.

But whereas earlier portraitists often fulfilled the command of wealthy patrons, Dinnerstein is working without commissions. His sitters are the people of Brooklyn; he brings them into his studio to study them carefully, and they often become his friends. This is the case with the powerful *Izzi* (fig. 30), the religious Jew with the demeanor of a prizefighter who manages to convince an audience that he is a figure both wizened and wise, whose physical strength is also a major attribute of his character. When we learn that Izzi is actually such a person—that he has served as a character actor in movies, playing Hassidic Jews— we marvel at the artist's talent to seize the essence of a character, a personality.[13] Completed in pastel at the end of the 1990s, this

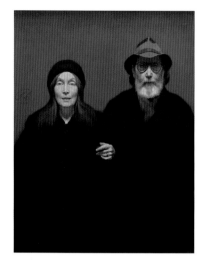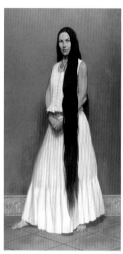

figs. 31, 32
Passeggiata oil on canvas, 42" x 32", 1999

Roseangela oil on canvas, 76" x 38", 2000

fig. 33 **Detail of Sundown, The Crossing** oil on canvas,
74" x 84", 1999

work follows in the tradition of earlier figural representations. Dinnerstein's portrait of Lois and himself (fig. 31), while not quite life-size in scale, conveys the closeness of their relationship.

Even when Dinnerstein worked on a smaller scale with a beautiful model standing before a mirror, the same effect of grandeur is there. In 2000, using the same model, Dinnerstein completed his *Roseangela* (fig. 32) as if it were destined to be a centerpiece in a Salon exhibition. The barefoot model, who leans on her left foot while extending the right forward, is wearing a striking white dress, against which her very long black hair flows almost to the ground. The artist has been able to combine the proud demeanor of his sitter and her unashamed sensuality. The tightly confined corner, implied by the base of the wall, brings the model directly into the viewer's space, giving the impression that one could talk to her. Other life-size portraits followed a similar plan as each figure seems about to interact with the viewer, to move out of the space of the painted illusion and become a real personality, as in *Tanya Pann* of 2002. These works all suggest an artist who is at the height of his powers. Dinnerstein's empathy and intuitions were to become even more apparent with his response to the tragedy of September 11, 2001.

Other canvases of the period reiterate Dinnerstein's reliance on well-known earlier traditions—such as in *Sundown, The Crossing* (fig. 33)—to provide him with the visual analogy for the passage of time and life. On the deck of an old ferry, Dinnerstein posed many of his models starkly against the background of the boat. Revitalizing the tradition used earlier by Gustave Courbet in his *Painter's Studio: A Real Allegory,* Dinnerstein includes himself and Lois among those onboard. He noted at the time of the work's completion that "to develop the crowd of figures across the deck of the boat, I went back over various paintings, pastels, and drawings I had done over the years to select individuals I could include. . . . The individual figures derived from various sources were not united in time or place. At the left, alongside figures taken from images of protest against the war in Vietnam, which I had done between 1968 and 1970, is a young woman flutist derived from a painting of a Brooklyn block party done in 1994. . . . Beside the carnival figure is a man with crutches, taken from a sketch of a beggar in Paris, done in 1963."[14] As Courbet had done in 1855, so too did Dinnerstein

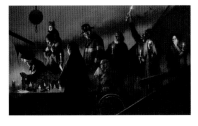

figs. 34, 35, 36
Ferry Crossing, Sunrise oil on canvas,
33" x 40", 2001

Fallout oil on canvas, 69" x 84", 2002

Candlelight Procession oil on canvas,
51" x 82½", 2003

in 1999, as he took stock of his life by painting an allegory of his world against the passage of time. His models have become his friends; in turn, they have enriched his life by making his paintings deeply personal. The transitoriness of life is further echoed in *Ferry Crossing, Sunrise* (fig. 34), in which Dinnerstein, and a frailer Lois, are at the head of a group of figures, suggesting the passing of time, as in the earlier painting. In the later painting, however, we get the impression, perhaps erroneously, that the painter's intention is to show more than just the passage of time in terms of one year passing into the next; the people are waiting for the ferry to arrive at sunrise to take them to another shore, as in the passage from life to death.

When the World Trade Center was destroyed, the event had a profound effect on everyone, especially those living in lower Manhattan and Brooklyn. Once again, Dinnerstein was a witness to a cataclysmic event, which affected the way he worked. In *Fallout* (fig. 35), he positioned his models, and himself, in such a way as to suggest the recognition of the terrible light that illuminated the New York skyline when the buildings were hit by airplanes. The interruption of lives, including that of the man on the cell phone at the left, is heightened by the way in which the black biker tries to shield his eyes from the blinding intensity of the explosion. Each figure plays a dramatic role in suggesting the devastating impact of the catastrophe, without the painter even needing to show the event itself. The effects of this tragedy were deepened in *Candlelight Procession* (fig. 36), a work drawn from another episode linked to the Trade Center disaster. At the time of the destruction, a candlelight procession took place outside Dinnerstein's local firehouse in Brooklyn. Squad 1, which had responded to the attack, had lost twelve men; according to Dinnerstein, the outpouring from the neighborhood "was overwhelming." Working from documentary photographs that he took at the scene, sketches done on site, and his memory, Dinnerstein completed another monumental canvas in which members of the community, along with members of the fire brigade, are illuminated by the candles they hold as they slowly move toward the makeshift altar at the left. In these two canvases, Dinnerstein maintained his dedication to tradition by constructing compositions that have the strength of historical epic moments. He now achieved completely what he

had been working toward in earlier studies linked to the Vietnam War. In these two paintings, and in *Ferry Crossing, Sunrise,* Dinnerstein also acknowledges his admiration for, and his indebtedness to, the works of Georges de La Tour, who used light or a lack of it to give meaning to his compositions.

In Retrospect

In revisiting many of Dinnerstein's paintings across his career, the viewer becomes acutely aware that the painter included himself as both a participant and an active observer. Being intensely aware that earlier generations of artists had frequently used this method allowed Dinnerstein to demonstrate his allegiances to the past, while formulating themes that speak to the present. Yet in a smaller painting, *Crossing Broadway* (fig. 37), the artist portrays himself not only as witness to a scene but also as an active participant—as he might have actually appeared on the streets of the city carrying an empty stretcher, dressed against the piercing cold of a winter day, and posed in front of a series of street workers and other travelers who are partially engulfed in the steam vapor rising in the background. Just visible is lettering on the background trucks: Korean, Russian, and New York's own graffiti. Through these small details, Dinnerstein invigorates the language of the city, the many varied tongues, to show how they are all bound together. He is in his element as the intrepid explorer searching for new sights in the life of the city—aware that what he is seeing will disappear over time—while remaining thoughtfully responsive to the world around him. His all-knowing expression demonstrates that he has become a visual philosopher of urban existence, whose canvases and studies transcend time by communicating the transient nature of life, while demonstrating that the realist tradition is still alive and vibrant in the painting of the twenty-first century. •

fig. 37 *Crossing Broadway* oil on canvas, 66" x 44", 2004

opposite page
Studio photograph of the artist at work
Photograph by Adam Reich, 1999

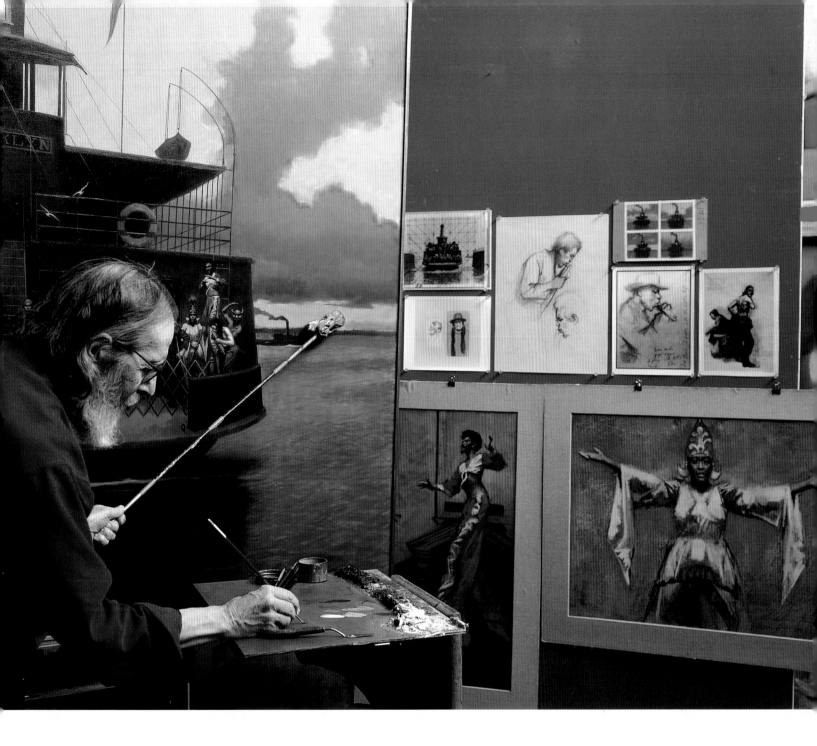

1 Telephone conversation with author, July 14, 2007.

2 Heather Meredith Owens, "An Interview with Harvey Dinnerstein," *American Artist* (May 1973): 27.

3 Paintings of New York Questionnaire, Bruce Weber, Berry-Hill Galleries, 11 East 70 Street, New York, New York, December, 1999: not paginated.

4 Harvey Dinnerstein, in *Harvey Dinnerstein, Artist at Work* (New York: Watson-Guptil, 1978): 51.

5 Telephone conversation with author, July 14, 2007.

6 Harvey Dinnerstein, "Paradoxical Aspects of a Singular Vision", *Journal of the Art Students League of New York* 6, no. 1 (spring 2002).

7 Telephone conversation with author, July 14, 2007.

8 Dinnerstein, in Harvey Dinnerstein: A Retrospective Exhibition, December 27, 1994–February 26, 1995. The Butler Institute of American Art, Youngstown: Ohio, 1994.

9 Telephone conversation with author, July 29, 2007.

10 Ibid.

11 Dinnerstein, in Dinnerstein: Paintings–Pastels–Drawings exhibition pamphlet, April–May, 1997.

12 Ibid.

13 Telephone conversation with author, July 29, 2007.

14 Harvey Dinnerstein in "Harvey Dinnerstein, Bruce Dorfman, Lorrie Goulet, New York: The Art Students League", *Process* (November 2003): 13.

Art and Life

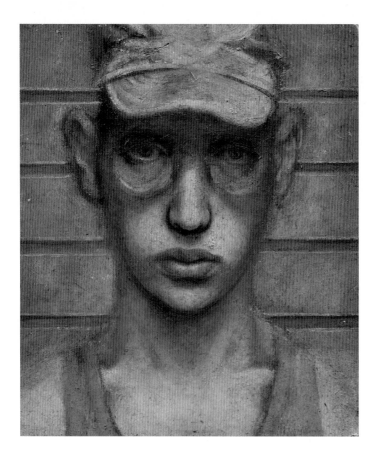

above
G.I. Self-Portrait oil on wood, 4^1/4" x 3^1/2", 1952

opposite page
Winter Self-Portrait oil on wood, 19^7/8" x 15^7/8", 2004

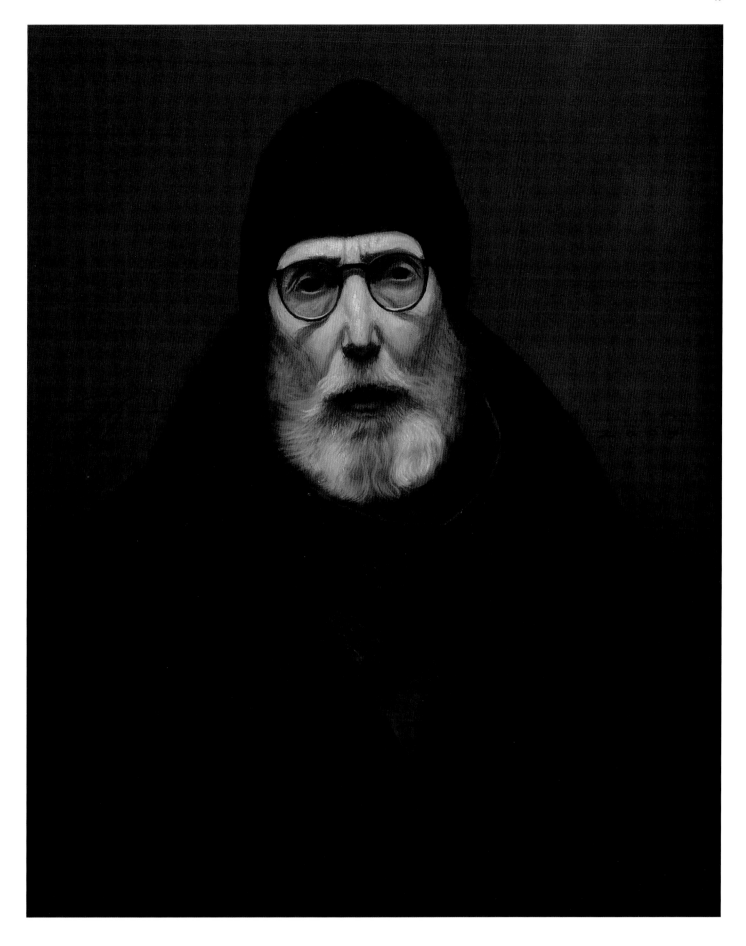

above, left
After the Cataract Operation (Right Eye)
graphite on paper, 8¼" x 6½", 1999

above, right
After the Cataract Operation (Left Eye)
graphite on paper, 8¼" x 6½", 2001

opposite page
Self-Portrait (After the Cataract Operation)
oil on canvas, 9" x 9", 1999

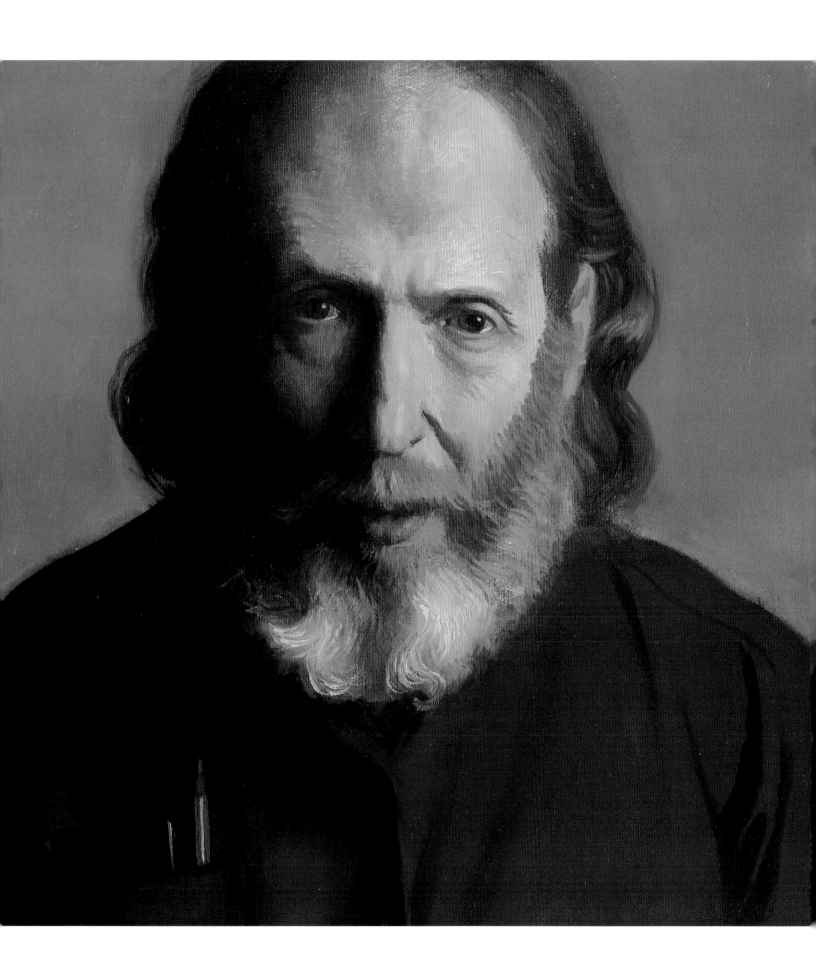

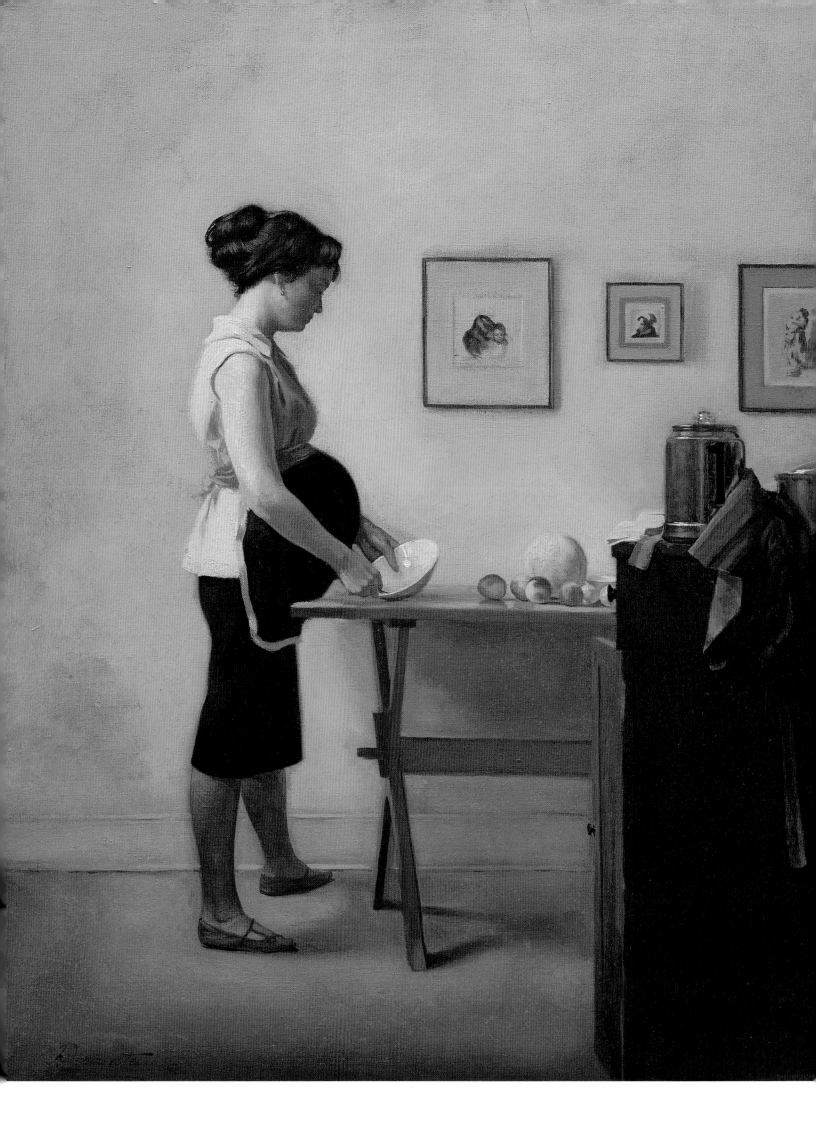

opposite page
In the Kitchen oil on canvas, 20" x 16", 1960–61

top
In Labor pen and watercolor on paper, 6¾" x 8½", 1960

right
Rachel and Lois graphite on paper, 7⅛" x 6⅛", 1957

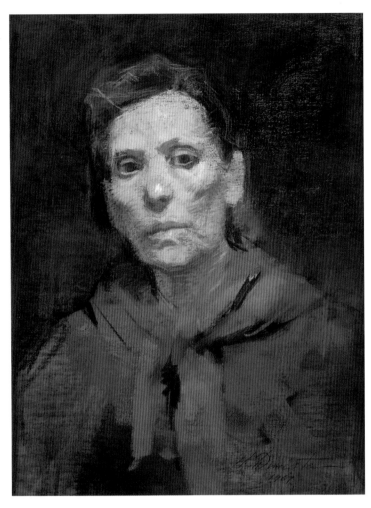

left
Sarah (A) pastel on canvas, 15½" x 11¾", 1967

bottom
Sarah (B) pastel on canvas, 10½" x 18½", 1967

opposite page
Sarah (C) *(My Mother on Her Deathbed)*
charcoal on paper, 14⅜" x 12⅛", 1967

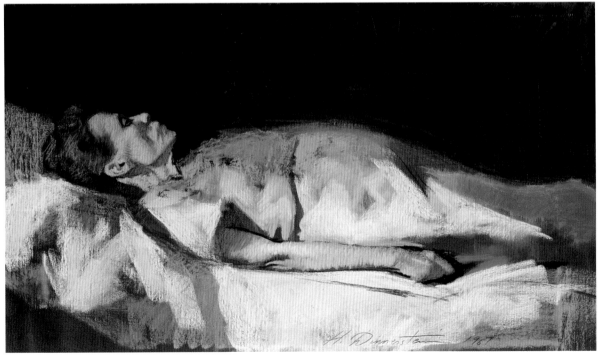

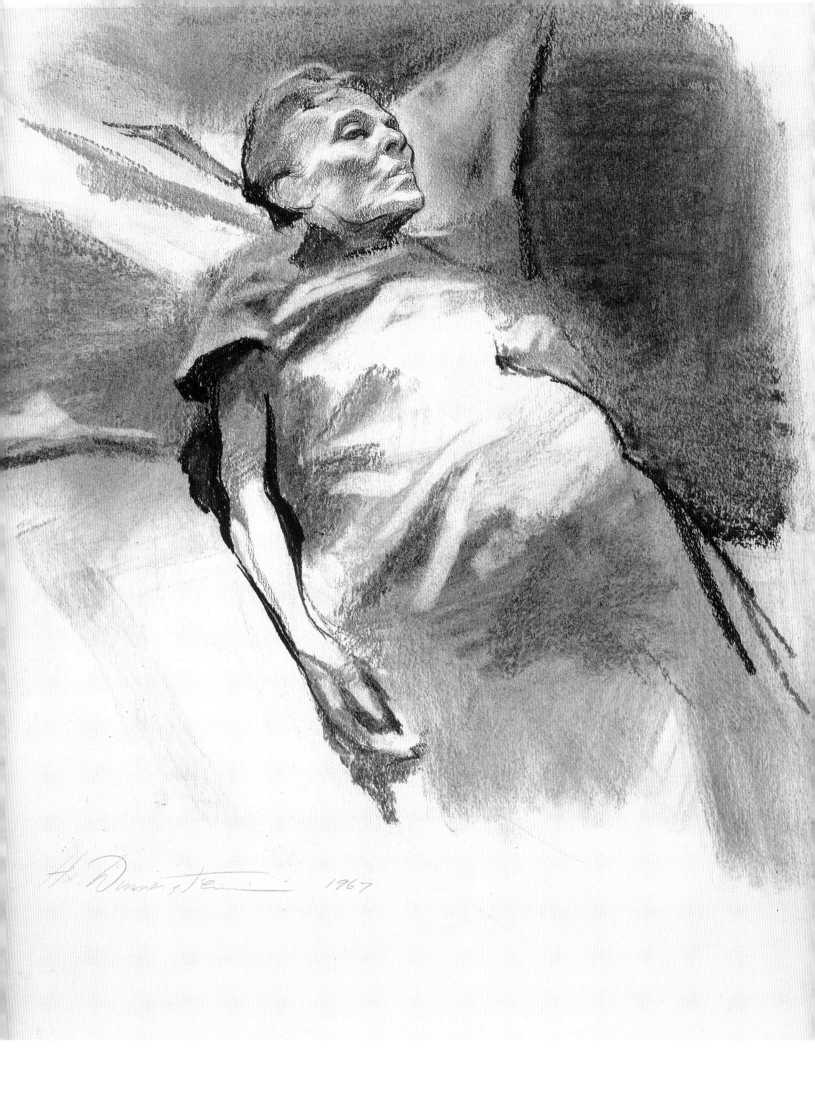

right
Self-Portrait with Mr. Meltzer
oil on canvas, 42¼" x 42¾", 1975
I always referred to him as Mr. Meltzer, perhaps out of
deference to his age or some other quality that I intu-
ited. I remember a time when Mr. Meltzer posed for
a drawing class that I taught, and one of the students,
disappointed that the standard nude model was not
present, referred to the old man as a *nebbish*, in Yiddish.
This translates as an insignificant individual, nobody
important. But I had a different sense of the man. As
I painted him many times over the years, he began to
reveal aspects of a remarkable life that spanned two
centuries. Isidore Meltzer was born in the province of
Minsk, Czarist Russia, in 1892, and escaped that coun-
try after being jailed for participating in the uprisings
against the regime in 1905. At the age of thirteen, he
traveled to America alone, without a family, and settled
on the Lower East Side of Manhattan, where he worked
in garment factories or as a peddler, anything to survive.
One day as we walked past a corner of lower Manhattan,
he pointed out the site of the Triangle factory fire and
described how he had viewed the bodies of the victims
of the tragedy, who had died during a strike against the
brutal working conditions of the period. There were
also family references to generational conflict as he rem-
inisced about the past. As he grew older, the old man
had to rely on a cane to walk through the streets, and I
remember him using the stick to beat his way through
traffic with a sharp awareness of the continual struggle
to survive. These paintings are a culmination of numer-
ous studies I had done of the old man in the 1970s,
searching for significant forms that would suggest the
complex interior life of the subject. I often wonder if a
portrait of an ordinary man or woman might represent
something more profound for our time than the images
of celebrities or political leaders that seem to dominate
contemporary culture.

opposite page
Mr. Meltzer oil on wood, 57¼" x 33½", 1973

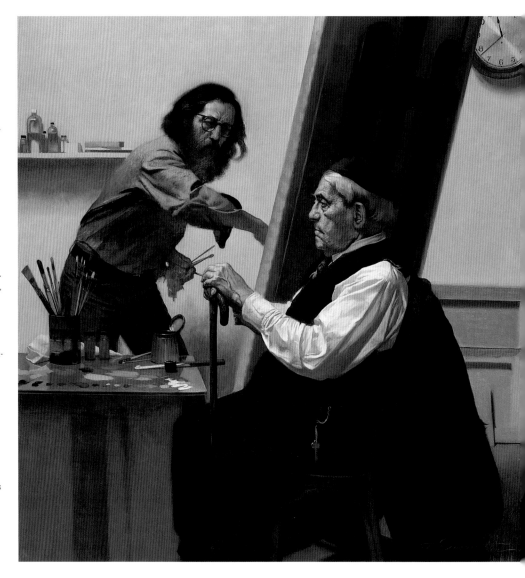

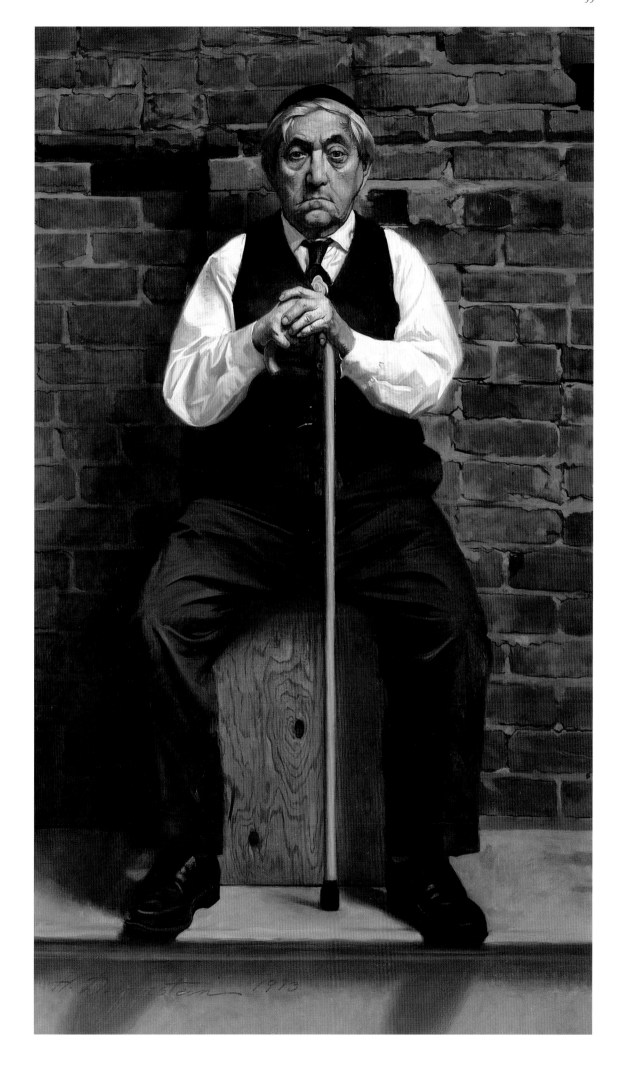

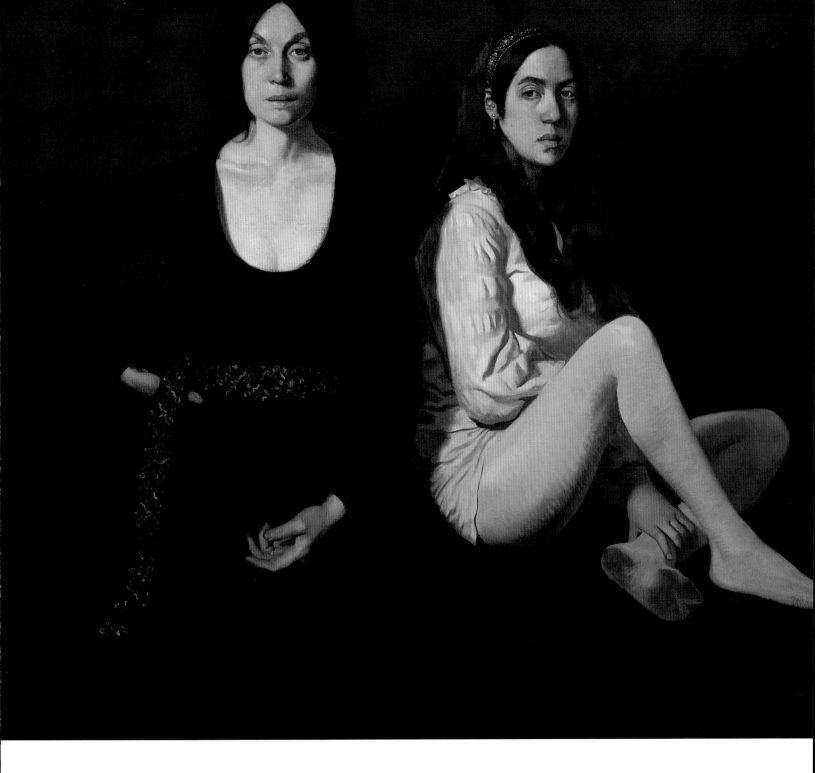

Lois and Rachel oil on canvas, 47" x 47", 1971
This was painted in Rome, with some final touches
added in my studio in Brooklyn. I could have painted
this double portrait anywhere, but there is a certain
clarity of light and form I associate with Rome that
reminds me of Caravaggio.

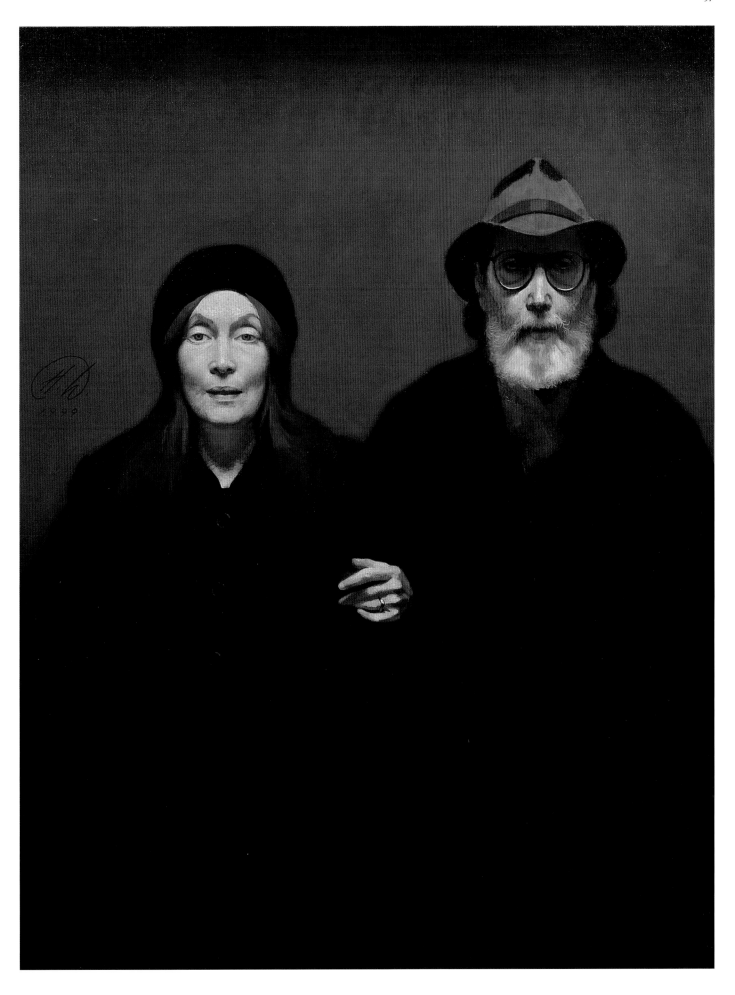

opposite page
The Passage oil on canvas, 84" x 46", 1981

above
Passeggiata oil on canvas, 42" x 32", 1999

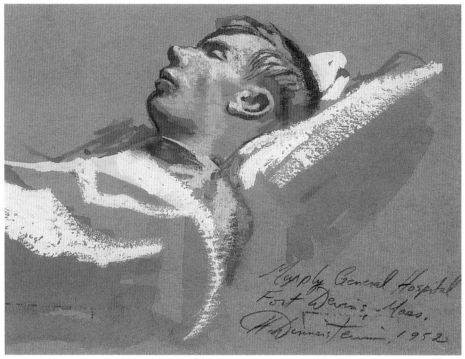

left
Murphy General Hospital Ft. Devins, Mass., opaque
watercolor on board, 5¼" x 7", 1952

bottom
Straddle Ditch opaque watercolor and pastel on board,
8½" x 6¾", 1952

opposite page
Burning Village oil on canvas, 42¼" x 35", 1951–53
The watercolor sketches were done during basic training
when I was drafted into the army during the Korean War.
Burning Village is a fragment of a larger painting I had
started before I was drafted. Initially the canvas included
other figures impaled on the bayonet, but years later, I
cropped the canvas, and reworked the painting to an image
that I thought was more focused.

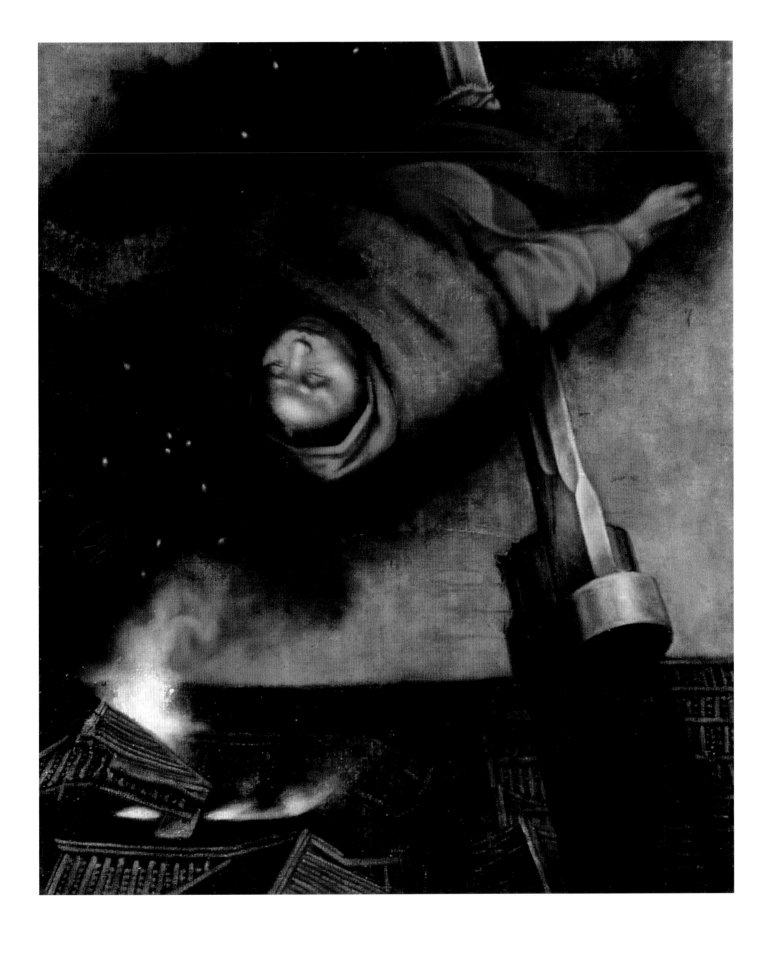

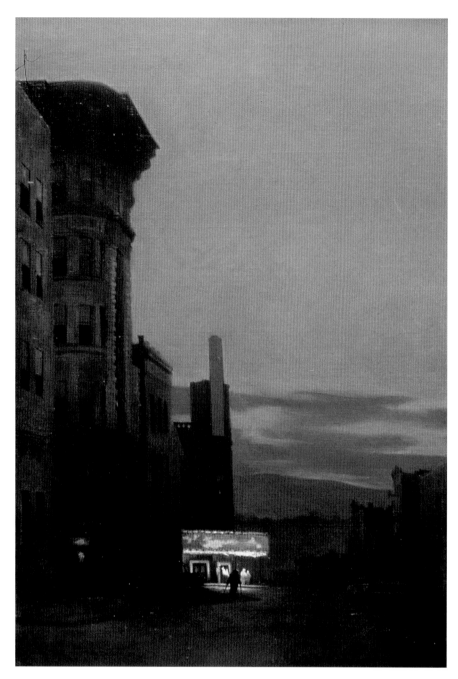

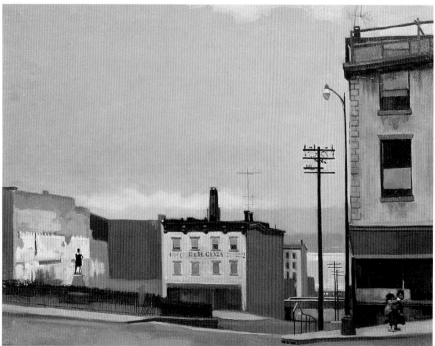

opposite page, top
Main Street Movie oil on canvas, 20" x 14", 1962

opposite page, bottom
Clinton Square, Newburgh oil on canvas,
16" x 20", 1962

In 1959, Lois landed a job teaching art history at Vassar College, and we moved upstate to Poughkeepsie. I had to adjust my vision to this new environment, so different from the life I was familiar with in New York City. I tried painting landscapes, but the results seemed so uninspired. After a while, however, I began to perceive aspects of the small towns on both sides of the Hudson River that interested me. In the *Main Street Movie* painting of downtown Poughkeepsie, I started with a drawing on a gray afternoon, with a careful description of the architecture and recession of space on Main Street, down to the mountain on the other side of the river. As the sky darkened toward evening, the old movie marquee lit up and the entire image was transformed. I returned the next evening to make another study and continued to develop the painting in my studio, based on these studies, color notes, and memory. Moving the pedestrian figures closer to the movie, silhouetted and illuminated by the light, seemed to focus the intensity of the painting. A thick buildup of paint in the lights and numerous glazes in the darks worked to enhance the mystery of the image.

Similarly, in approaching the subject of *Clinton Square, Newburgh*, I devoted a great deal of time to resolving the shapes and subtle color changes in the painting. In this case, I returned to the location many times to work directly from the subject. I had considered the painting just about finished, when I noted a black child carrying another child on her back in this run-down part of town, and added this element that seemed a poignant counterpoint to the official statue of Governor Clinton on the other side of the canvas.

right, top
Motorcycle Ride oil on canvas, 54" x 66", 1960

right, bottom
Foliage Study for Motorcycle Ride charcoal on paper, 9⅞" x 12⅝", 1960

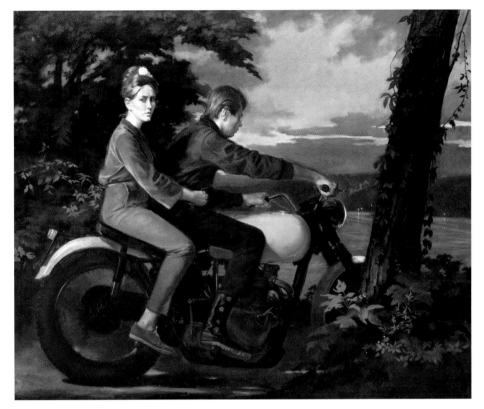

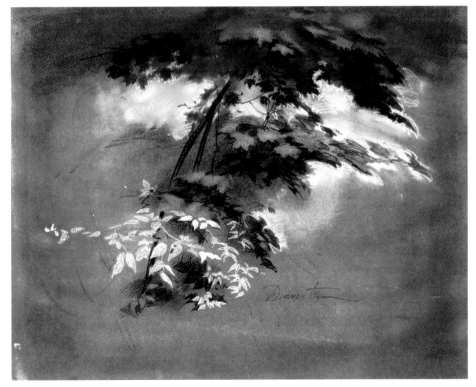

Roman sketchbook

In 1963, I had an opportunity to take my first trip to
Europe and study firsthand all the great art that had been
familiar to me only in reproductions. When I arrived
in Rome, I found the light and color, layers of time, and
vibrant contemporary street life most exciting. I returned
in 1965 for nine months, and revisted the city many
times in the years thereafter. I can still remember with
great clarity wandering about the neighborhood I lived
in over forty years ago. From Via di Parione, I would
turn right and across Piazza Navona to the Church of
St. Agostino, with Caravaggio's painting of the peasant
with muddy feet worshipping the Madonna, and con-
tinue down the street to his extraordinary paintings of
the Calling and Martyrdom of St. Mathew at St. Luigi
dei Francesi. Returning to Via di Parione, I would turn
left and cross Corso Vittorio Emanuele to the large
market at Campo dei Fiori, where Giordano Bruno was
burned at the stake by the Inquisition in 1600. And I
could imagine Caravaggio in the crowd of spectators wit-
nessing the execution. I did many sketches and paintings
of this market, and perhaps the last image, a pastel
that I did in 1998, sums up my feelings about the city.
A statue of Bruno hovers over the piazza, on a rainy
afternoon when the vendors have left the market, and
an old woman is gleaning the space for leftover scraps
of food.

below
Roman Market Women charcoal on paper,
13" x 11¼", 1963

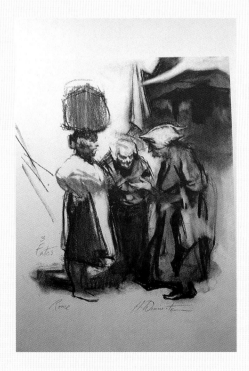

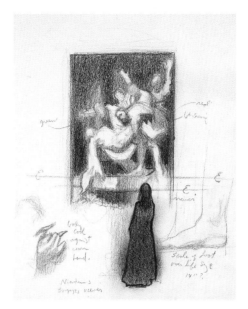

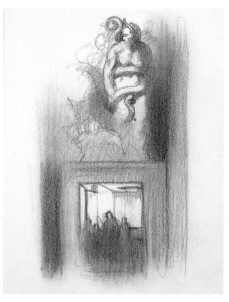

above, clockwise from top left

Roman sketchbook (Caravaggio, Entombment of Christ) 1976

Roman sketchbook (Entering the Sistine Chapel) 1976

Roman sketchbook (Graffiti B) 1976

Roman sketchbook (Graffiti A) 1976

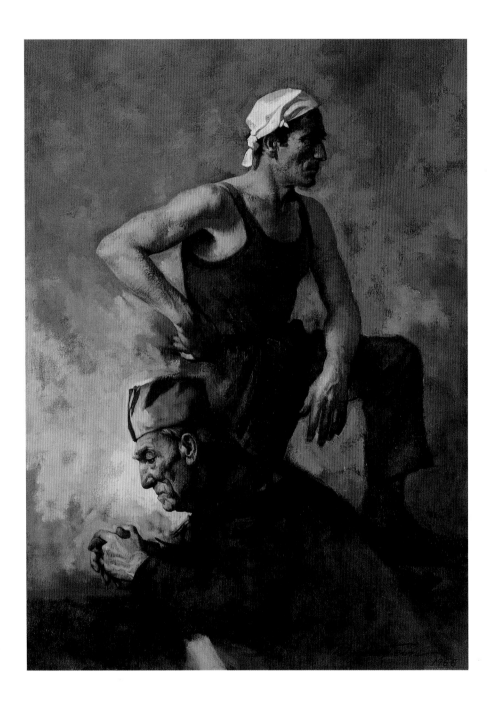

above
Garlic Lady oil on canvas, 36" x 50", 1965

opposite page
Roman Workers oil on canvas, 50" x 36", 1966

 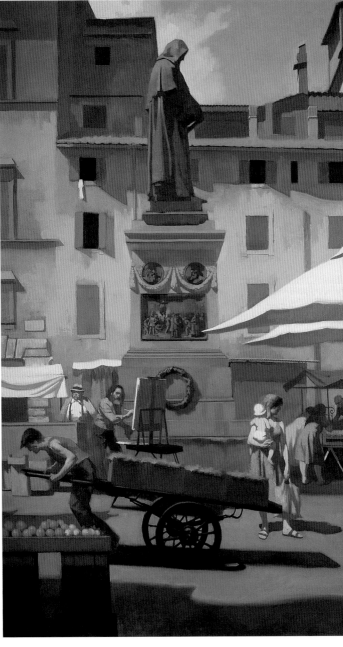

above, left
Lay in of the painting *Campo dei Fiori* 1984

above, right
Campo dei Fiori oil on canvas, 84" x 50", 1984

opposite page
The Gleaner pastel on board, 28 ¾" x 17 ¼", 1998

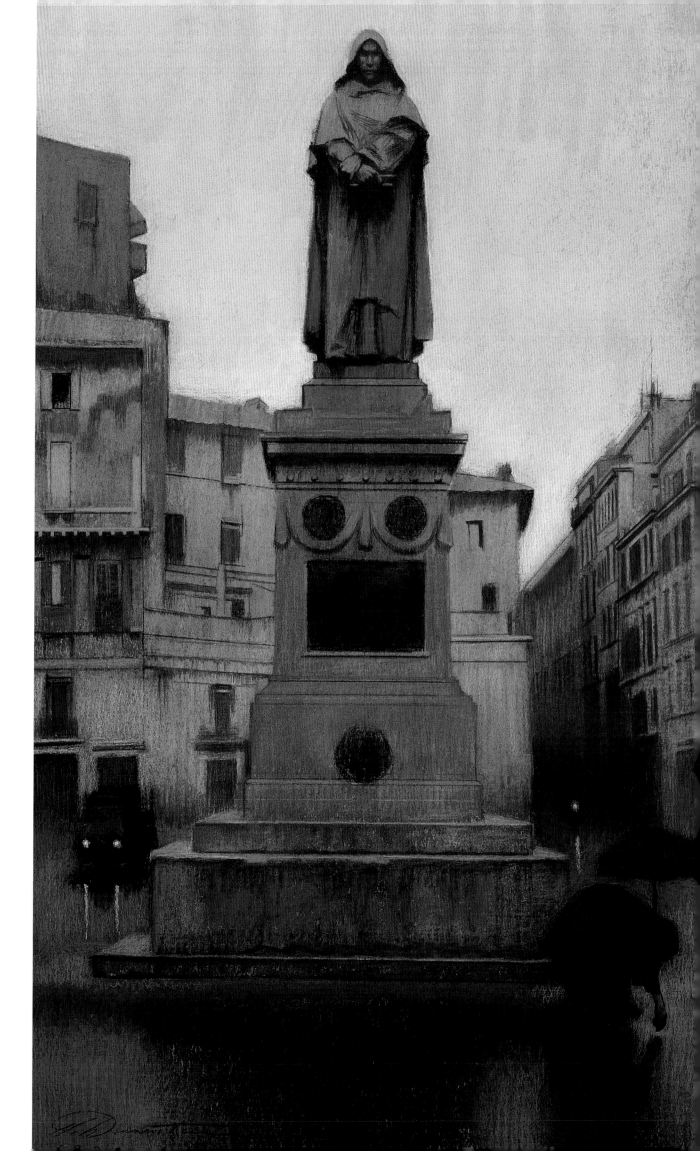

above
Mezzogiorno, Firenze pencil and graphite powder on
paper, 16½" x 11 ¾", 1980
Sketchbook drawing on a trip to Florence. I had started
to indicate the Duomo in the upper right, through the
window. . . but erased the architectural element, to focus
on the detail of the figure.

opposite page
Mezzonotte, Venezia pastel on board, 19" x 15½", 1989

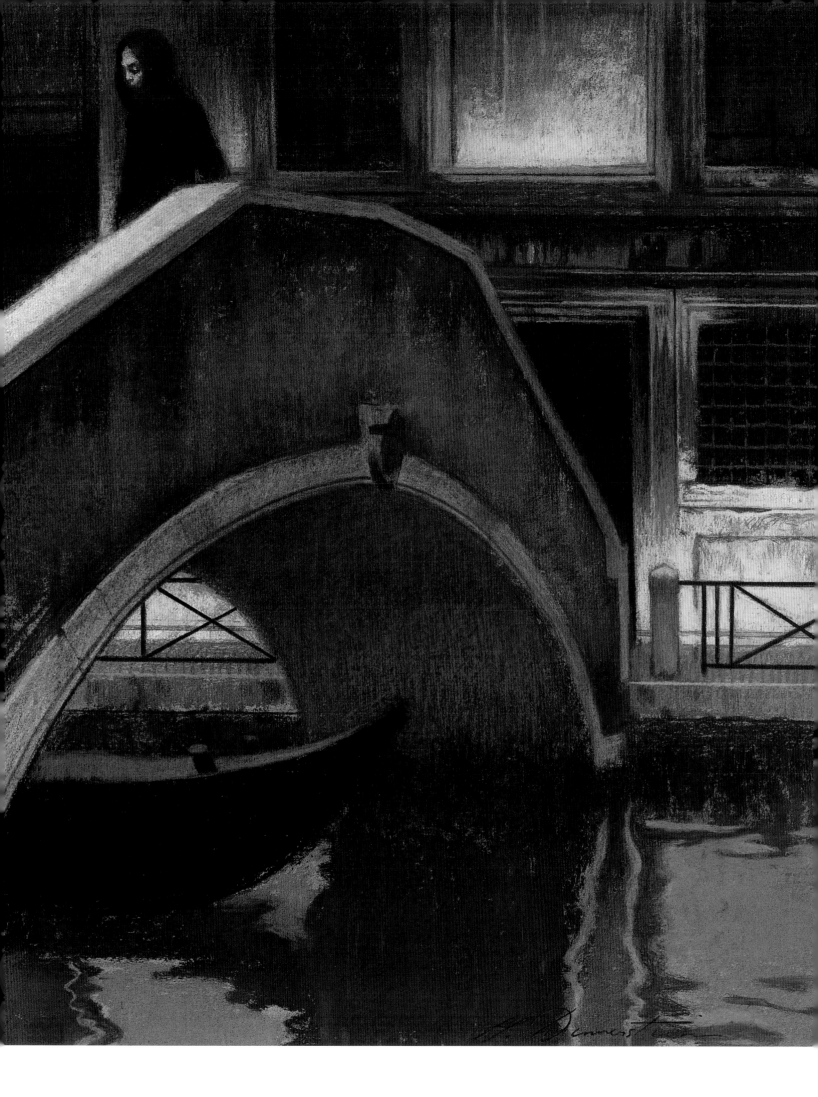

In 1956, I traveled with Burt Silverman to Montgomery, Alabama, to draw the bus boycott. Lois accompanied us to provide a written account of the journey. Perhaps as a nascent art historian, she was especially aware that our visual images would engage significant contemporary events. There was an elevated spirit to the struggle that went far beyond seating arrangements in a segregated bus, and sought to challenge the moral concerns of the nation. Though we depicted Martin Luther King Jr., Rosa Parks, E. D. Nixon, and other leaders of the movement, we focused mostly on those ordinary people who were the heart and soul of the struggle. Half a century later, I have a vivid recollection of the rhythmic cadence of the church meetings. As the minister preached, "God said take one step and I'll make two," the congregation responded with a resounding affirmation. I did numerous sketches of people walking, culminating with the drawing *Walking Together, Montgomery*, searching for a graphic image that would express the spirit of the remarkable events we had witnessed.

right
Old Woman Walking, Montgomery graphite on paper, 11 1/8" x 7", 1956

opposite page, top
Walking Together, Montgomery charcoal on paper, 17 3/4" x 25 7/8", 1956

opposite page, bottom
Rosa Parks, Montgomery graphite and pastel on paper, 15 1/8" x 12 3/8", 1956

Montgomery, Alabama 1956

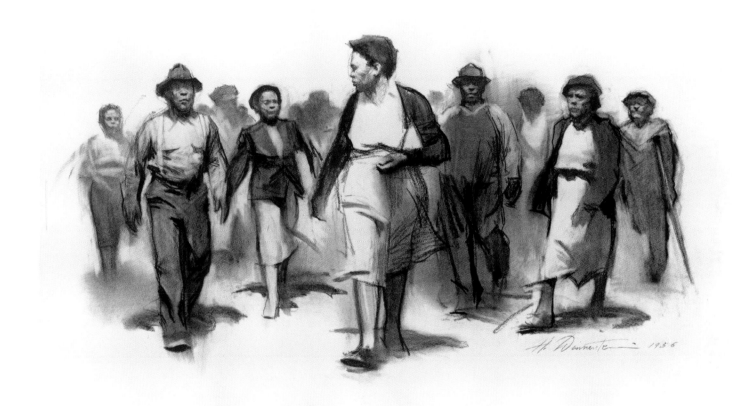

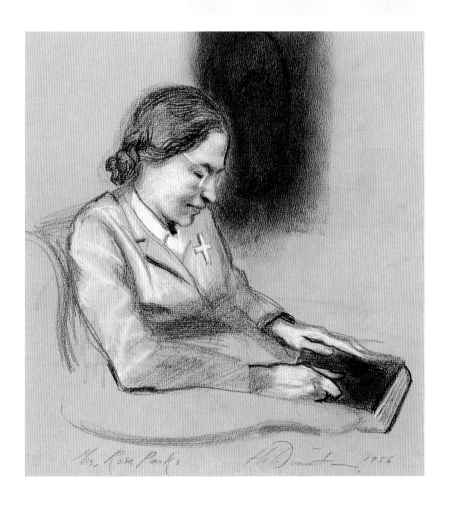

Turbulence of the 1960s and '70s

This is a series of images of the turbulence reverberating across the country in the 1960s and '70s. Fannie Lou Hamer from Mississippi portrayed as she addressed members of the Hospital Workers Union in New York City. *Burning Shack, Sick Child,* and *Hunger's Wall* depict the Poor People's Encampment in Washington, D.C., after the assassination of Martin Luther King Jr. *Prophet, Uprising,* and *Vigil* reflect protests against the war in Vietnam as the death toll mounted. They were based on individuals and events I encountered in the streets of Chicago, New York, Washington, D.C., and other parts of the country. When I painted Carlos and his monkey, it was the week after he had returned from the gathering at Woodstock, and I was struck by the effect on a younger generation of tumultuous forces sweeping across the nation. *Confrontation at Fort Dix* refers to an incident I witnessed at the army base where war protestors appealed to GIs to disobey officers' orders as they were dispersed with tear gas. In *Vietnam Veterans,* I documented protests against the war by veterans, who were discarding their medals in Washington, D.C. *Vigil* represents candlelight ceremonies that occurred in the nation's capitol, where the names of dead GIs were read throughout the night and placed in a casket.

Many of these images were reproduced in various publications at the time, including *Esquire, Harper's,* the Hospital Workers Union publications, and the *New York Times,* as an ad by the Clergy Committee for the Moratorium. I welcomed this opportunity to reach a broad audience.

above
Fannie Lou Hamer Local 1199 Hospital Workers Union newspaper, 1965

right
The Face of Protest *Esquire* Magazine, 1968

opposite page, top
Hunger's Wall, Resurrection City pastel on board, 14¾" x 28¾", 1968

opposite page, bottom
Burning Shack, Washington, D.C. pastel on board, 5" x 8¼", 1968

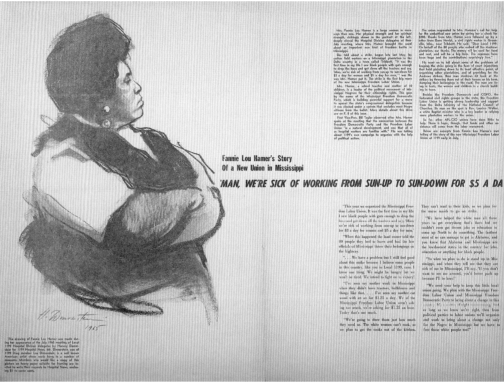

Fannie Lou Hamer's Story
Of a New Union in Mississippi

'MAN, WE'RE SICK OF WORKING FROM SUN-UP TO SUN-DOWN FOR $5 A DA

THE FACE OF PROTEST/19

Text and drawings by Harvey Dinne

It was black, white, red, American and

May and June, Washington
The Poor People's Cam

Sweet Willie
Memphis
Invaders

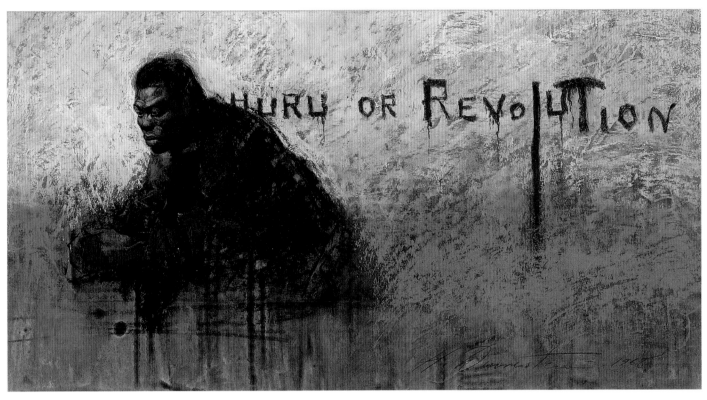

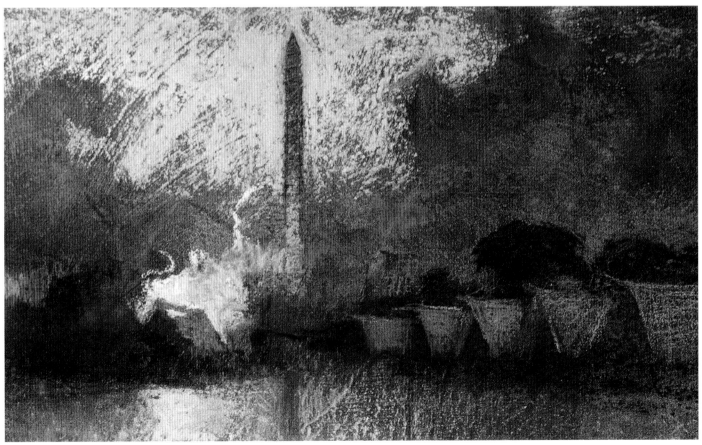

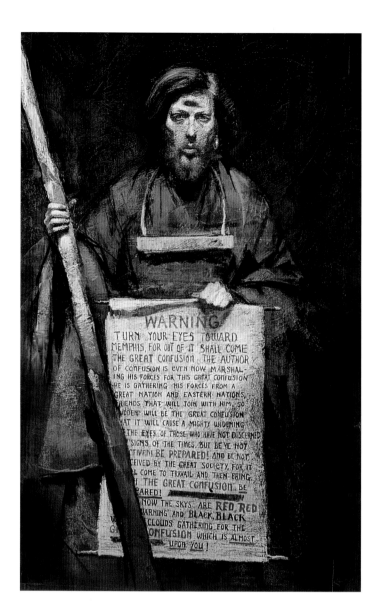

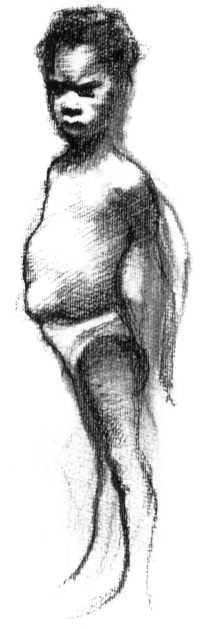

Sick child
Resurrection City

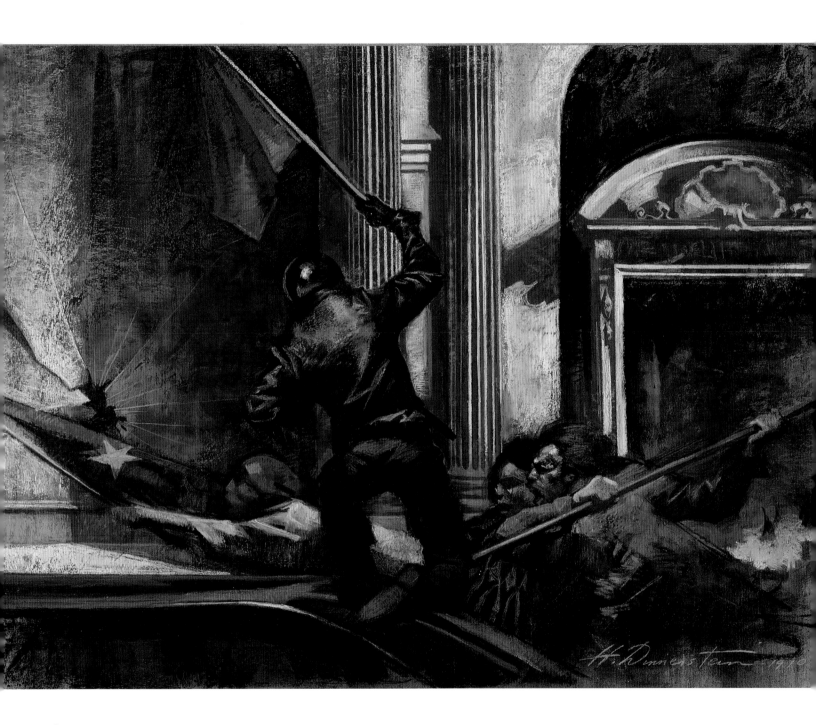

above
Uprising pastel on board, 21¼" x 29¼", 1970

opposite page, left
Sick Child charcoal on paper, 12" x 5½", 1968

opposite page, top
Prophet pastel on board, 15½" x 29", 1970

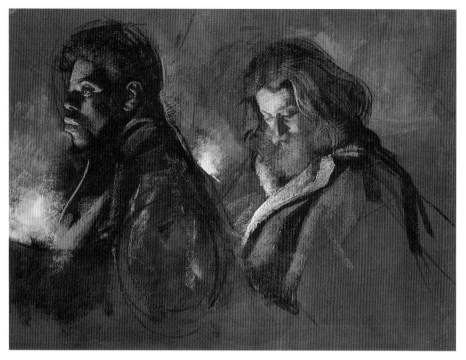

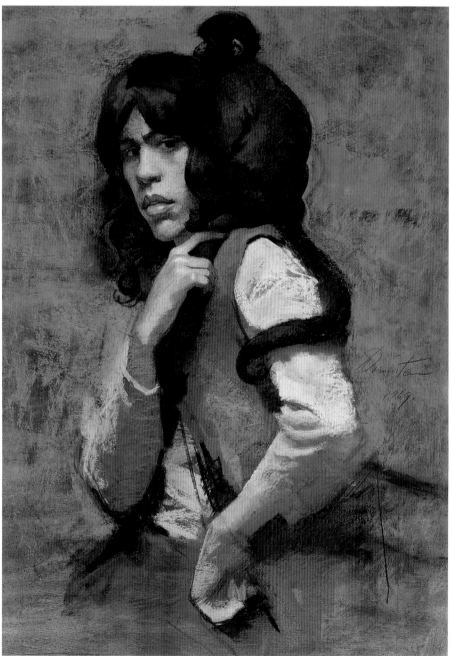

above
Vigil pastel on board, 22" x 30", 1970

left
Carlos and Monkey pastel on board, 29" x 20½", 1969

opposite page, clockwise from top left
Confrontation at Fort Dix pastel on board,
19½" x 29¼", 1970

Pray for Peace *New York Times* advertisement,
Clergy Committee for the Moratorium, 1969

Vietnam Veterans Reproduction in *Harper's* magazine,
quote by John Kerry, 1971

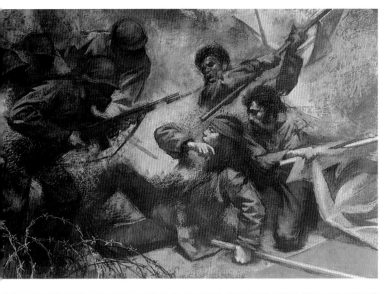

The country doesn't know it yet but it . has created a monster in the form of millions of men who have been taught to deal and to trade in violence, and who are given the chance to die for the biggest nothing in history.

–John Kerry, Vietnam Veterans against the War, from a statement to the Senate Foreign Relations Committee

Pray for peace.

It is a lonely Christmas this year for many Americans.

Lonely because their sons, husbands or fathers are thousands of miles from home, fighting a terrible, senseless war.

While you are enjoying this Christmas season, think of what it must be like for them.

The hopeful counting of days until their men come home.

The dreadful knowledge that even as they are counting, their men may be dead or dying in Vietnam.

It is not a joyful time for these Americans, nor for the families of those who have already given their lives.

And so, as they were asked to give a loved one, we ask something of you, too.

We ask for a day of prayer on Dec. 24.

We ask that you give up this one day of merrymaking and make it instead a day of penitence and mourning for all the victims of this war.

We ask that on this day of prayer you think about the immorality of this war.

We ask that you think about our responsibility to the innocent victims of this war who want only to live in peace in their own land.

We ask that you pray for peace.

And in this season of giving, we ask, too, that you give.

We ask that you find it in your heart to give aid to Vietnamese civilian relief agencies, that these people may have something to live for.

We ask that you ask your churches to give.

We ask that you give to the peace movement, so that we may continue in our efforts to bring this ungodly war to an end.

And we ask, during this season of good will towards men, not only those who have worked with us for peace, but also those who have not.

Because only through the efforts of all men can we ever truly have peace on earth.

The Christmas Clergy Committee For The Moratorium
1029 Vermont Avenue, N. W.
Washington, D.C. 20005
Tel. 202-347-4737

Enclosed is my contribution of $_____
☐ $500 ☐ $100 ☐ $50 ☐ $25 ☐ $10 ☐ $5

Name_____
Address_____
City_____ State_____ Zip_____

Make checks payable to:
Clergy Committee For The Moratorium

Rev. William Sloane Coffin, Jr., Chaplain, Yale University; Bishop Charles Golden, Methodist Bishop, San Francisco; Bishop Thomas J. Gumbleton, Auxiliary Bishop, Roman Catholic Archdiocese of Detroit; Mrs. Coretta Scott King; Rt. Rev. Paul Moore, Suffragan Bishop, Episcopal Diocese of Washington; Reinhold Niebuhr, Theologian; Father John Sheerin, Editor, The Catholic World; Mrs. Cynthia Wedel, President, National Council of Churches.

*Church World Service (Vietnam Christian Relief), 475 Riverside Drive, New York, N.Y. 10027; Committee of Responsibility, 40 Madison Avenue, New York, N.Y. 10010; American Friends Service Committee, Vietnam Program, 160 North 15th Street, Philadelphia, Pa. 19102; Caritas Internationalis, Vietnam Relief Fund, 77 United Nations Plaza, New York, N.Y. 10017.

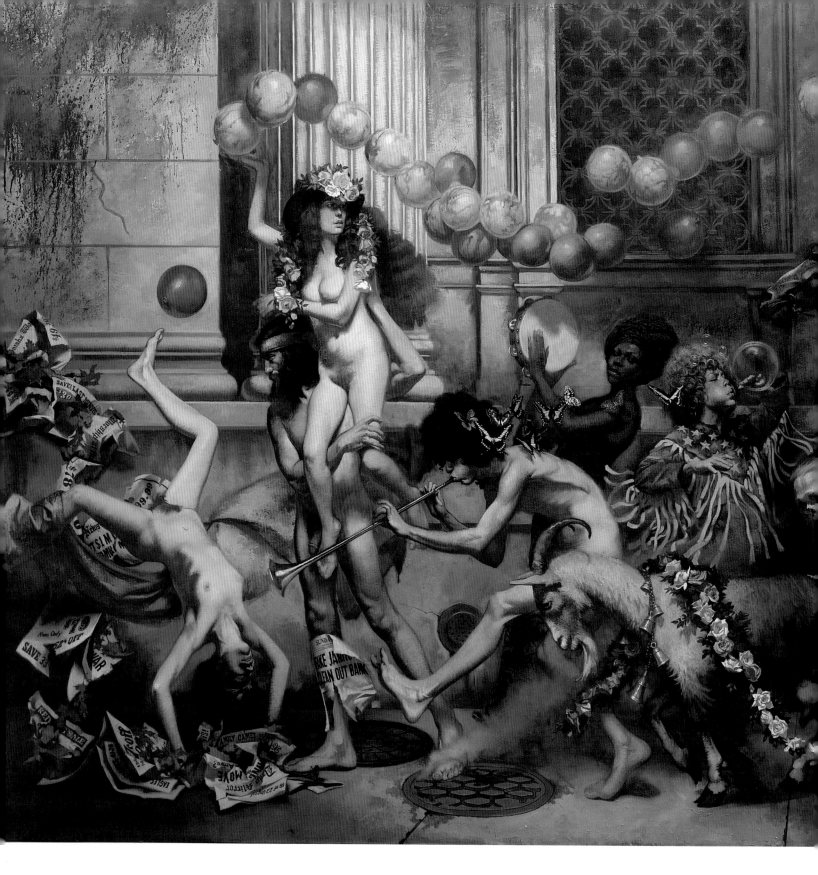

Parade oil on canvas, 74" x 153", 1970–72

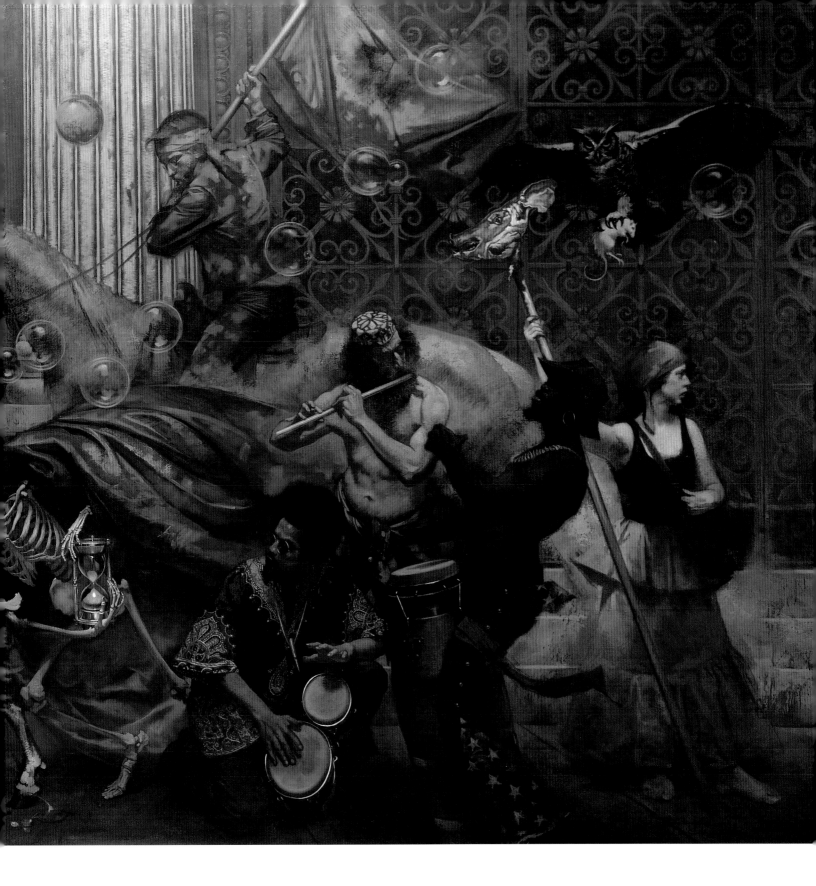

Constructing the Epic Image

As I reflected on the events I had witnessed, the possibility occurred to me of an epic image that would encompass all the diverse elements of that time and reflect contemporary events with a vision that resonated beyond narrative description. Demonstrations against the war in Vietnam addressed concerns beyond political issues of the moment and expressed a profound disaffection with material and spiritual qualities of contemporary life. This often took the form of street theater, utilizing masks, costumes, animals, blood, and skulls, challenging the establishment. The demonstrations reminded me visually of street performers in Italy at carnival time, or pageants that Bosch might have seen or perhaps designed himself. In planning the painting, I imagined a procession related to Ruben's wild bacchanalian images. As the painting evolved, I combined and expanded various elements I had noted in observing the events I have described. For example, the conga drummer in the right-hand side of the painting is based on a sketch of a man from Oakland, California, that I had met at the Poor People's Encampment in Washington, D.C., where he was beating on metal barrel drums. This was after the assassination of King, and my sketchbook notation has an inscription with a quote I overheard: "This may be the last time." Moving across to the group of figures leading the procession, I thought it would be more interesting visually if all of the figures were not on the same level. I had taken a photograph of a young man carrying a woman on his shoulders at one of the demonstrations, and I tried drawing a couple in my studio in a similar position. This seemed unconvincing, until I remembered a drawing I had done in an old sketchbook of the Bernini sculpture of Aeneas and Anchises at the Borghese Museum, and this helped clarify the structural relationship of the figures. As I studied the copy of the Bernini sculpture, it occurred to me that the group leading the procession could be nude. I wondered if this was simply an echo of the art of another time, or related to the spirit of contemporary events, and I finally decided to incorporate the nude figures into the composition. Sometime later, after I had established the compositional drawing, but before I started working on the canvas, I encountered a group of protestors removing their clothes and confronting the authorities at a demonstration in the nation's capital. This confirmed my intuitive feeling about the image I was developing. In the midst of this wild confrontation between demonstrators and police, I also noticed a young man blowing bubbles. It seemed an absurd and humorous note against the heavy action of the moment. I made a sketch on the spot, and the young man posed for me afterward in my studio. The study finally evolved into a child blowing bubbles when it occurred to me to introduce the element of another generation in the final image. After the painting was completed, I came across an eighteenth-century allegorical engraving with a symbolic figure of Time, blowing bubbles over a papal tiara, scholar's hat, and military order. The inscription, which is really superfluous, reads, "Naught under the sun is eternal."

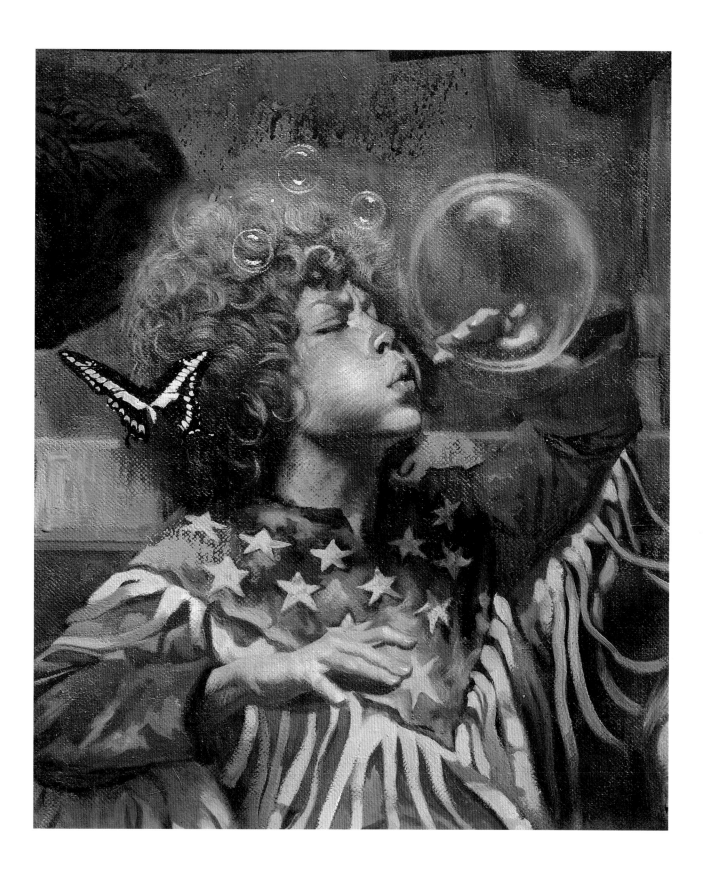

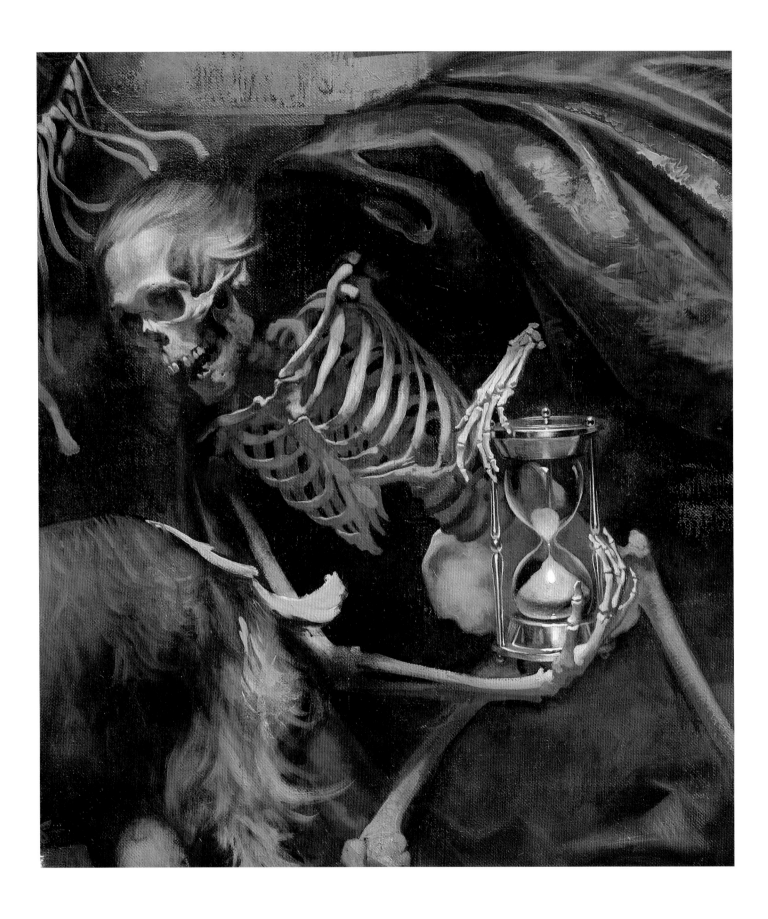

above
White Rat oil on board, 5½" x 9¾", 1972

left
Studies for *Parade* 1970–72

opposite page, top
Studio photograph, Working on *Parade*
Photograph by Geoffrey Clements, 1972

opposite page, bottom
Studio photograph
Photograph by Walter Rosenblum, 1970

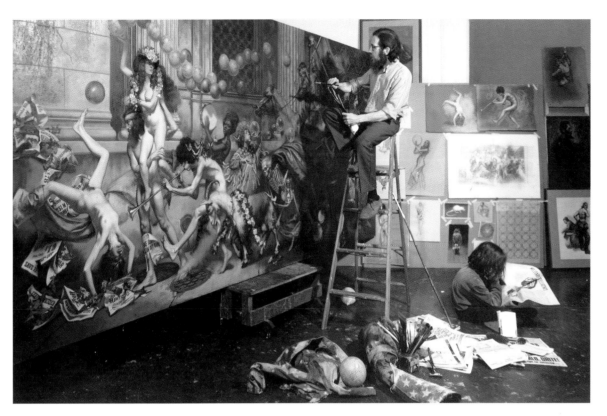

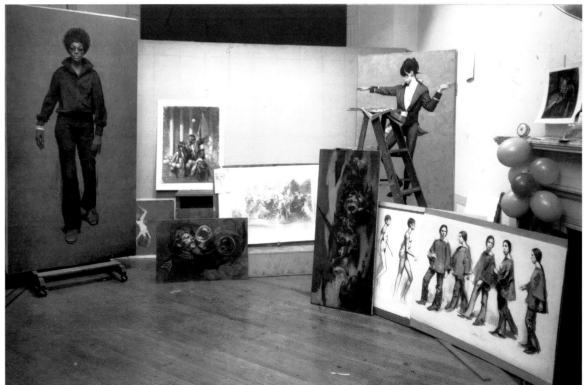

above and opposite page
Parade being moved from my studio through the
window. Photographs by Harvey Dinnerstein, 1972.
The canvas, which is 153" long, was initially stretched
and primed in my studio; I did not realize until I had
completed the painting that it was too large to be carried
down the stairway. I had to arrange for a piano mover to
move the painting through a window out of the studio.
He was amused at my predicament, comparing it to a
man who had constructed a boat in his garage, too large
to fit through the doorway and out to sea.

Detail of *Spring*

In 1972, I completed *Parade* after devoting two years
to the project, and felt a sense of exhilaration, release,
and an empty gap after the relentless solitary effort
necessary to realize a complex project. I longed for a
change, with a great desire to enjoy some fresh percep-
tion outside of the studio. I started to wander about
Prospect Park.

As I explored the park, I noted the shift in spec-
trum as the seasons changed, and the range of people.
Visual images presented themselves in all directions:
a black woman running in a brilliant orange-red jogging
outfit, cool lights on her warm complexion; a blond-
haired boy stripped to the waist, sunlight luminous on
his muscular form as he tossed a blue Frisbee across
the meadow; and a group of Orthodox Jews silhouetted
against the setting sun beside the lake, casting bread
upon the water in a ceremony that precedes the new year.
Occasionally, I would encounter a group of musicians,
and the pastoral gathering reminded me of Arcadian
images by Titian, Rubens, or Watteau.

There are a number of tunnels throughout the park
that include various kinds of arches (round, pointed, and
elliptical), with varicolored stones and ornament. The
dark of the tunnel and the light at the inner recess draws
one into the meadow, or wooded path, and I came to
view the tunnel as a passage through time and space.

It gradually occurred to me that the paintings could
be a series of images relating to different times of the
year: images of the seasons that would relate to a journey
through time and space, and passages of life. I began
to feel that I was engaging the subject on another level,
beyond genre images of everyday life in the park, and
a larger scale seemed appropriate.

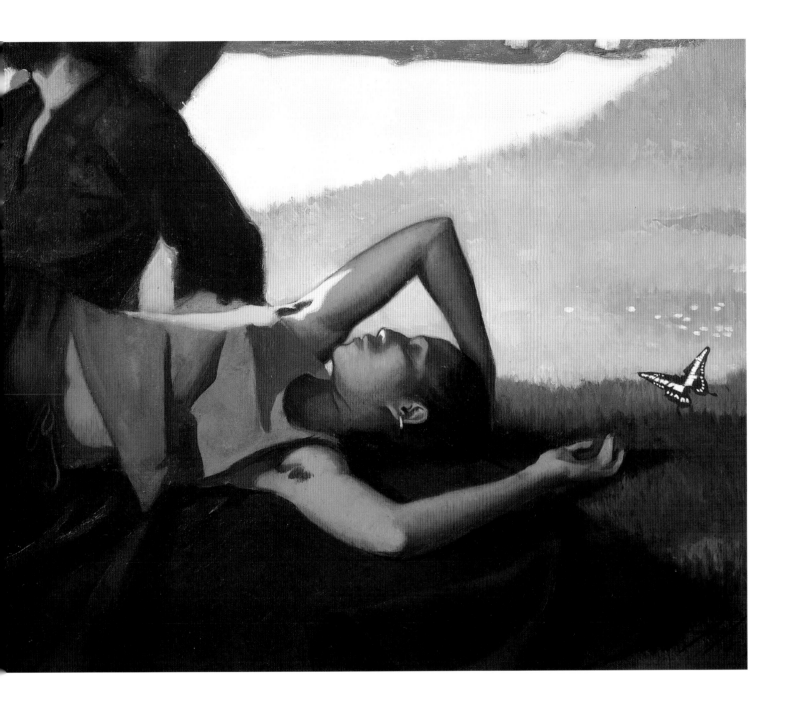

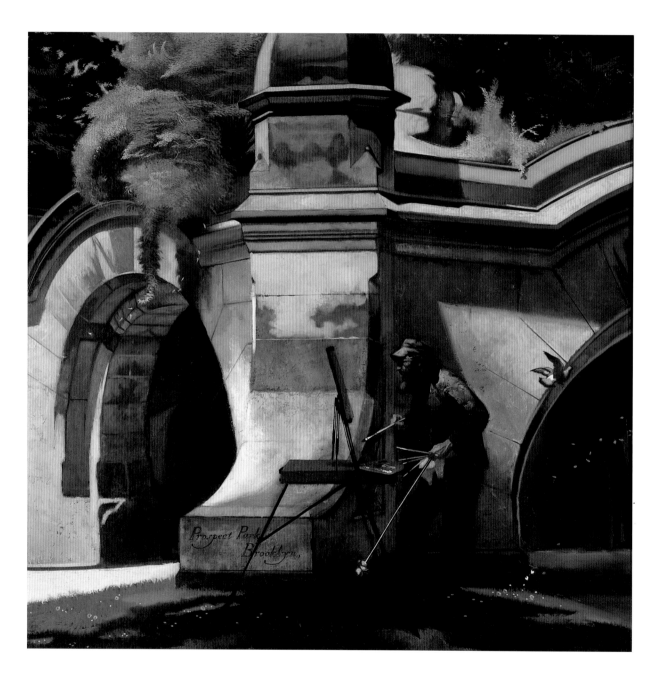

Working in the Park oil on canvas, 44" x 44", 1978

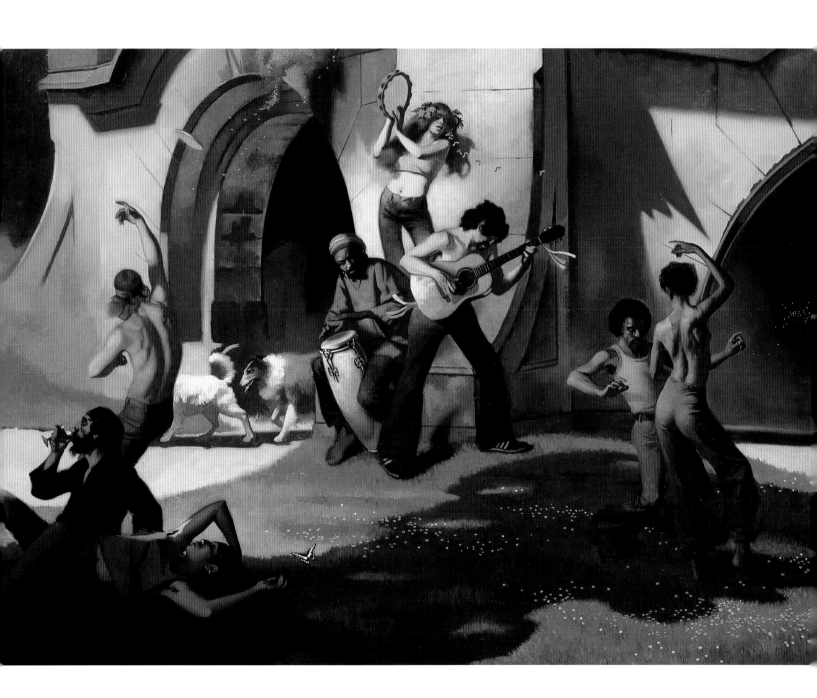

Spring oil on canvas, 40"x 64", 1982

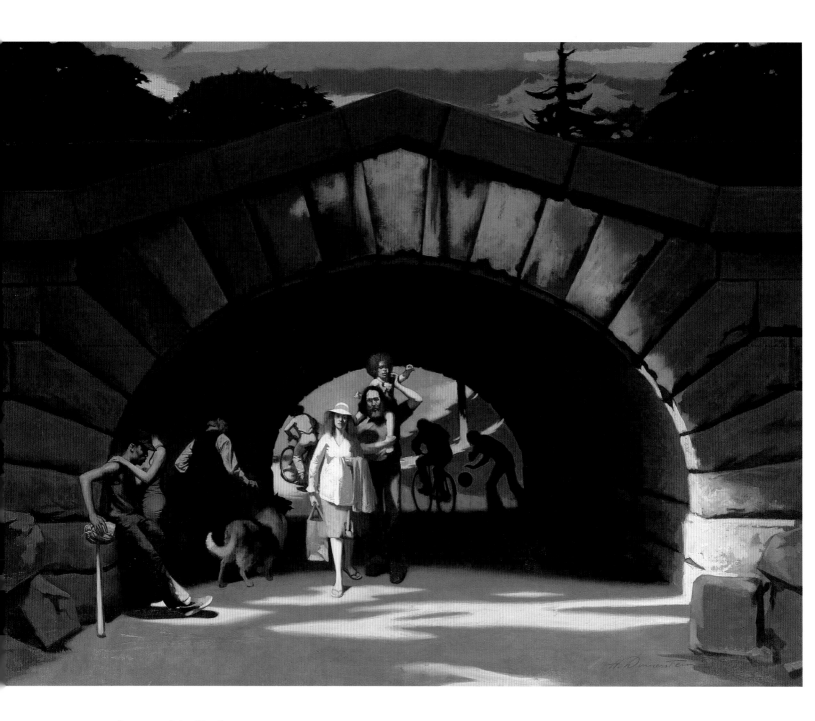

Summer oil on canvas, 60" x 78", 1982

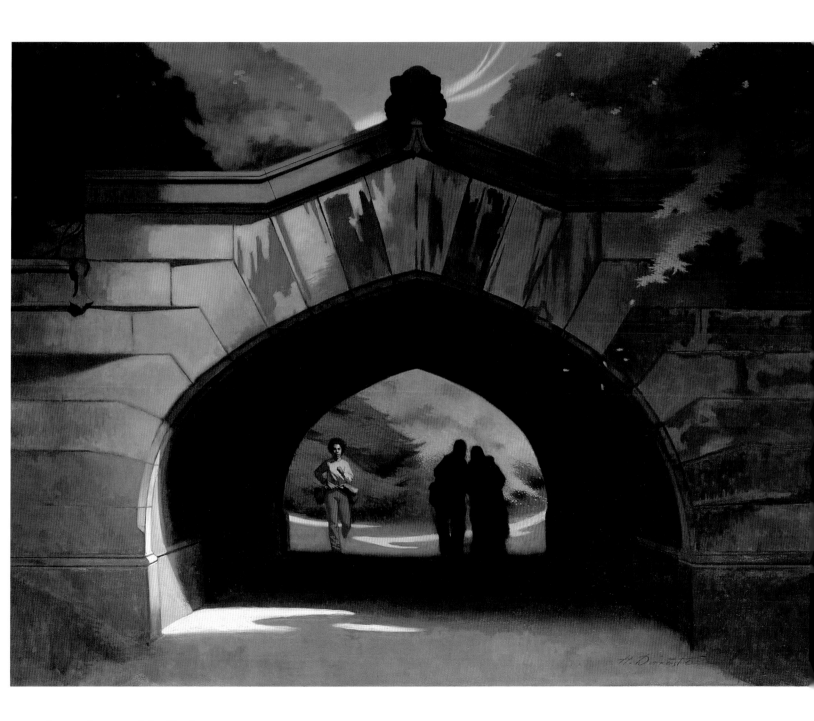

Autumn oil on canvas, 60" x 78", 1982

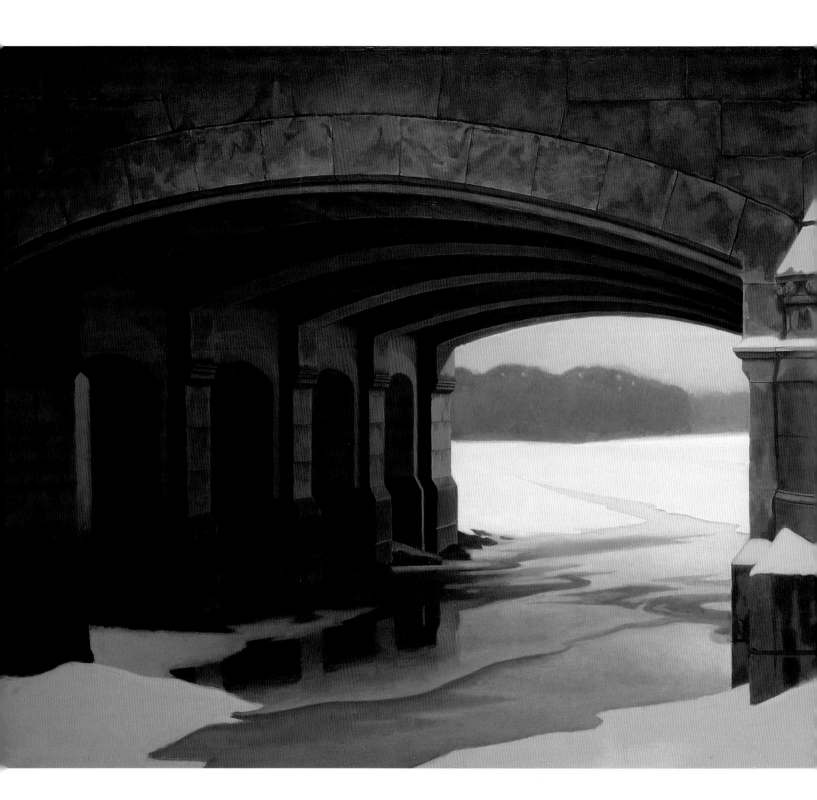

Winter oil on canvas, 60" x 144", 1982

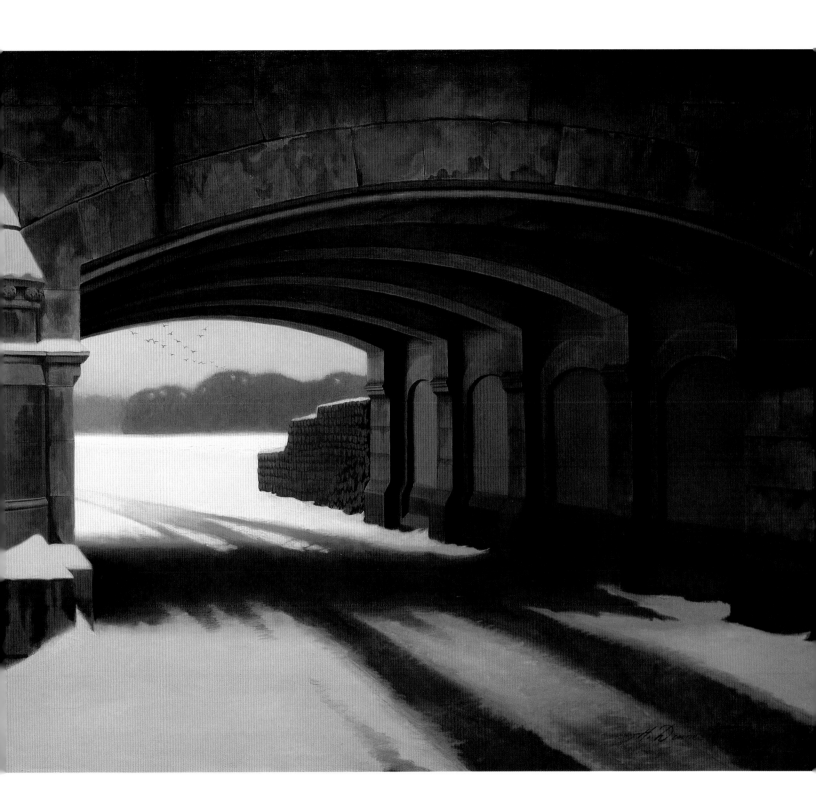

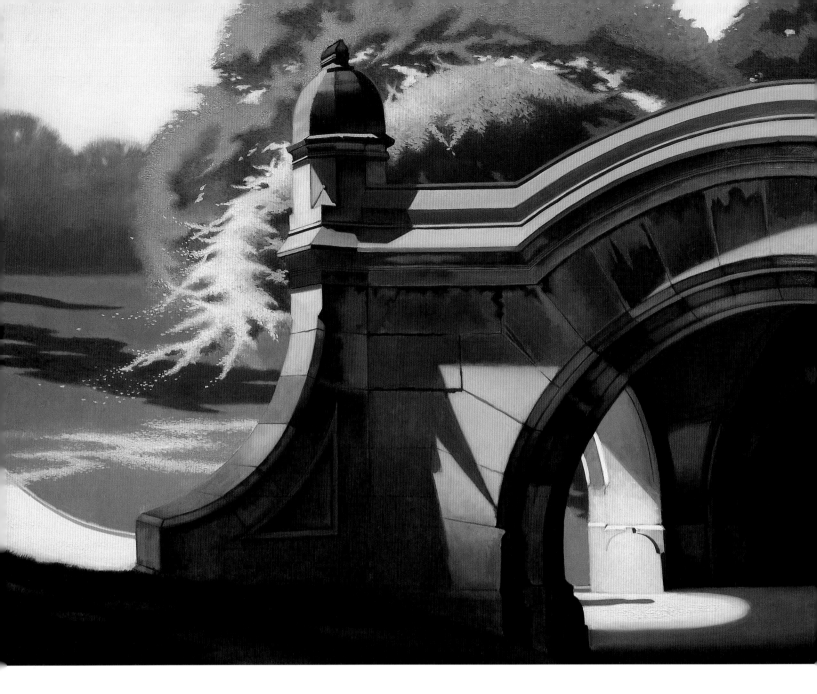

above
Another Spring oil on canvas, 60" x 78", 1982

opposite page, top
Autumn, Meadowpoint Arch pastel on board,
6⅞" x 12", 1975

opposite page, bottom
Spring, Study for the Seasons pastel on board,
10¼" x 15", 1975

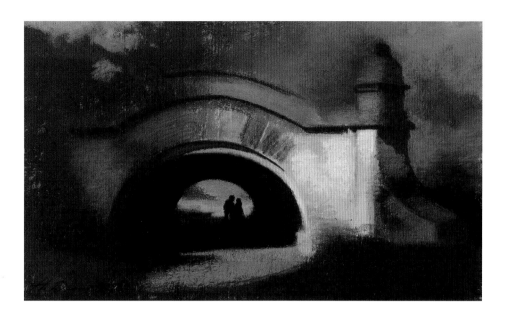

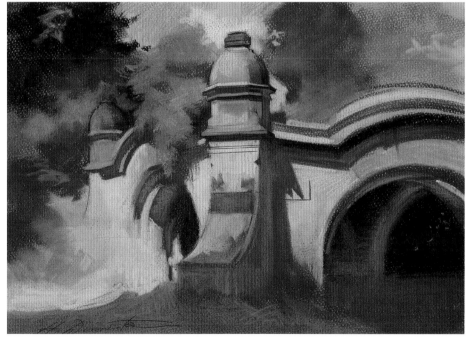

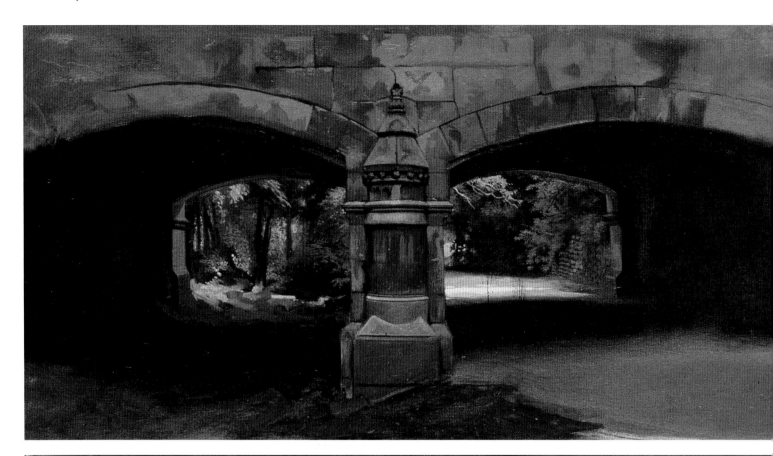

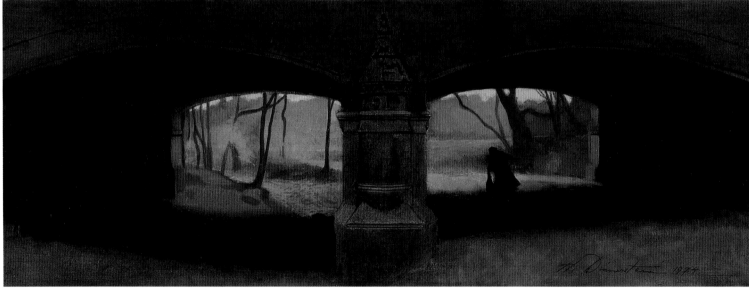

above, top
Summer, Nethermead Tunnel oil on board,
10" x 18½", 1974

above, bottom
Autumn, Nethermead Tunnel oil on board,
8¼" x 22¾", 1974

I worked over the next 10 years on this series of paint-
ings. The studies were done on location, and the large
paintings resolved in the studio. After the initial study
in oil, working on location, I switched to pastel because
the medium is so much faster than oil, expediting the
work in cold weather. *Study for Winter (A)* is the initial
lay in of this pastel, and *Study for Winter (B)* the final
resolution of the pastel. As the image in the large paint-
ing evolved, it occurred to me that if I eliminated the
wooded area and established a deeper recession of space,
it would intensify the infinite mystery of the final passage.
I returned to the park for additional studies of the dis-
tant landscape, like the pastel *Study for Winter,* to work
out the receding spatial relationships.

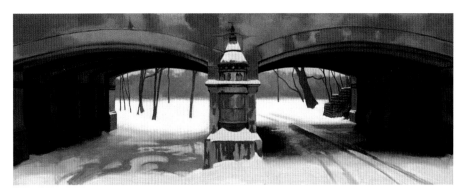

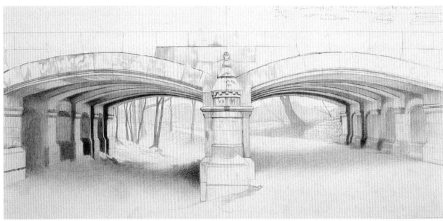

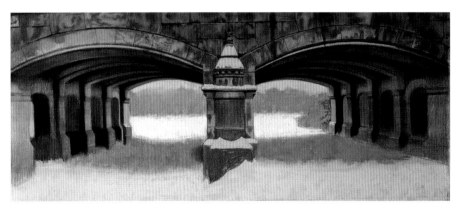

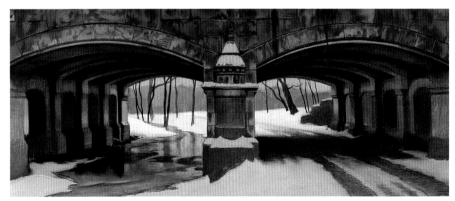

right, top to bottom

Study for Winter oil on board, 10¾" x 28½", 1978

Study for Winter pencil on paper, 9" x 22¼", 1981

Study for Winter (A) (initial lay in, work in progress) pastel on board, 11⅞" x 28¾", 1982

Study for Winter (B) (completed pastel, work in progress) pastel on board, 11⅞" x 28¾", 1982

Study for Winter (Distant Landscape) pastel on board, 15¼" x 13⅜", 1982

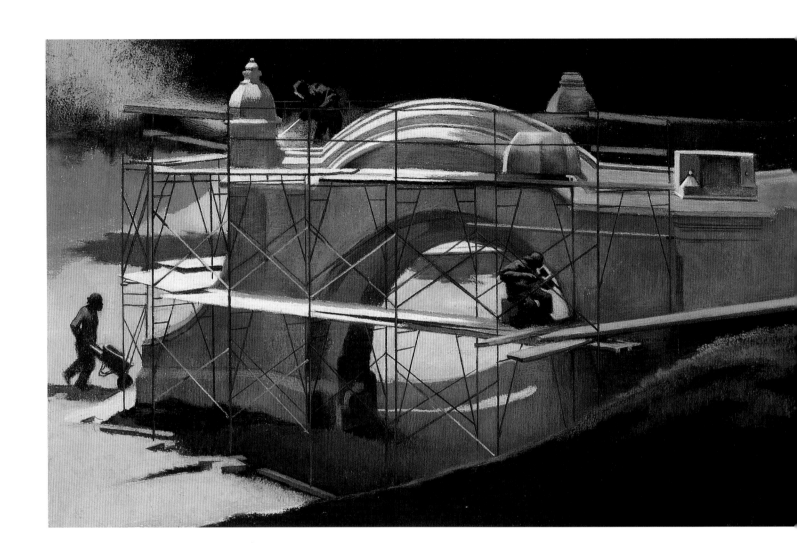

above
Restoration of Meadowport Arch pastel on board,
15" x 24½", 1987

opposite page
Studio photograph, Working on *The Seasons*
Photograph by Tony Mysak, 1982

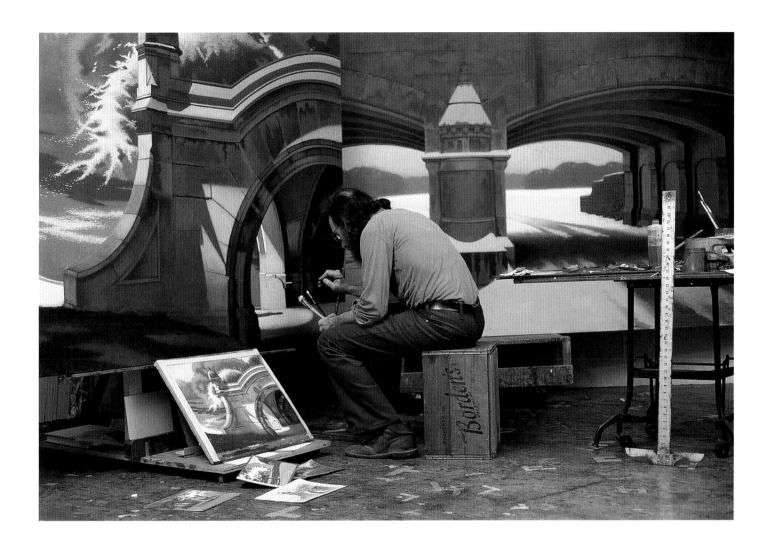

above
Stay Amazed oil on canvas, 48" x 44", 1976
A painting of my son, Michael, that reflects his
intense curiosity in exploring the world. I tried
to approach the painting with a related sense of
discovery.

opposite page
Shaka oil on canvas, 44" x 36", 1976

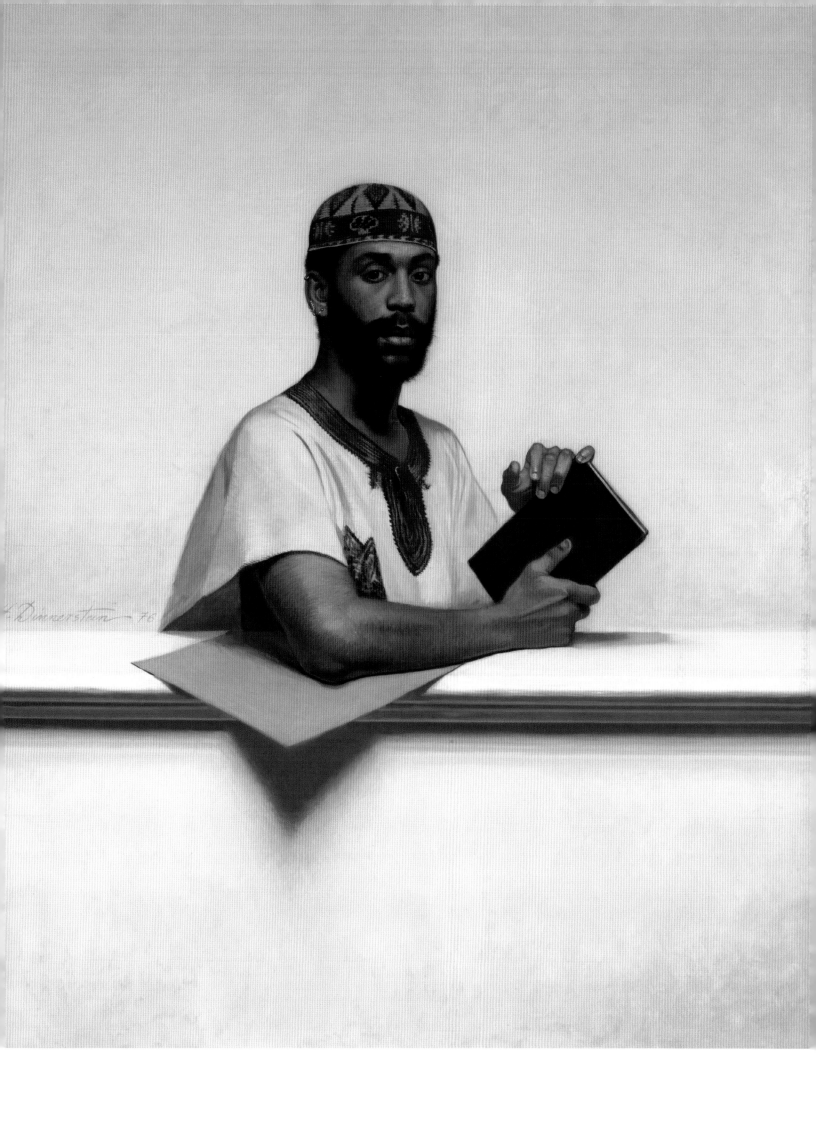

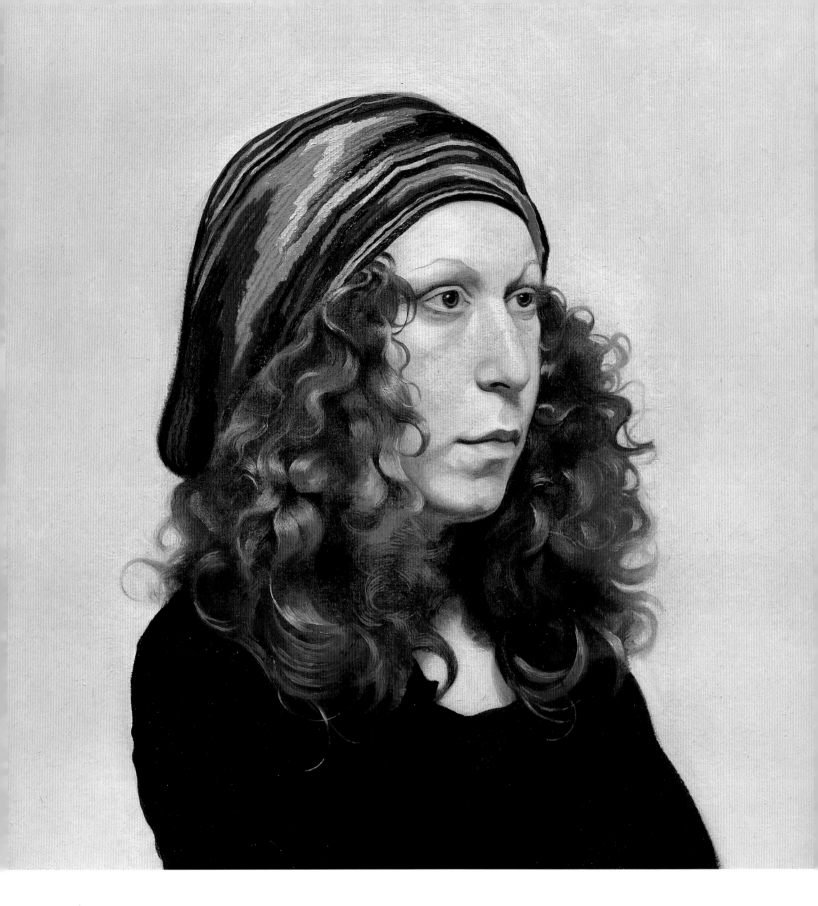

above
Linda oil on board, 14" x 13¾", 1977

opposite page, top
Mercedes oil on board, triptych,
each panel 15½" x 15½", 1977

opposite page, bottom
Mercedes left panel

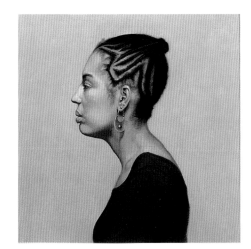 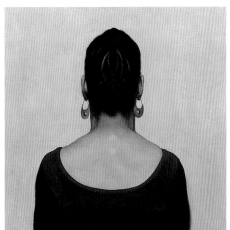 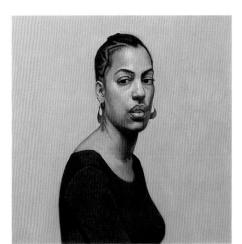

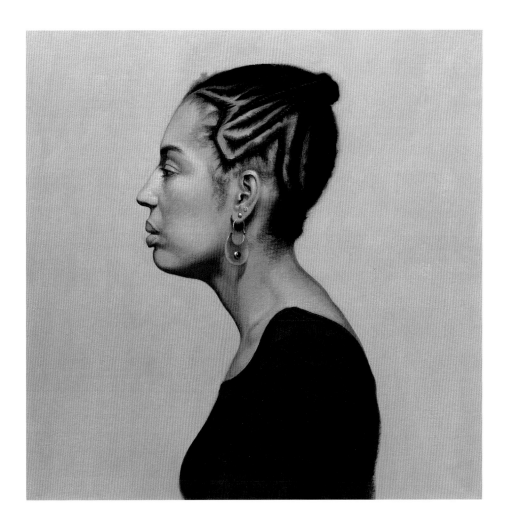

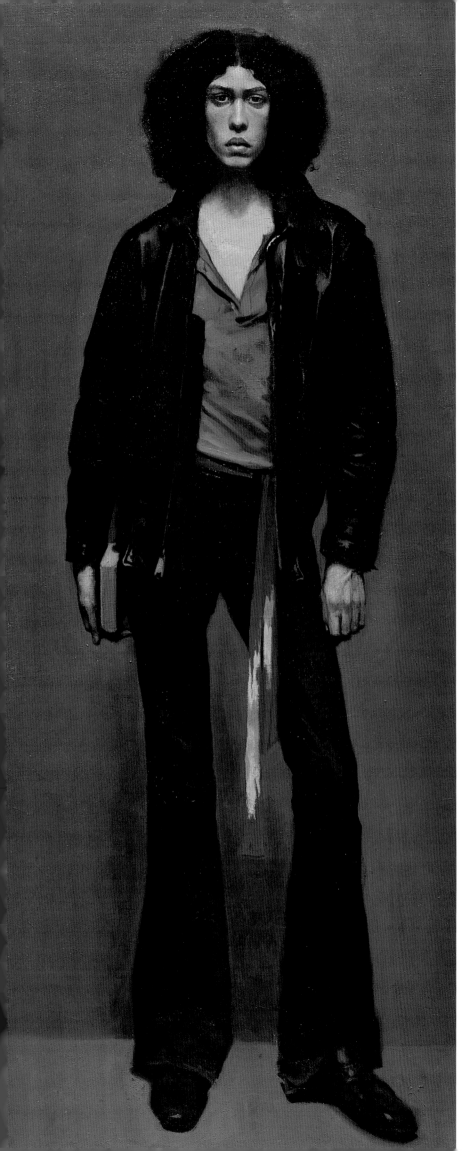

left
Michael S. oil on panel, 28" x 12", 1970

opposite page
Michelene oil on panel, 28" x 12", 1970

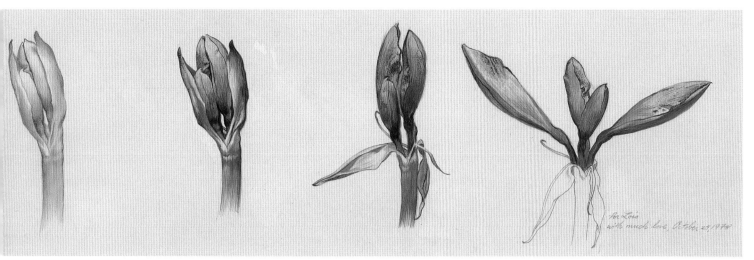

opposite page
Ladino Song oil on board, 17¾" x 17¾", 1975

top
Eros (to Lois) watercolor and pencil on paper,
4⅜" x 14", 1978

right
Amaryllis silverpoint on board, 28¼" x 17", 1975

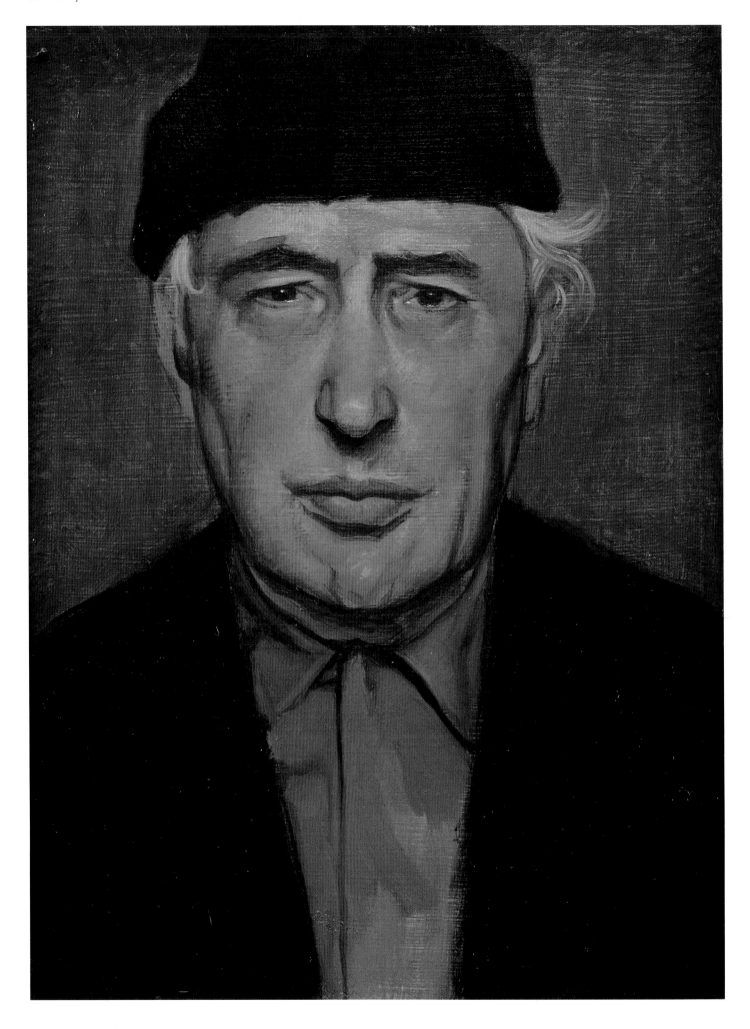

opposite page
Lou oil on wood, 8" x 5⅞", 1972
Portrait of my father

right
Sunflower in Brooklyn oil on board,
28¼" x 12¼", 1988

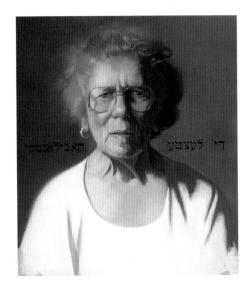

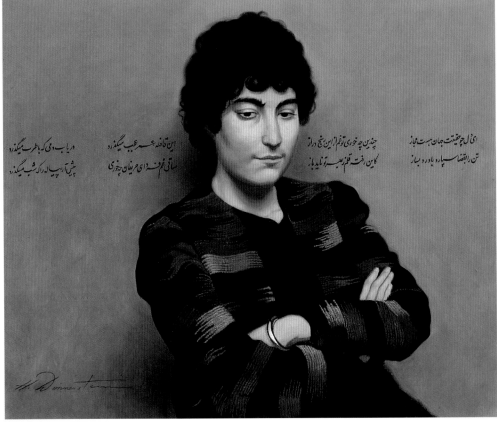

above, left
The Last Kobilansky oil on board, 16" x 12", 1989
Occasionally, I include an inscription in a painting,
with calligraphy related to the subject. As my mother's
younger sister Gertrude posed for this portrait, she
remarked that she was the last surviving member of
the family, and it occurred to me to inscribe the paint-
ing in Yiddish, "The Last Kobilansky."

above, right
Pavenah oil on board, 15½" x 18½", 1990
Pavenah is a portrait of a young Iranian American
who was fond of the poetry of Omar Khayyam. The
translation from the *Rubaiyat* in Persian is:
One Moment in Annihilation's Waste,
One moment, of the Well of Life to taste —
The Stars are setting, and the Caravan
Draws to the Dawn of Nothing—oh, make haste!

opposite page
Self-Portrait with Burt Silverman oil on canvas,
38½" x 31½", 1987
The inscription in Yiddish, translates: "Two boys from
Brooklyn, Fifty years later"

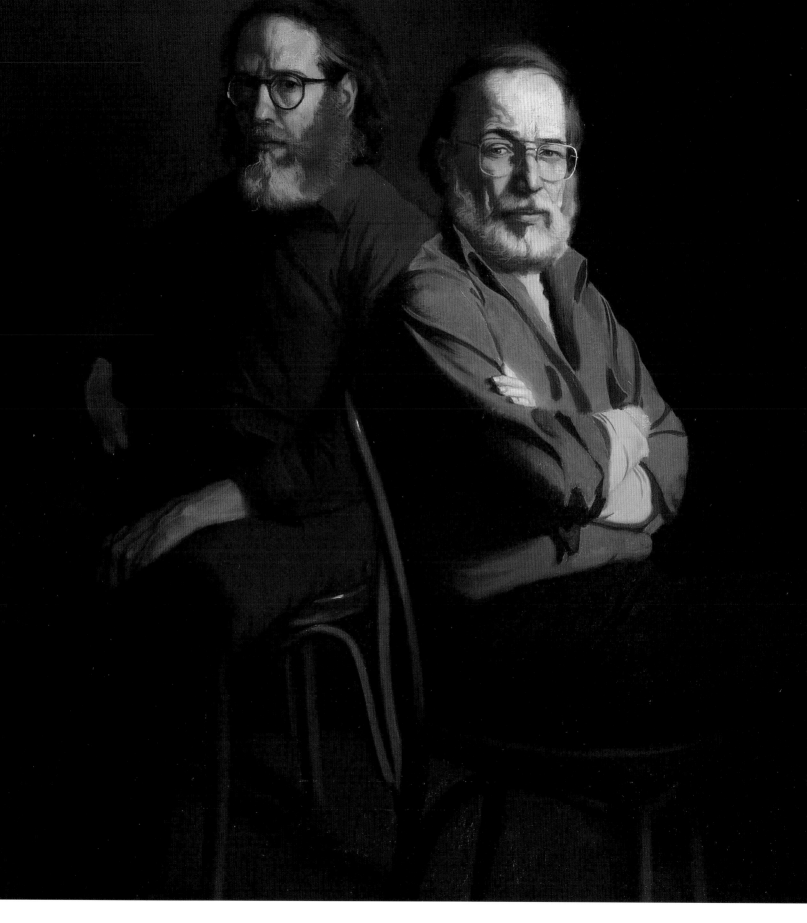

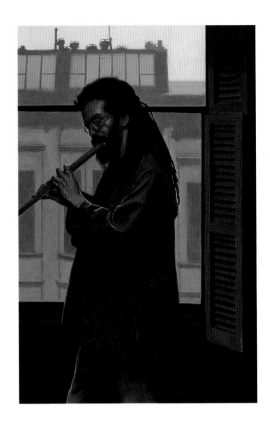

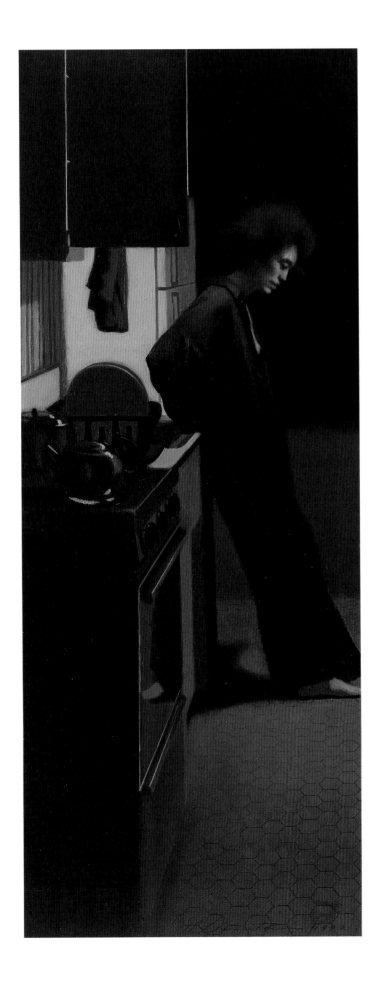

above
The Flutist oil on board, 21" x 13½", 1988

left
Sleepless Night oil on board, 23½" x 9¼", 1990

opposite page
Roseangela, Mirror oil on canvas, 14¾" x 14¾", 2000

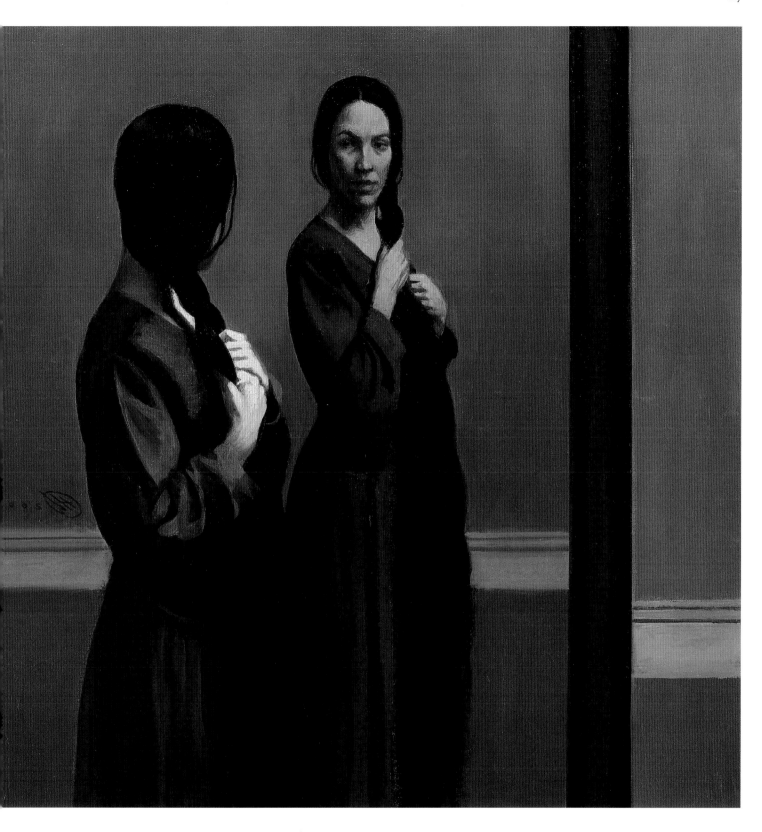

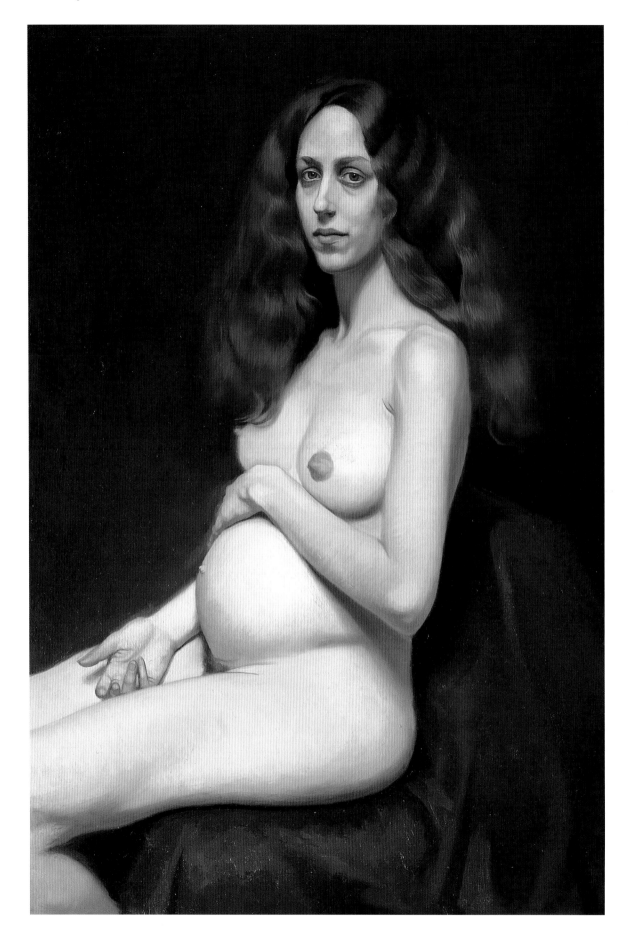

above
Carla Pregnant oil on board, 33¾" x 22¾", 1978

opposite page
Carla and Arlyn oil on canvas, 48" x 28", 1978

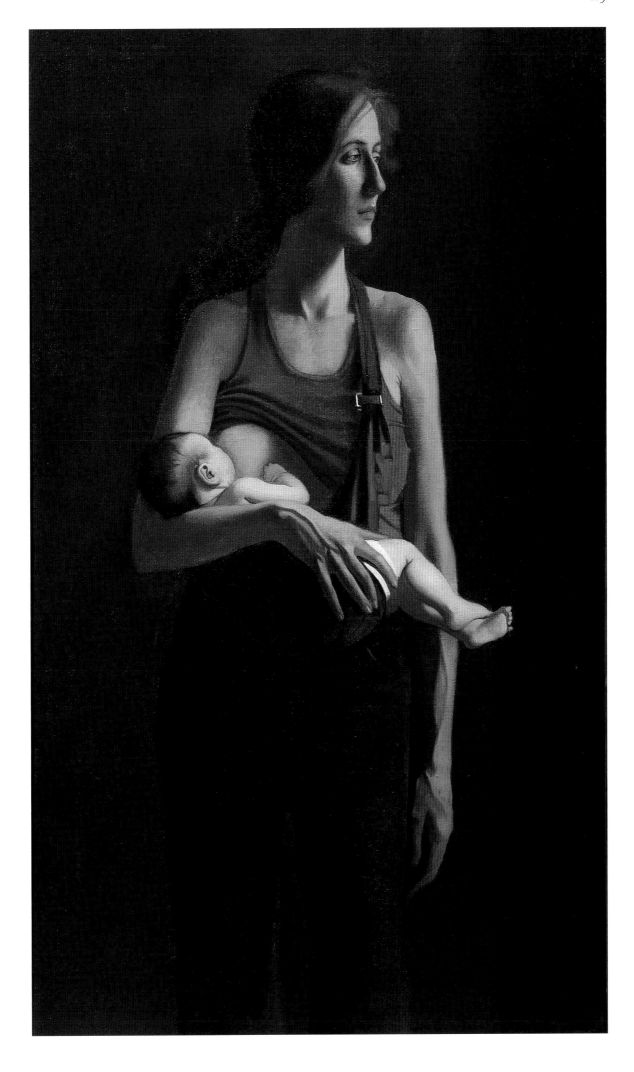

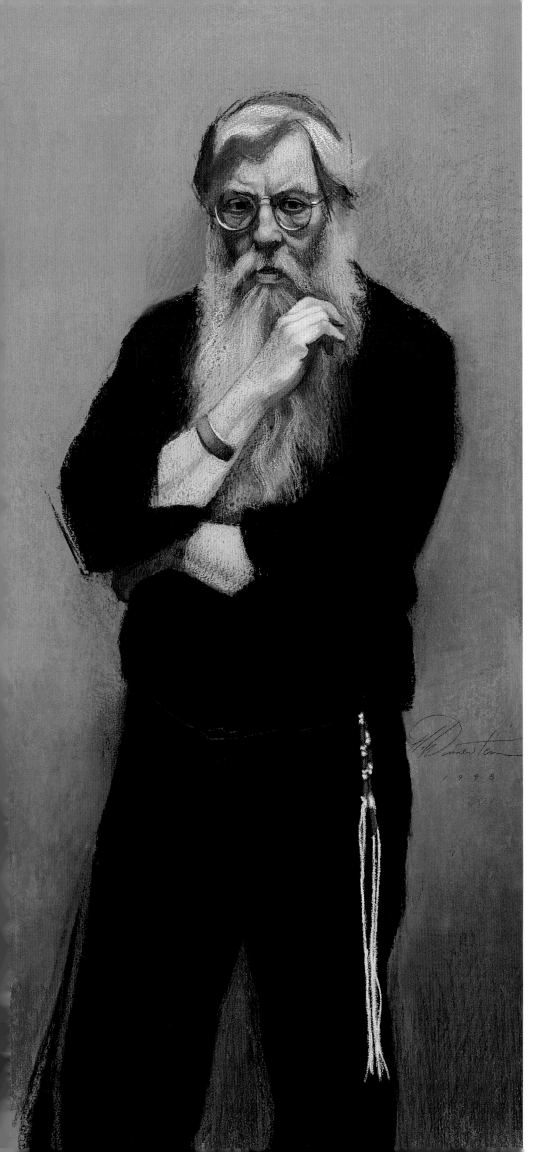

left
Izzi pastel on board, 51½" x 25", 1998

opposite page
Althea pastel on board, 29" x 17¾", 2000

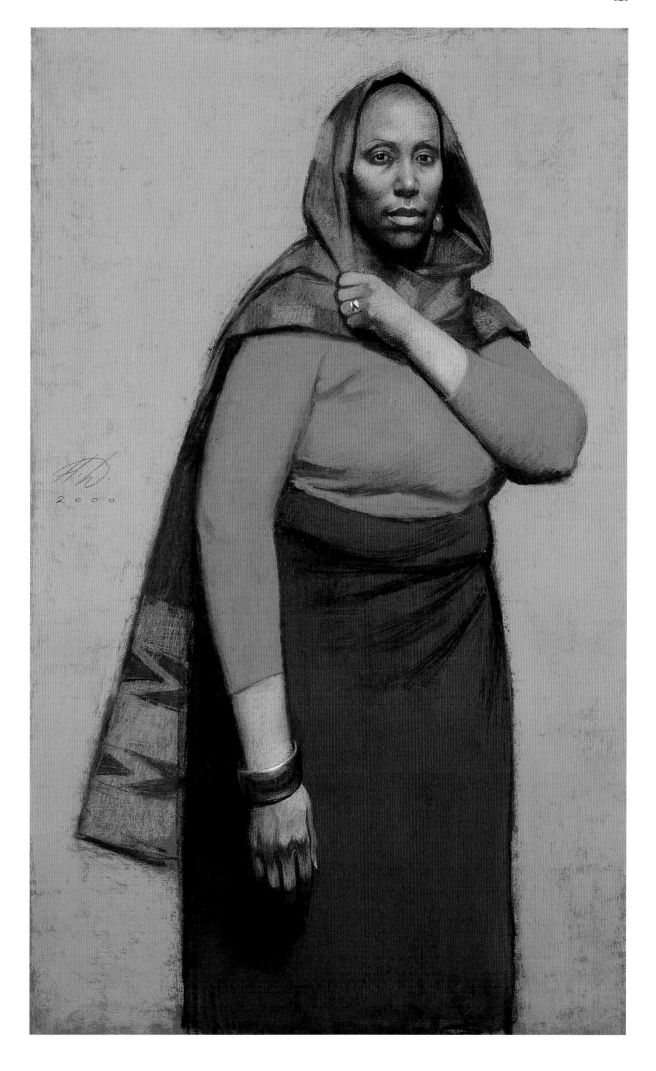

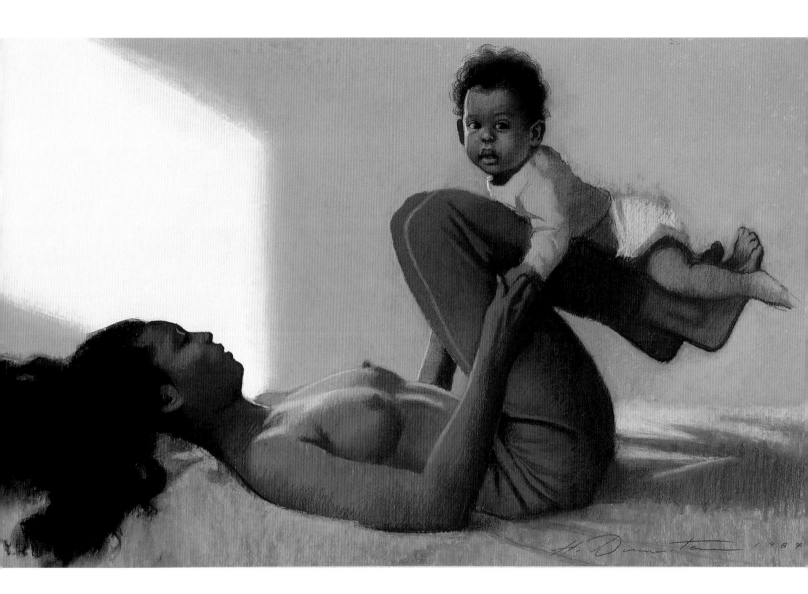

above
Morning Light (Mani and Manisha) pastel on board,
16 ½" x 27", 1987

opposite page, top
Nursing (Mani and Manisha) pastel on board,
27" x 19", 1987

opposite page, bottom
Dancing Shiva (Mani and Manisha) pastel on board,
17 ½" x 18 ½", 1987

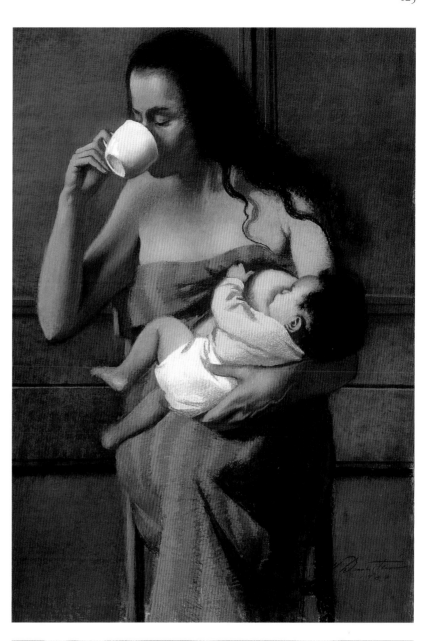

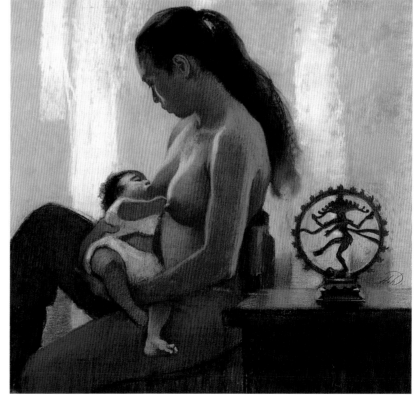

Carol with Tallis oil on canvas, 35" x 41", 1995

Amina oil on canvas, 30" x 24", 2005

When I painted these portraits, I was aware that the
subjects presented themselves in contemporary roles
that would have been inconceivable in the past. Carol
suggested to me that she pose with a tallis, which she
wears at her synagogue but is traditionally limited to
men in the Orthodox faith. When Amina described how
she works out at boxing, I asked her to show me how
she wraps her hands under the boxing gloves. (I noticed,
after I had completed the painting, a sculpture by the
19th-century American sculptor Charles Henry Niehaus
of a boxer, *Caestus*, with a related gesture—wrapping
an ancient Roman version of a modern boxing glove
around his fist.)

I would emphasize that this anecdotal information
relating to the paintings is only relevant in my mind if
it is conveyed in visual terms—light, color, and form—
that enhance the content of the image.

above
Daybreak oil on board, 18" x 19½", 1996
This image is related to Vermeer. I know that the jog-
ging pants and photograph of the nebula on the wall
could only be perceived in our time, but I wonder if
the quality of light that illuminated the 17th-century
interiors of Delft was that different from the light
entering a room in Brooklyn today.

opposite page
Elaine oil on wood, 46" x 35", 1979

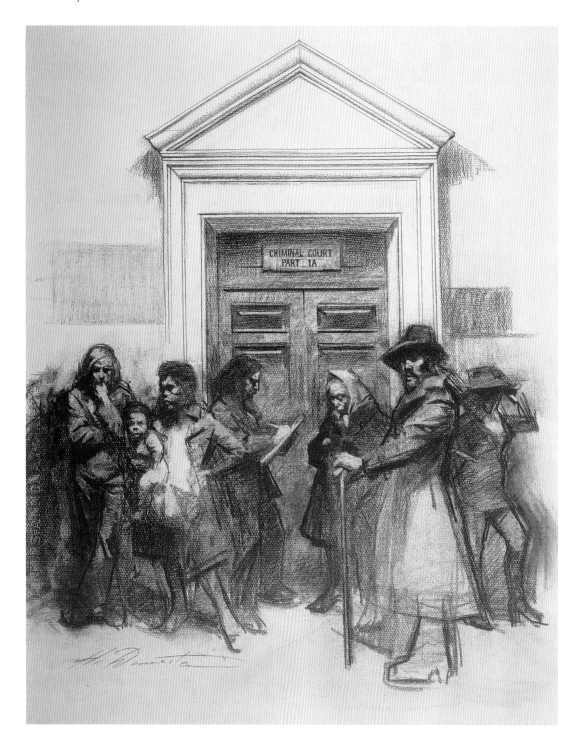

above
Arraignment Court, Brooklyn
charcoal on paper, 24" x 19¼", 1975

opposite page
Arraignment Court, Brooklyn, 11 Sketches
graphite and charcoal on paper, 47" x 47" (framed), 1975

A procession of defendants, victims, lawyers, cops, pros-
titutes, landlords, and tenants in the crowded courtroom.
The pimp asked me to include his portrait, as he con-
ducted his affairs like a small businessman. I had only
a short time to sketch the proceedings as the judge dis-
patched each case in the busiest arraignment court in
the country.

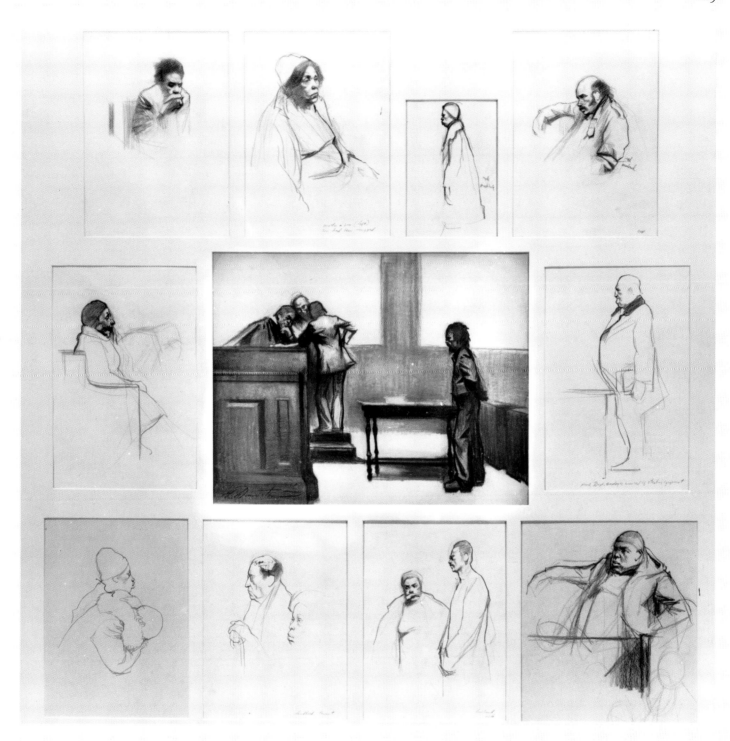

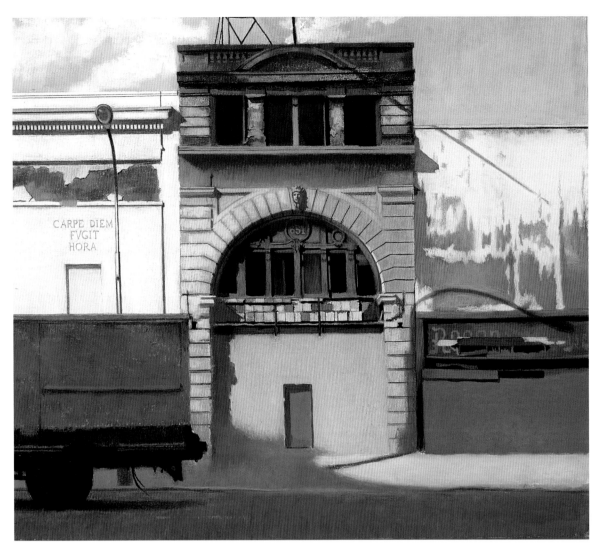

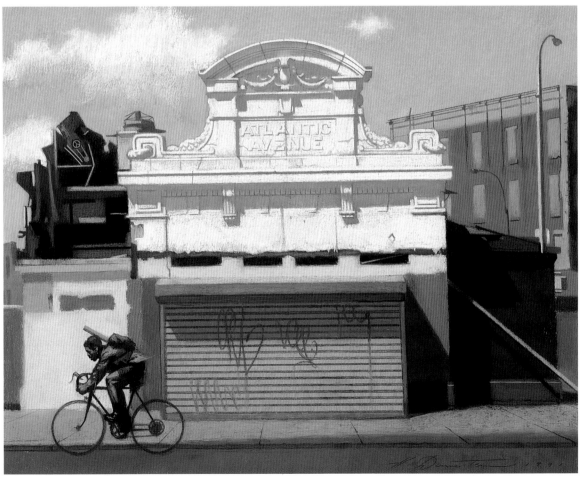

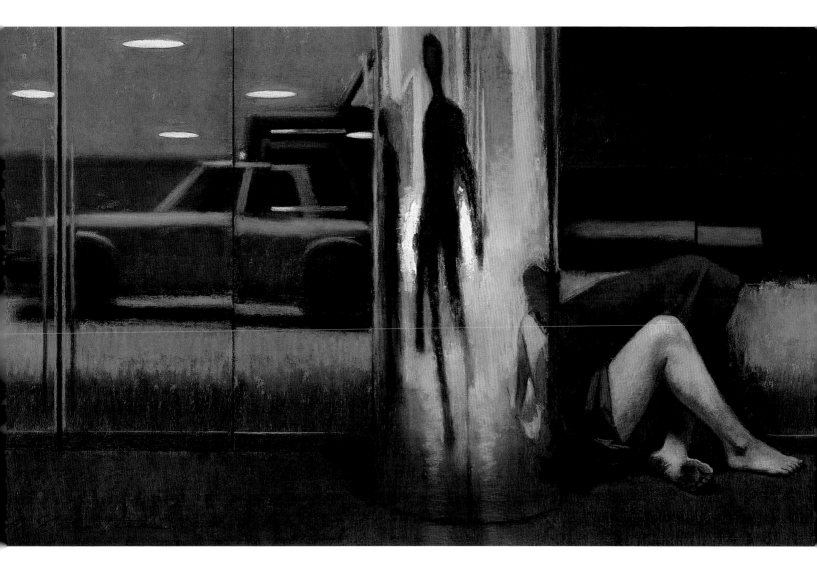

opposite page, top
Carpe Diem pastel on board, 20½" x 23½", 1984
I started to lay in this pastel of abandoned buildings on
Fulton Street, Brooklyn, on a gray afternoon. When the
clouds parted and the sun came through, the light and
shadow patterns dramatically altered the image. The cen-
ter building had been a theater, but I had no idea of the
previous life of the building at the left. The inscription
on its facade was still intact: "Carpe Diem Fugit Hora."

opposite page, bottom
Morning Light, Brooklyn pastel on board,
17½" x 22⅜", 1991

above
Homeless pastel on board, 17" x 28 ½", 1986
I occasionally pass the facade of a hotel on E. 42nd St.
in Manhattan, surrounded by a series of chrome-plated
columns that seem to serve no architectural function
outside of reflecting bizarre images of traffic on the
street, like the crazy mirrors one encounters at Coney
Island. The distorted images and fractured sense of
reality suggested a painting of the homeless that would
convey some aspect of the erosion of human values
that I perceive in the city. Distorted reflections in the
chrome-plated column include a businessman with an
attaché case . . . perhaps homeless also, in spirit.

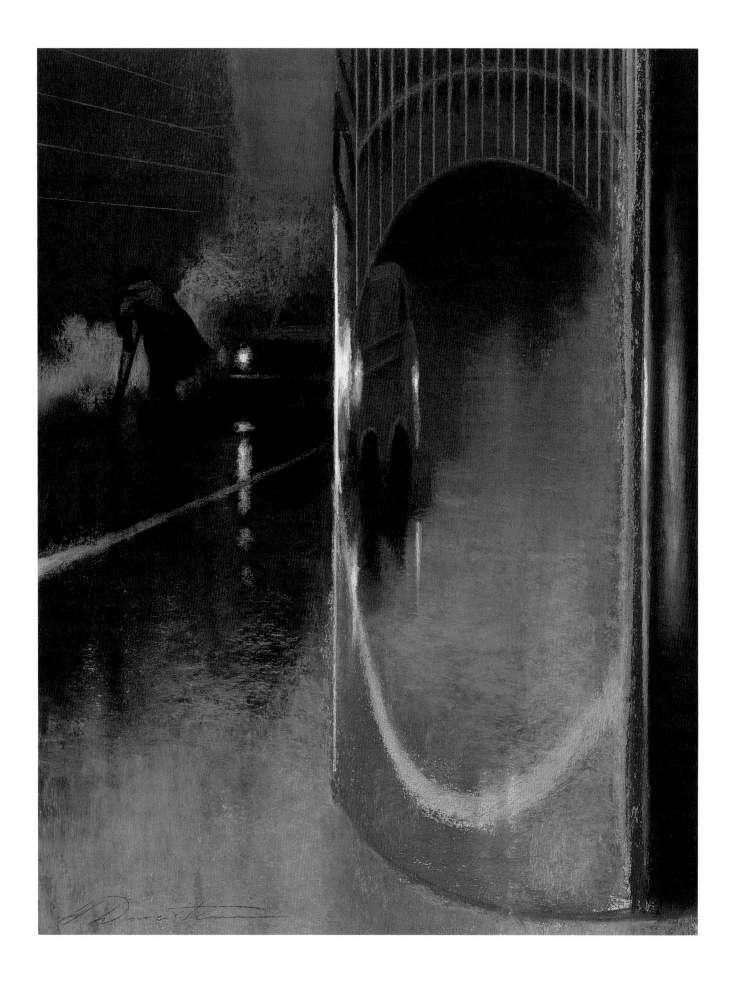

opposite page
Past Midnight pastel on board, 23½" x 18¼", 1989

right
Rainy Evening, Broadway pastel on board,
38" x 11¼", 1998

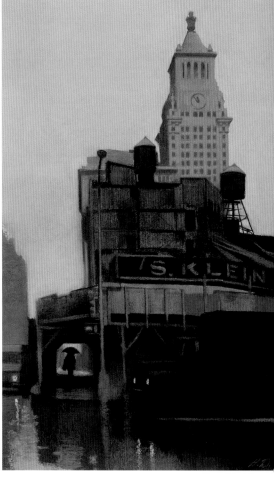

above, left
Demolition, Union Square pastel on board,
17½" x 20¼", 1984

above, right
Rainy Evening, Union Square pastel on board,
20" x 13", 1986

opposite page
Underground, W. 57th Street oil on canvas,
71" x 26", 1989

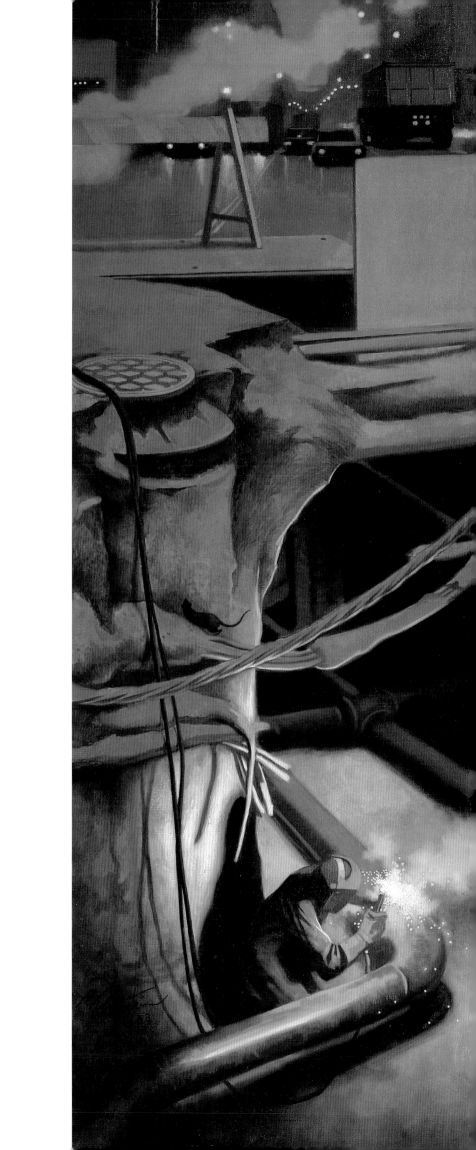

Triumph of Time oil on canvas, 59" x 67", 1991
A view of the Guggenheim Museum on 5th Avenue
in Manhattan: the concrete facade of this Frank Lloyd
Wright building seems to be in continuous need of
repair. As I noted the construction crew working over
the building, in the last decade of the 20th century,
it sparked an image in my mind of the passage of
time . . . and the ephemeral quality of so much con-
temporary culture.

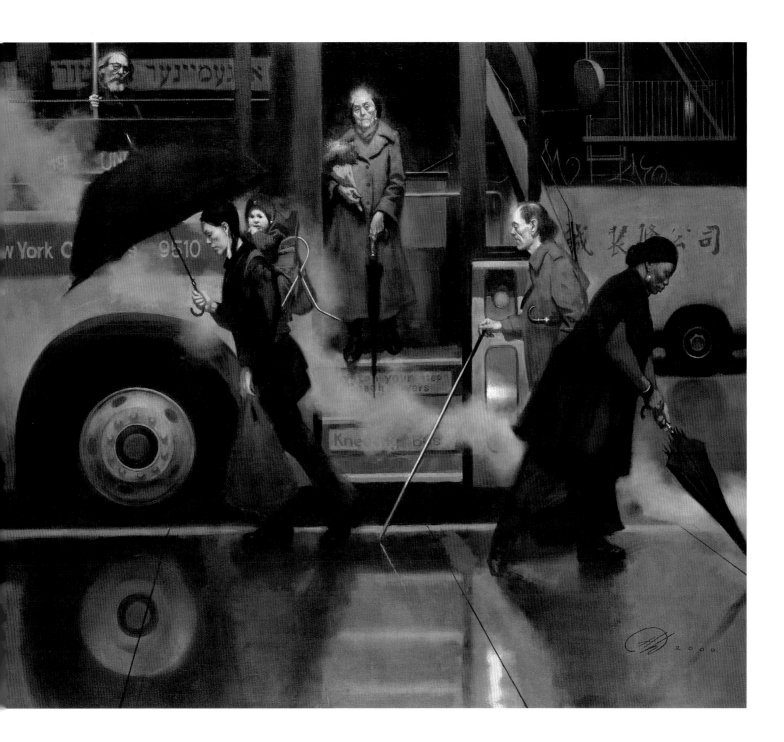

Rainy Evening, Lower East Side oil on canvas,
35" x 41", 2001
The initial response to the subject of this painting occurred
from the interior of a restaurant, where I noted the differ-
ent levels of the bus and street traffic that suggested
possibilities of staging a composition that would include
the variety of people one could encounter in the city. As
the image evolved, I established the location as the Lower
East Side of Manhattan, on a rainy evening, with reflec-
tions in the wet pavement and a fluid sense of movement
that would unify the figurative composition.

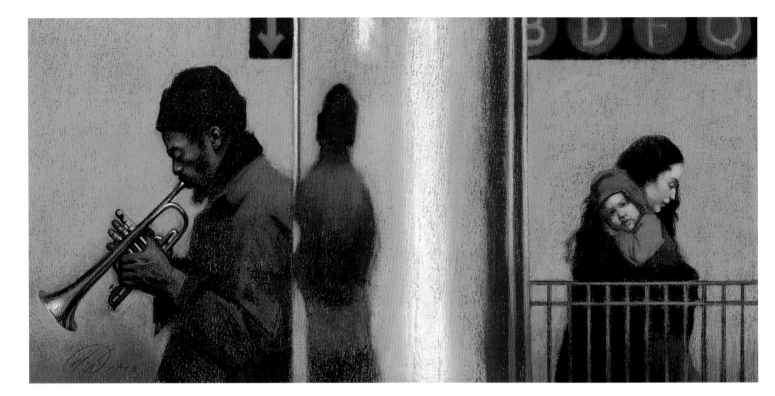

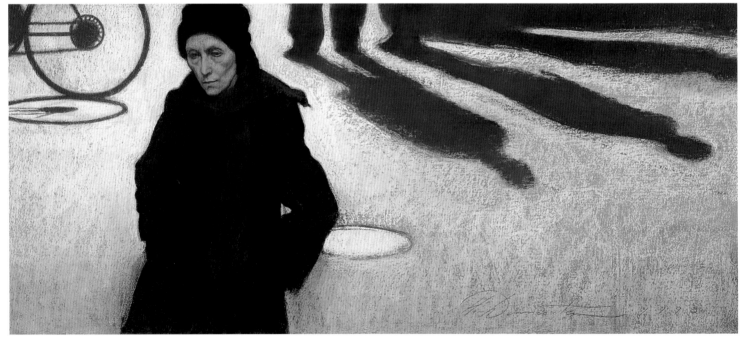

above, top
Underground Musician pastel on board,
27" x 55¾", 1998

above, bottom
Winter Light, W. 57th Street pastel on board,
24¾" x 56¼", 1998

opposite page
Crossing Broadway oil on canvas, 66" x 44", 2004

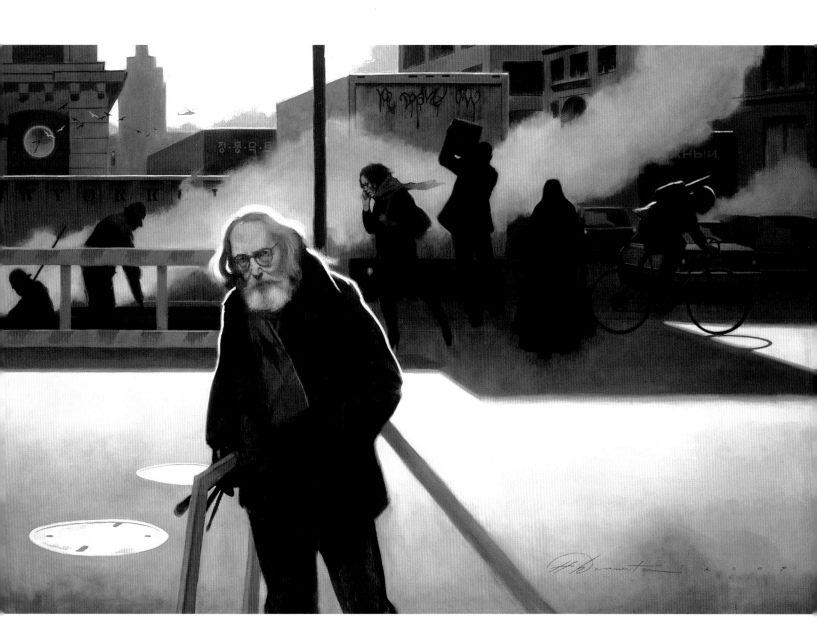

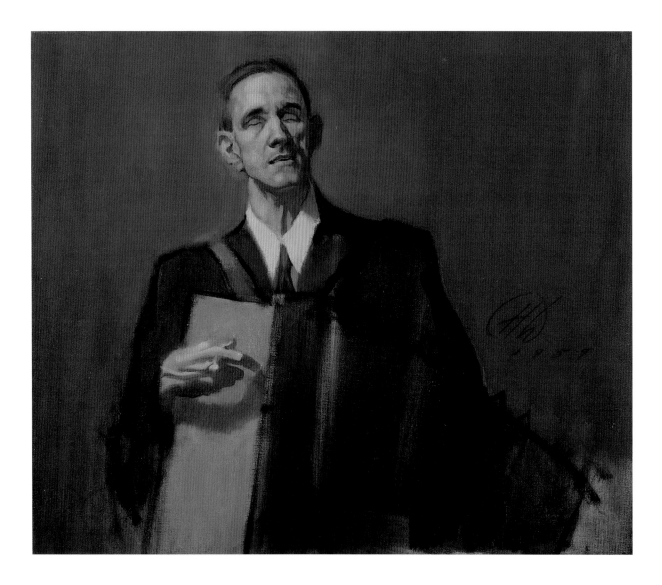

Blind Musician oil on canvas, 19½" x 23", 1959

Here is a selection of various musicians I have encoun-
tered in the streets of the city. Some I have sketched
on location, others posed in my studio. I met the blind
musician on 72nd Street near Broadway in Manhattan,
Guy Fielder on 57th Street outside of Carnegie Hall,
and Ricardo, playing with his group, Antara del Barrio,
on 7th Avenue in Brooklyn.

above
Guy Fielder pastel on board, 21" x 17¾", 1984

right
Ricardo, Antara del Barrio charcoal and pastel on board, 32" x 27", 1991

far right
Tenor Sax graphite on paper, 10½" x 14", 1984

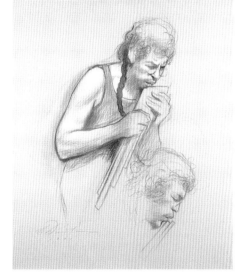

above
Studio photograph, Working on *The Scenic Artist*
Photograph by Tony Mysak, 1985

opposite page
The Scenic Artist (Arnold Abramson)
pastel on board, 74" x 40", 1985

This is an ongoing series of life-size portraits that I have
been working on for the past three decades. The scale
lends a presence to the image that I find exciting. I like
to exhibit the paintings so that they are not elevated, but
low down almost to the floor, so the viewer can connect
directly with the image. Along with the visual impact,
there is a comprehensive quality to the figure portrayed
head to foot. I usually start with a quick sketch in graph-
ite or charcoal to establish my response to the subject
and proceed to a small color study, usually in pastel. All
of the paintings—usually in oil, sometimes in pastel—
are constructed sight size (one exception is the recent
self-portrait *79th Winter*, which was painted from
a mirror).

 The painting I am working on, this time in pastel,
is set up so that the panel is placed exactly parallel to
the paint carrier and buckets on the frontal plane of the
painting. Then I walk back a distance where I can see
the entire subject and pastel panel next to each other.
All my sightings and visual decisions are made from this
vantage point, so that when I move up to work on the
painting, I am setting down what I remember from the
distant view. Then I return to check it out from the dis-
tant station point. At some point in the development of
the painting, when I wish to work out details in the head,
I move in closer, pull the easel back three feet (maintain-
ing the same trajectory), and work from that position.

 Then I move the painting back, alongside the sub-
ject, and check the progress of the work from a distance.
Though it may seem that all this moving back and forth
would be tedious, I find that it really expedites the work
and reinforces the construction of bold forms that carry
from a distance. I would also emphasize that when I
approach the subject for the initial small sketch, I start
with an intuitive response, guessing at proportions. This
response is most important to me. Then I proceed to
measure and check proportions carefully. Both elements,
subjective and objective, are essential ingredients from
my point of view in the creative process.

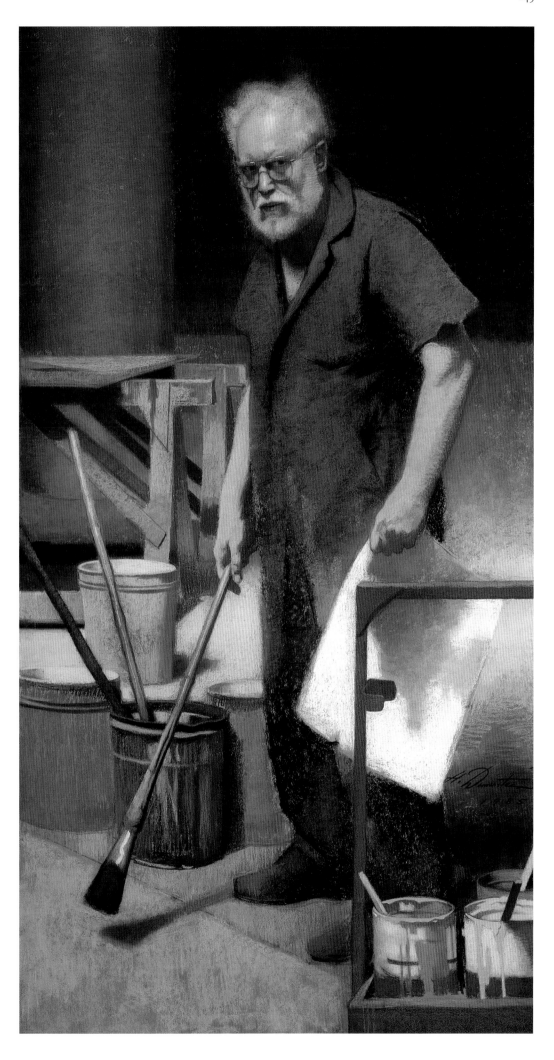

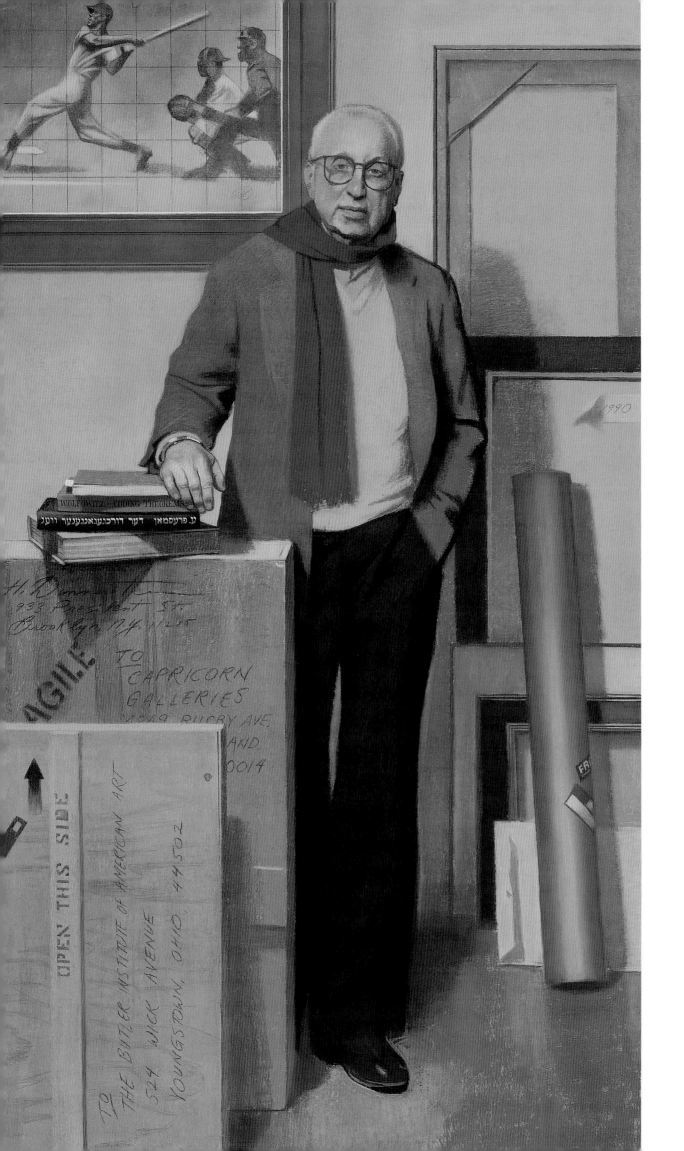

WOLFOWITZ CODING THEOREMS

ע. פרעסמאן דער דורכגאנגענער וועג

TO
CAPRICORN
GALLERIES
10049 RUGBY AVE.
.....AND.
....0014

H. Dinne Kunn
933 President St.
Brooklyn N.Y. 11215

FRAGILE

OPEN THIS SIDE

TO THE BUTLER INSTITUTE OF AMERICAN ART
524 WICK AVENUE
YOUNGSTOWN, OHIO, 44502

1990

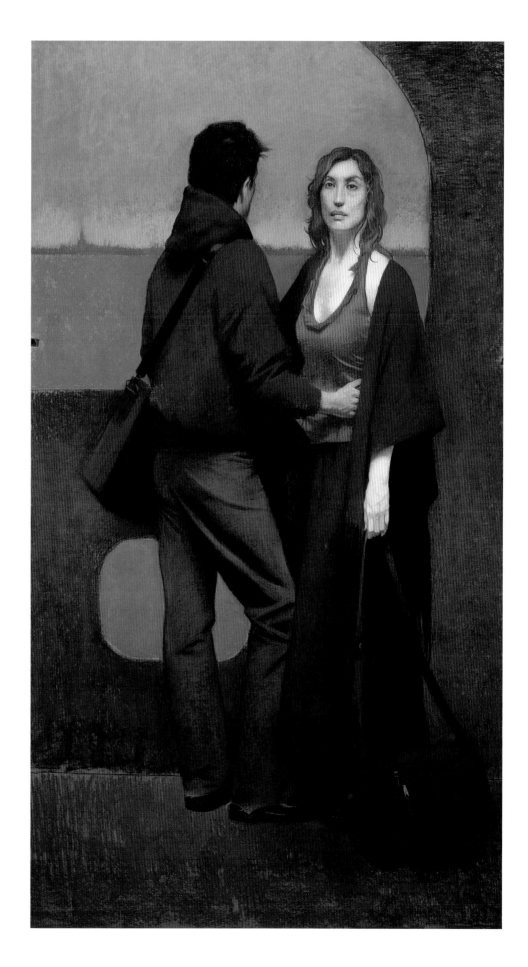

opposite page
The Collector (Philip Desind) pastel on canvas,
70" x 40", 1990

right
Leticia and Esteban pastel on board,
83" x 47", 2007

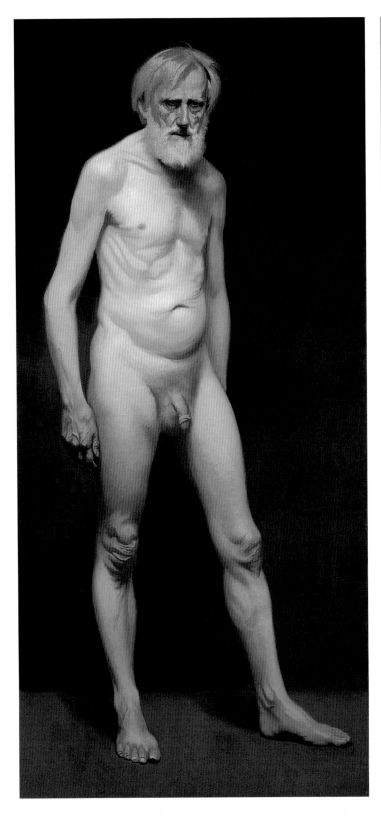

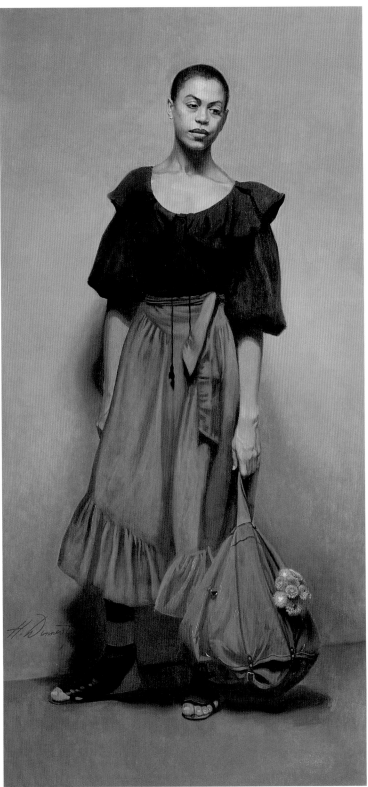

above, left
Earthbound (William Preston) oil on canvas, 68¼" x 32¼", 1985

above, right
Maggy Buissereth oil on canvas, 74" x 36", 1985

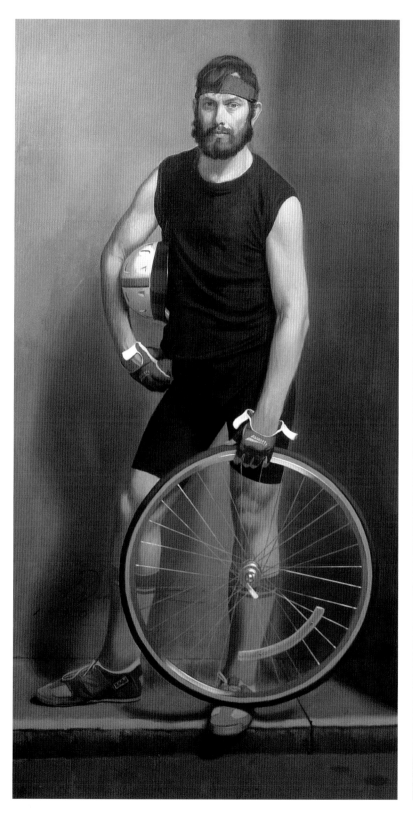

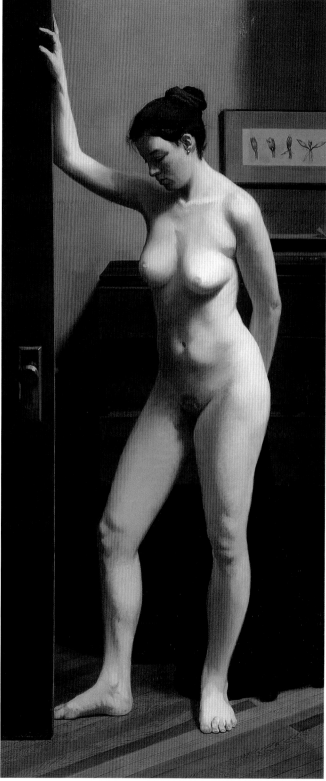

above, left
The Cyclist (Bill Straughn) oil on canvas, 79" x 42", 1991

above, right
Mikele oil on canvas, 74" x 32¼", 1993

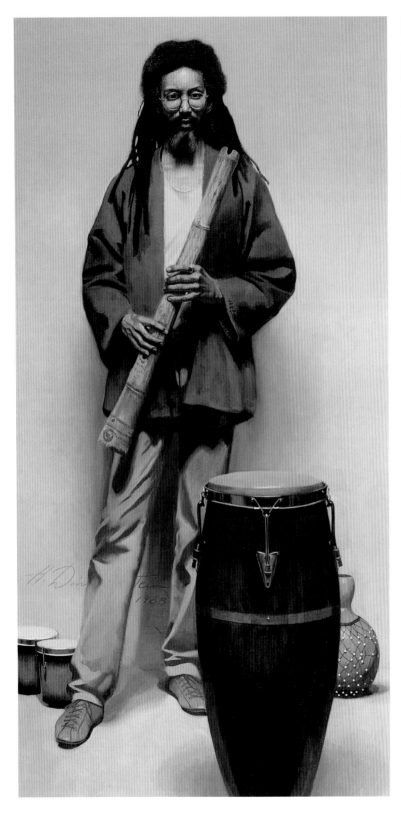 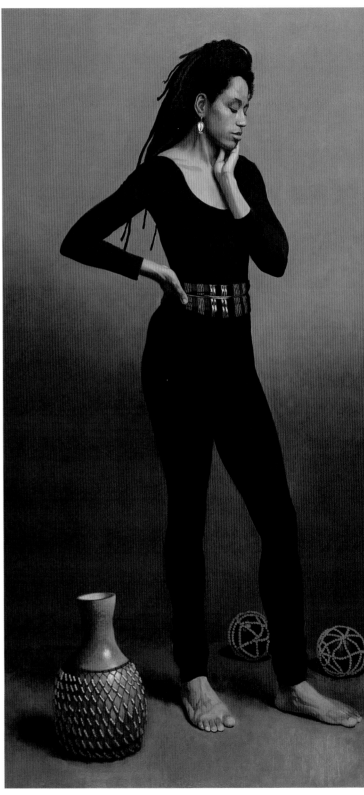

above, left
Bamboo Flute (Ralph McAden) oil on canvas,
76" x 37¾", 1988

above, right
The Dancer (Asma Feyyinmi) oil on canvas,
78½" x 40", 1991

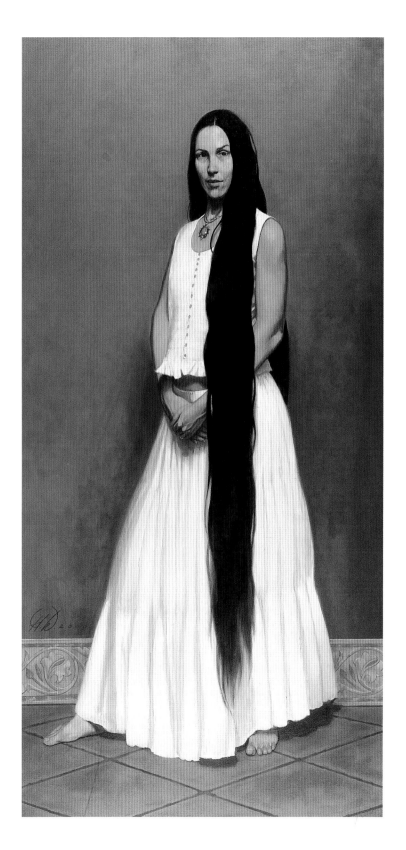

Roseangela oil on canvas, 76" x 38", 2000

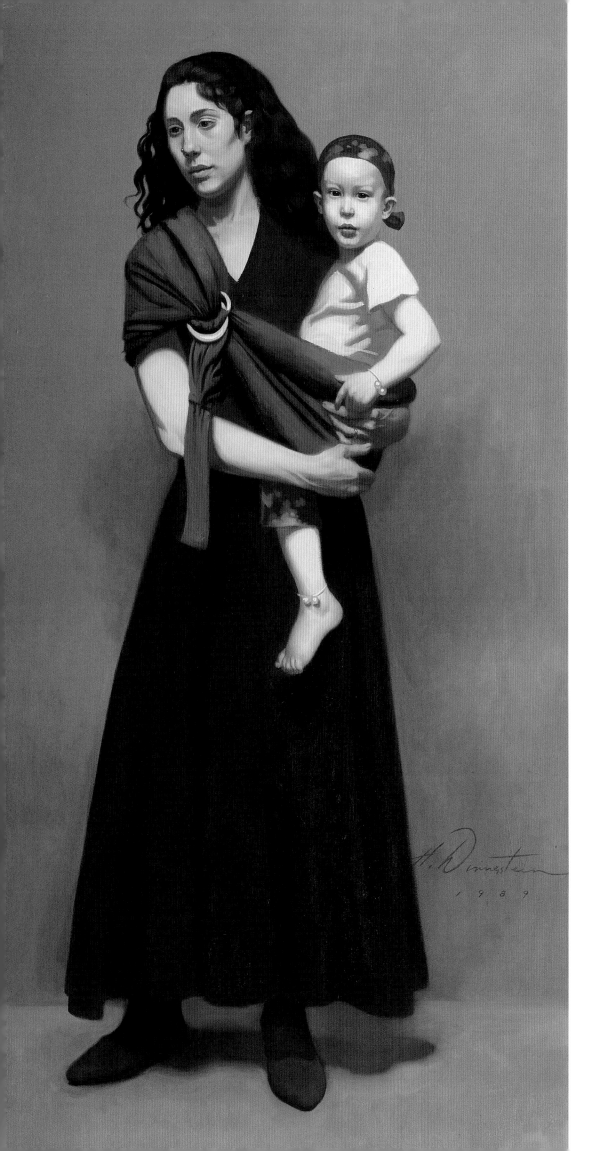

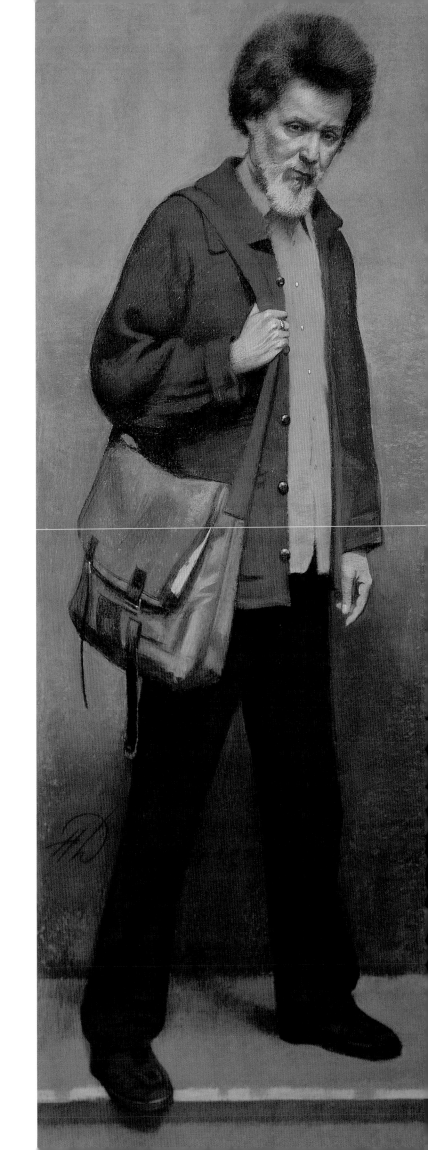

opposite page
Jorrun and Theo oil on canvas, 64" x 32", 1989

right
Ralph McAden pastel on board, 71³/8" x 25", 2006

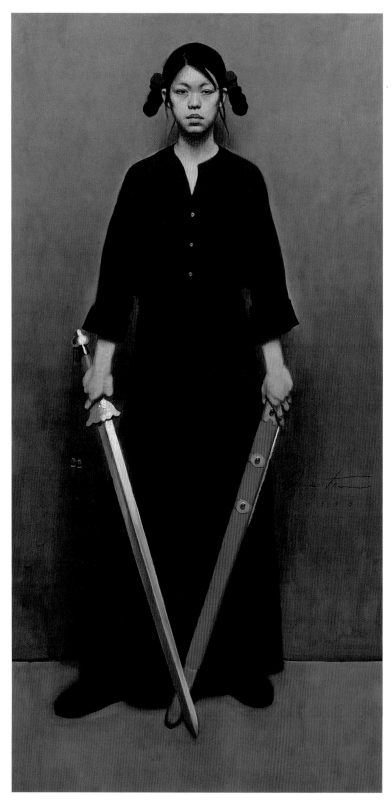
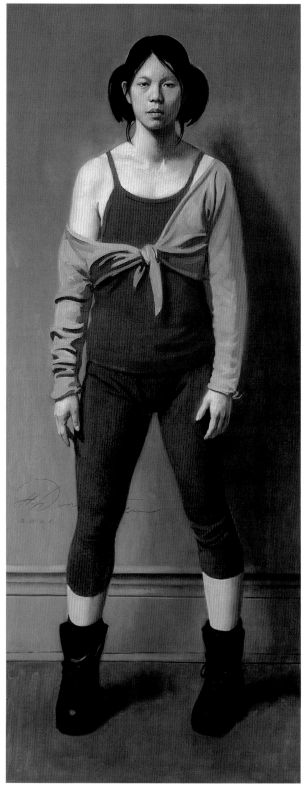

above, left
Mei Ciao (A) oil on canvas, 68" x 34", 1998

above, right
Mei Ciao (B) oil on canvas, 68" x 27", 2001

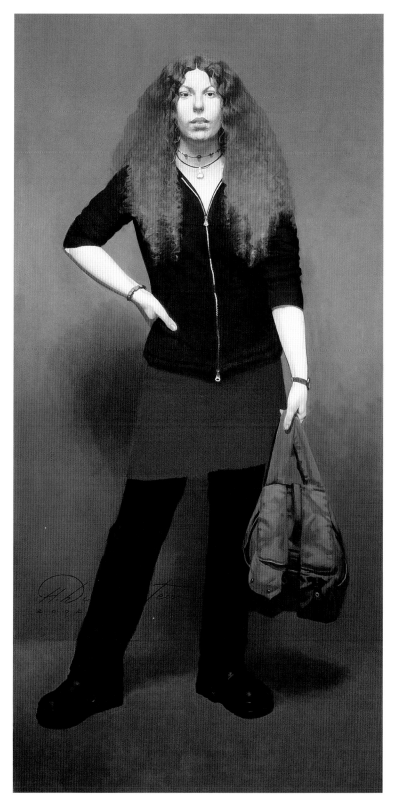

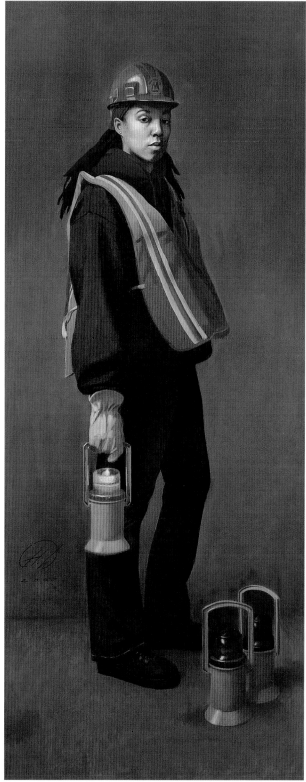

above, left
Tanya Pann oil on canvas, 74¼" x 36¼", 2002

above, right
Night Shift oil on canvas, 81" x 33", 2005

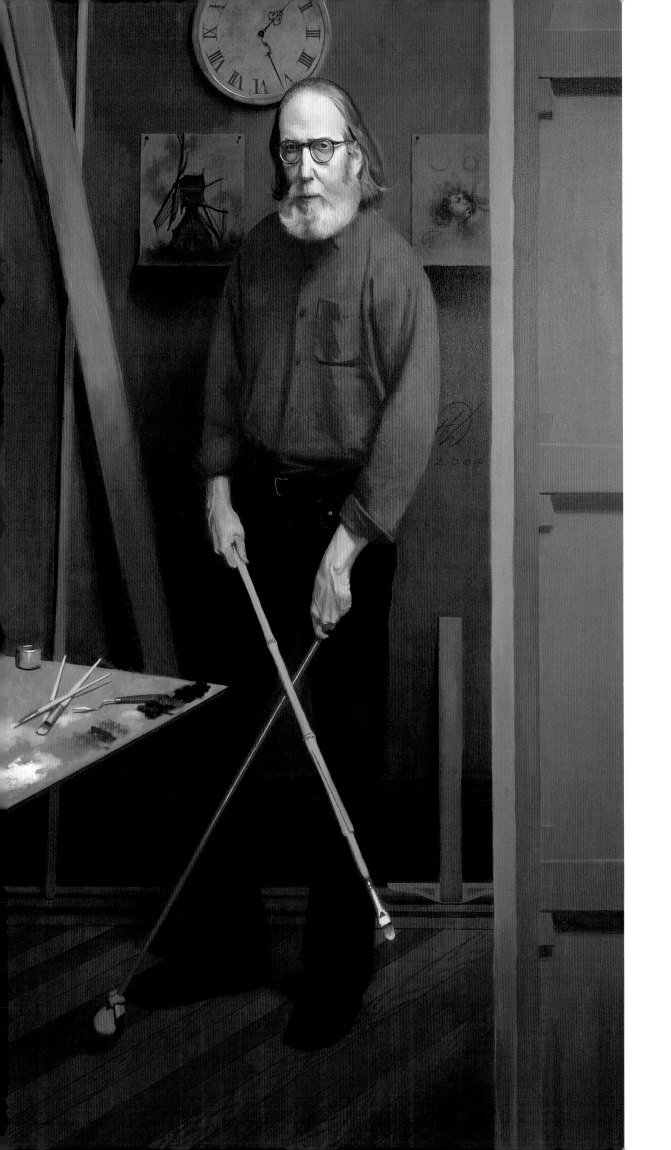

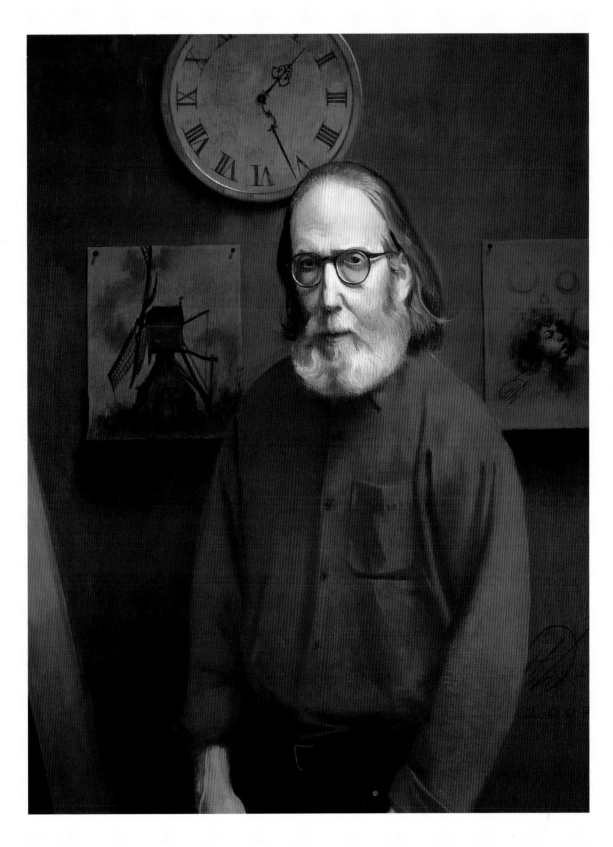

opposite page
79th Winter oil on canvas, 80" x 45", 2007

above
Detail of 79th Winter

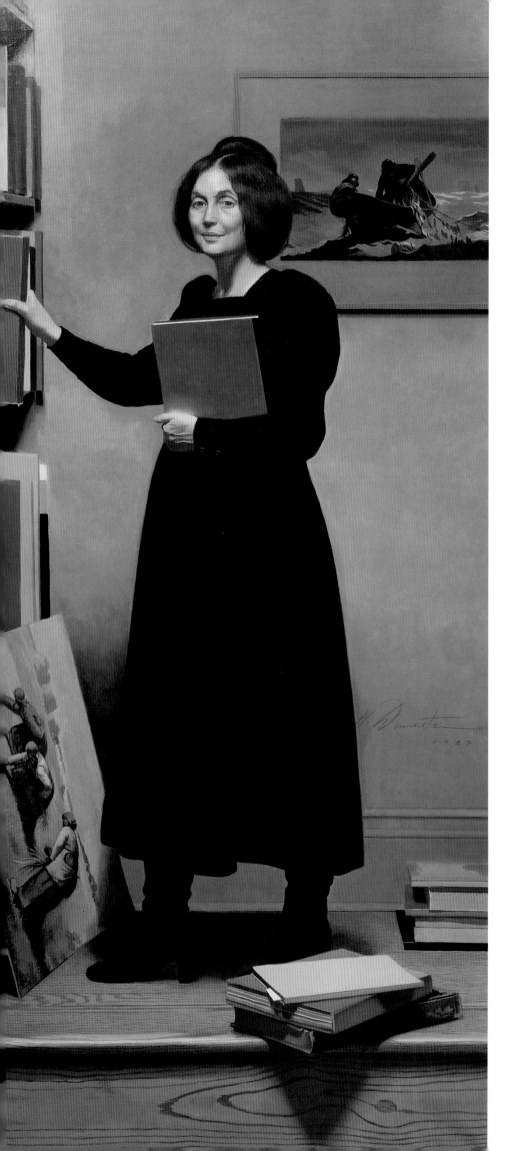

left (detail) and opposite page
The Art Historian (Lois Dinnerstein) oil on canvas,
83¼" x 36¾", 1987
This painting was designed so that it fits within a wood-
door-frame construction, with an actual wood step at the
base, to enhance the trompe l'oeil effect of the books
on the edge of the painted step within the painting. The
concept of illusion and reality was inspired by Charles
Willson Peale's door-framed portrait of his two sons,
Raphaelle and Titian. As an aside, I included reproduc-
tions of work by Millet and Homer to convey my affinity
with a classical tradition that encompasses simple, mon-
umental forms with an awareness of contemporary life.

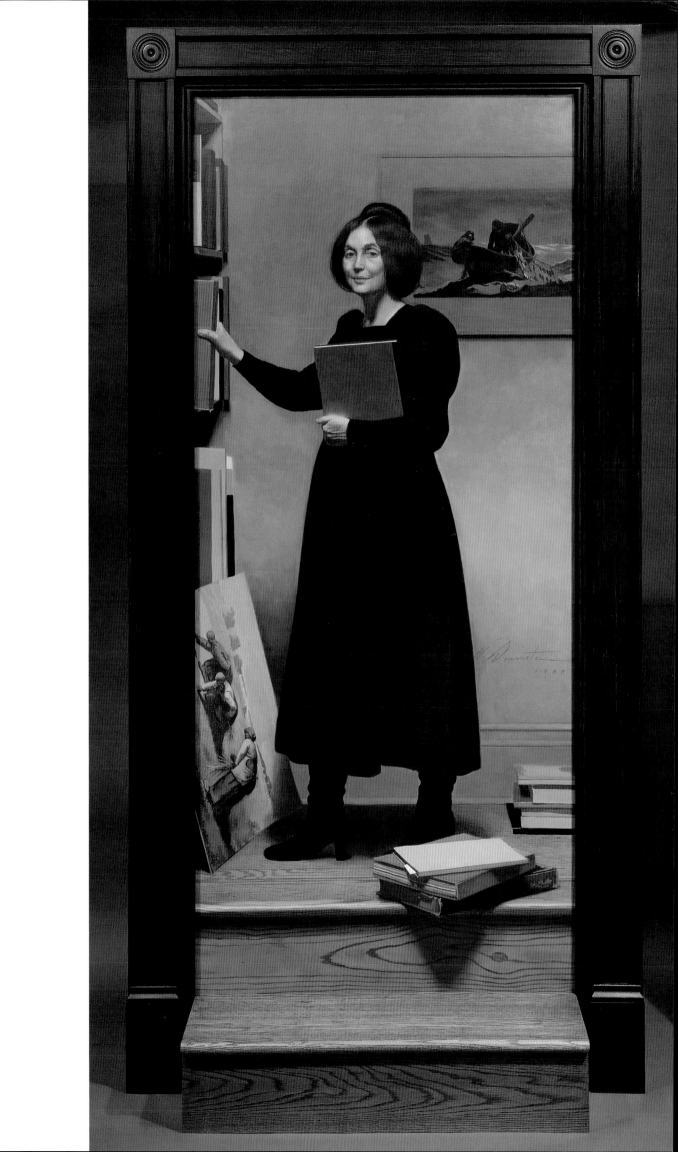

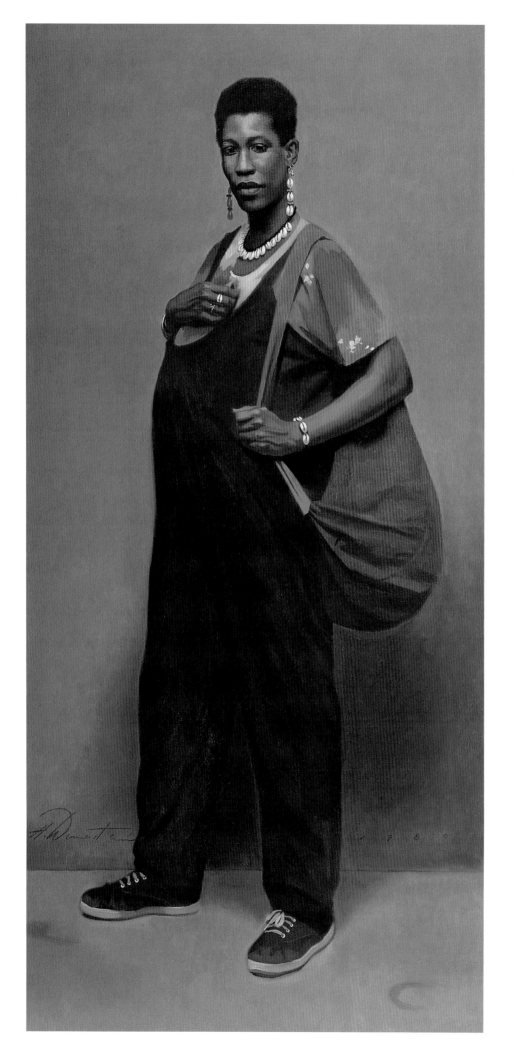

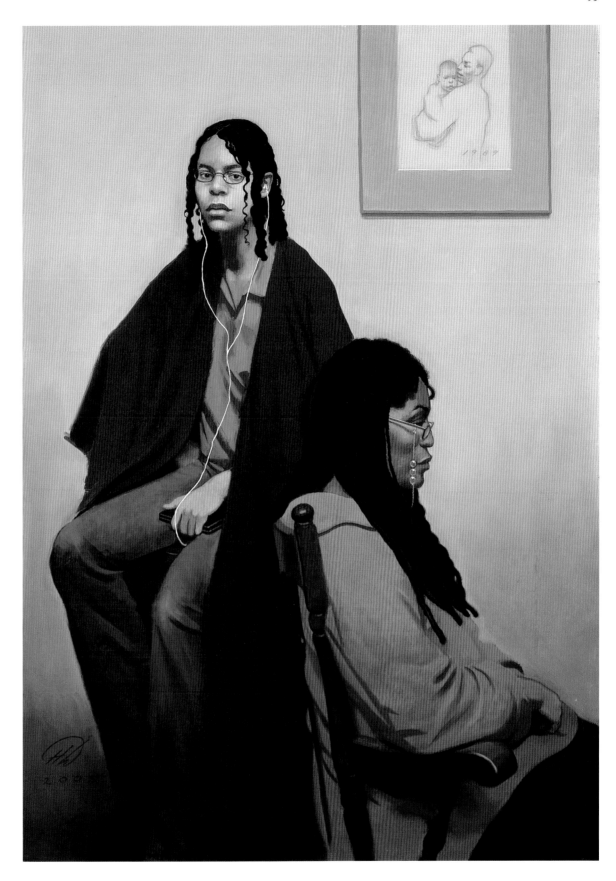

above
Phyllis and Zuri oil on wood, 29½" x 21", 2006

opposite page
Phyllis and Zuri oil on canvas, 65" x 32", 1989

I had painted Phyllis pregnant with Zuri in 1989,
and it was fascinating to engage the subjects again,
17 years later.

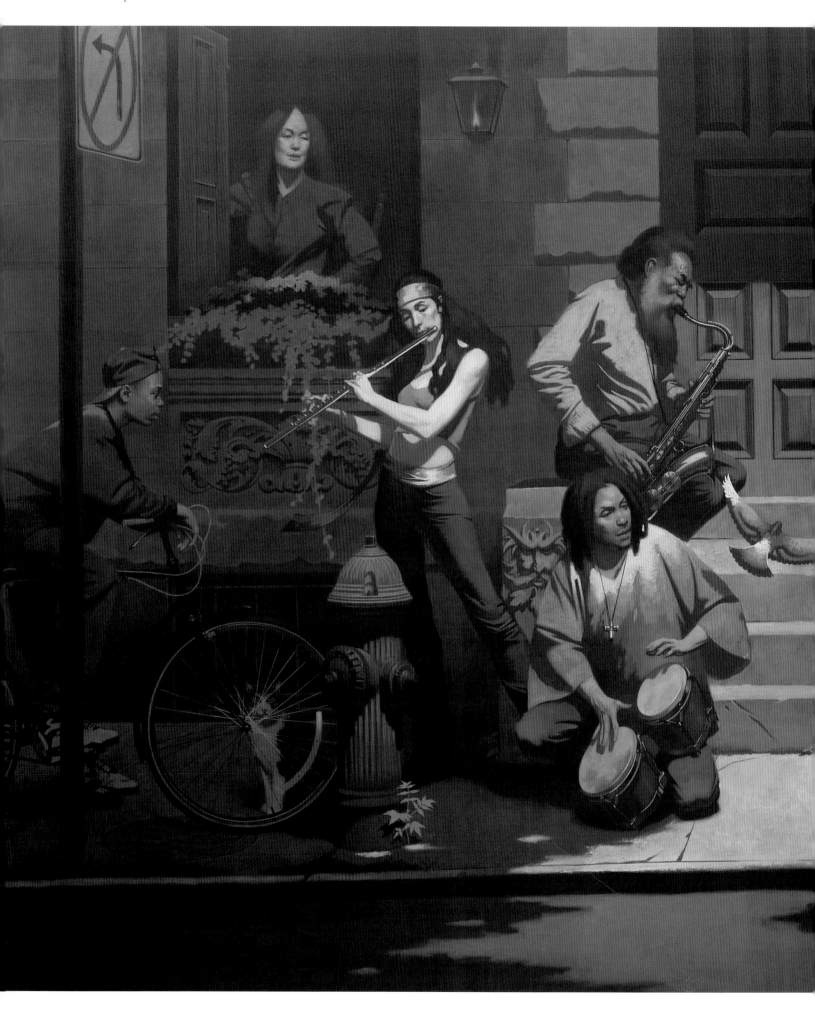

Past and Present oil on canvas, 96¼" x 172¼", 1994

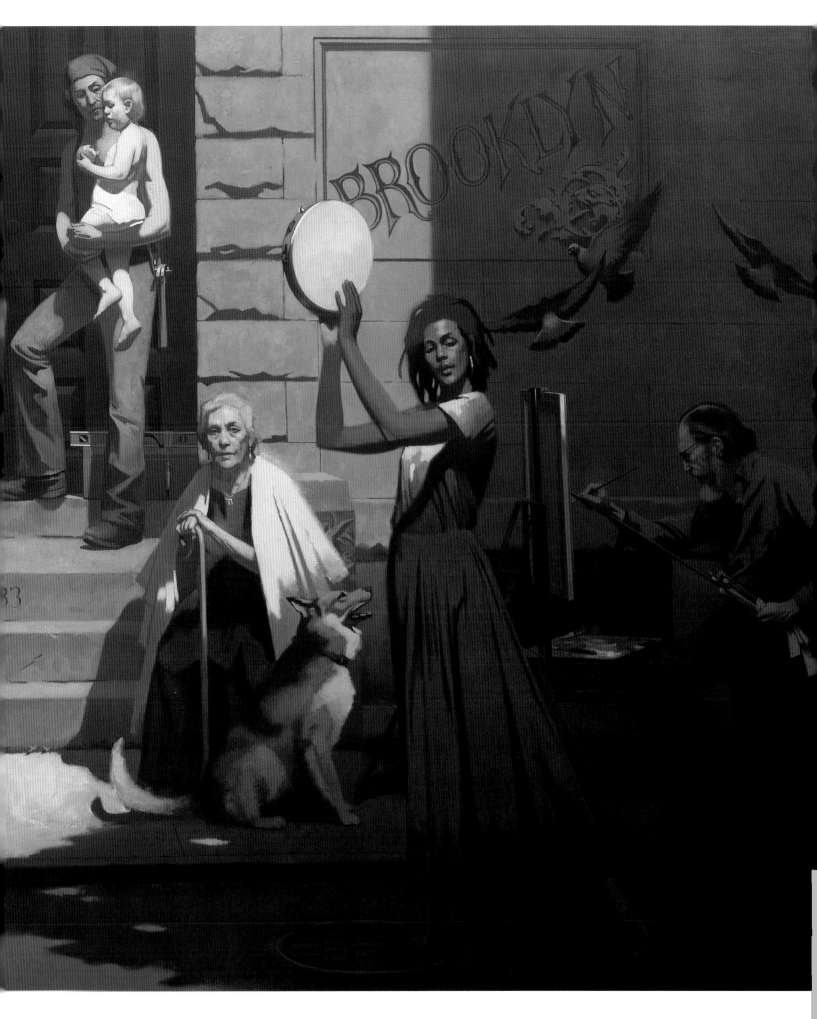

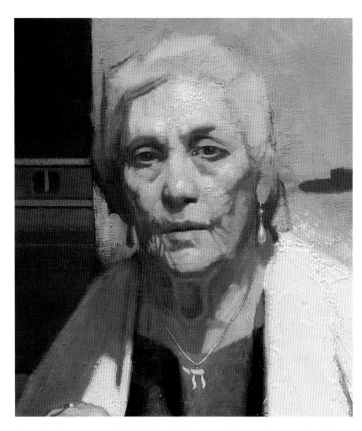

opposite page, clockwise from top left
Past and Present (Detail 1)

Past and Present (Detail 2)

Past and Present (Detail 3)

Past and Present (Detail 4)
The subject is a block party in Brooklyn, but I had in mind expanding the concept to include autobiographical elements, past and present. The old woman represents my mother, as I imagined she would have looked had she lived to an old age. The building is a composite of various buildings in my neighborhood, providing a stage for the composition.

The studio photograph on page 37 includes the initial compositional sketch for the painting, various drawings, pastel studies, and the grisaille underpainting on the canvas.

right
Underpainting of Past and Present (Detail)

When I began my art studies, the subway enabled me
to travel from a provincial neighborhood in Brooklyn to
art classes across the river on the island of Manhattan.
I studied anatomy, drawing, color, and composition in
art school, but I also learned a great deal observing and
sketching in the subway. The immediacy of a direct
response to the human subject on a moving train forces
one to develop powers of perception and memory. The
subway also revealed a view of the great diversity of life
in the city that shaped my artistic vision over the years.

Here are a selection of sketches and paintings that
reflect my fascination with the range of visual impres-
sions, multicolored, young and old, of various trades and
occupations, that seemed to be concentrated with greater
intensity underground. I enjoy the spontaneous response
to the subject on location, but I'm after other levels
of perception, and the paintings are finally resolved in
my studio, based on these direct visual impressions.
Sometimes, the final image is suggested by a related
sketch of another individual I had noted in the subway.
For example, *Linda and Alicia*, painted in my studio,
was suggested by a sketch I had done on the back of
an envelope of a Muslim mother and child in a related
position on the subway.

below
Subway Sketch (Muslim Woman and Child)
graphite on paper envelope, 12" x 9", 1991

opposite page
Linda and Alicia oil on canvas, 48¼" x 44", 1992

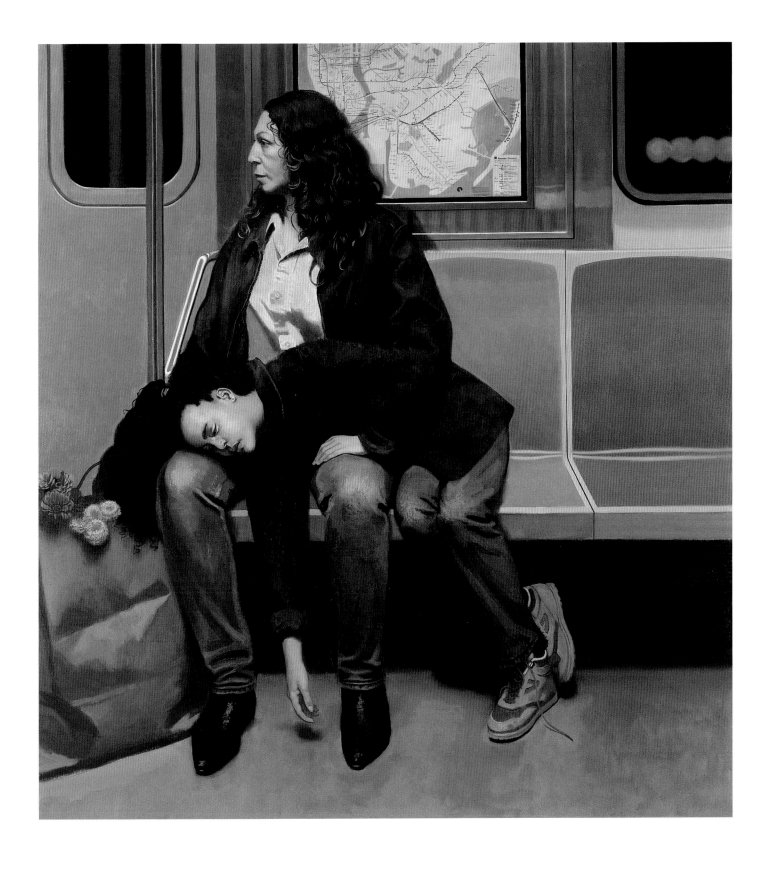

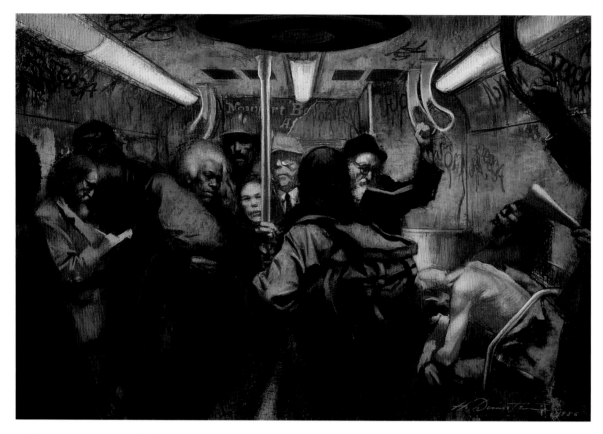

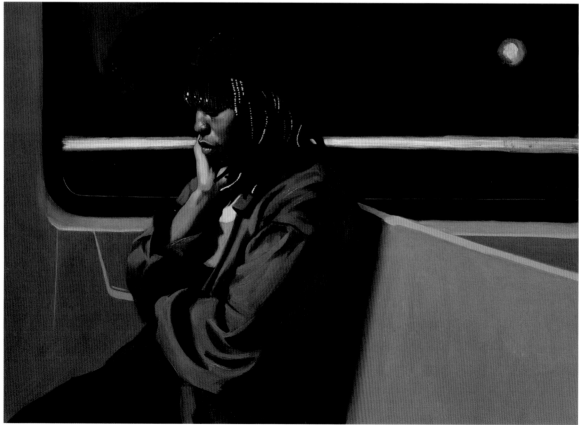

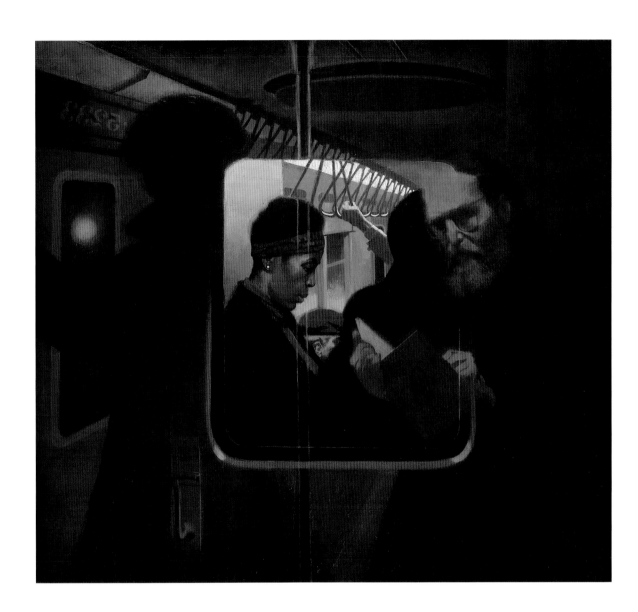

above
Underground Reflections oil on canvas,
39" x 42", 1995

opposite page, top
Underground pastel on board, 26" x 38½", 1986

opposite page, bottom
D Train to Coney Island oil on board,
20¾" x 28¾", 1988

above
The Exile oil on canvas, 32" x 32", 1995

opposite page
No. 7 to Flushing pastel on board, 23" x 16", 1999

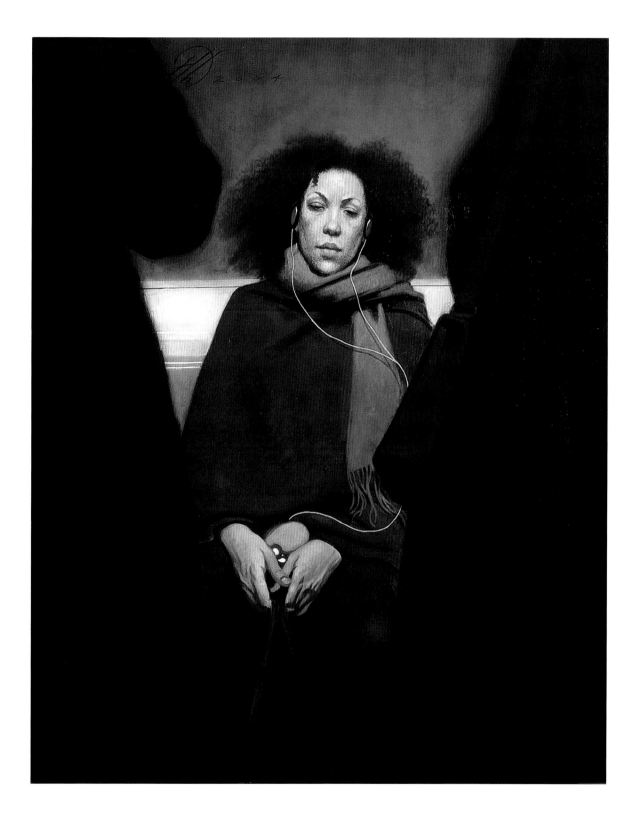

above
Tosca's Aria oil on canvas, 31½" x 24¾", 2004

opposite page
Flatbush Express oil on canvas, 54¾" x 29½", 2004

above
Broadway Local pastel on board, 24" x 31", 2006

opposite page
Subway Musician oil on canvas, 32" x 16", 2004

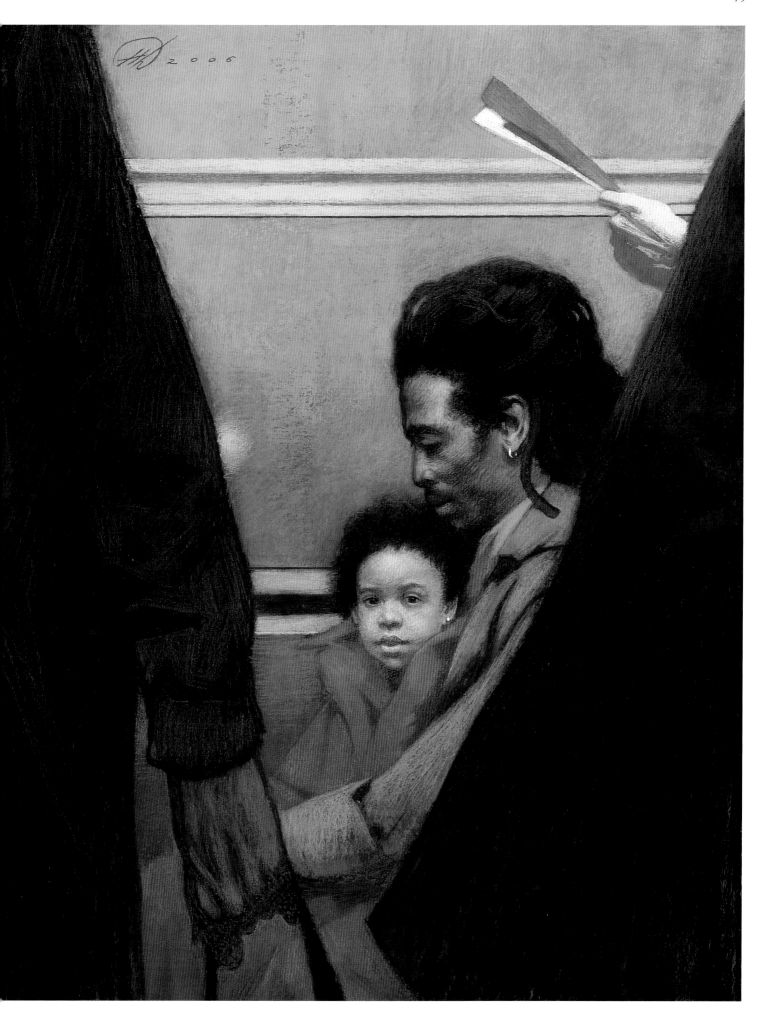

Rene and Oshun pastel on board, 29" x 24 ½", 2006

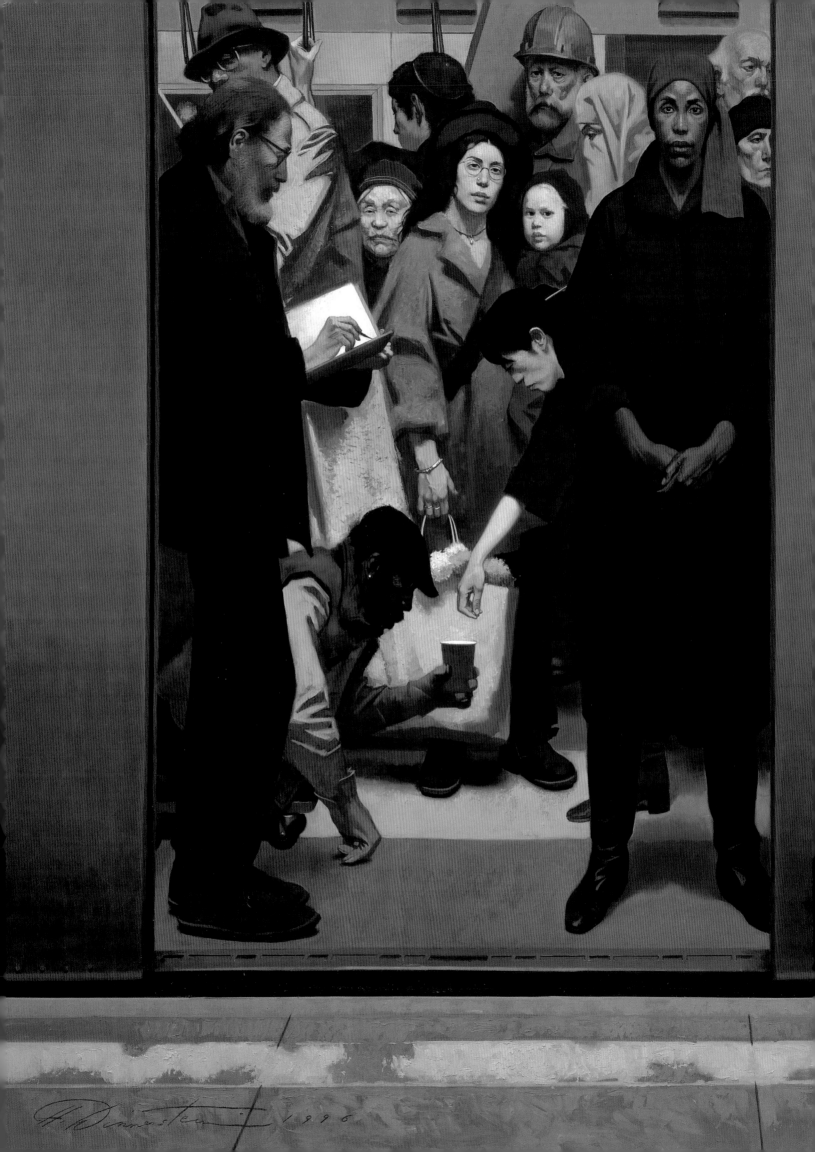

Underground, Together oil on canvas, 90" x 107¼", 1996

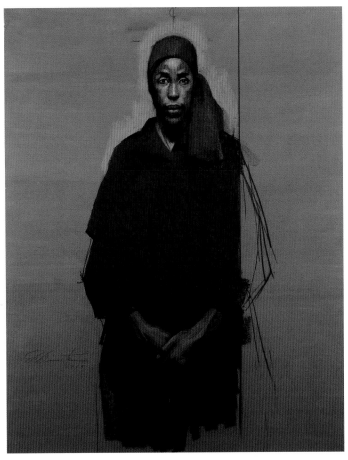
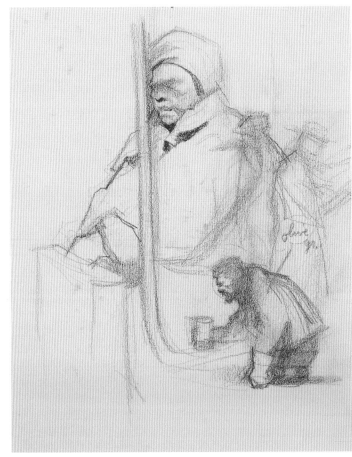

above, left
Elaine, Study for *Underground, Together*
pastel on board, 48" x 38", 1996

above, right
Subway Sketch graphite on paper, 9¼" x 7½", 1995

When I initially contemplated this painting, I was unsure
about the size of the canvas, considering the expense of
materials and models for such a complex, non-commissioned
undertaking. But on a trip to Paris, viewing Courbet's large
canvas of *The Burial at Ornans*, and *The Studio of the Painter*,
something clicked in my head, and confirmed my intuitive
feeling about the life-size scale of the painting I was plan-
ning in my studio in Brooklyn. It suggested the possibility
of an image that would go beyond incidental narrative
description to another level of perception, with implications
of a journey that we all share. At one point I even thought
of including the inscription, "Who Are We? Where Do We
Come From? Where Are We Going?," like the inscription
in Gaugain's canvas painted at the end of the nineteenth
century. But then I had an amusing conversation with my
son Michael, who had been a classics major as an under-
graduate student. When I described the inscription I was
considering, he responded with the Latin phrase, *Res ipsa
loquitur*, and translated for me, "The thing speaks for itself."
And that settled the matter.

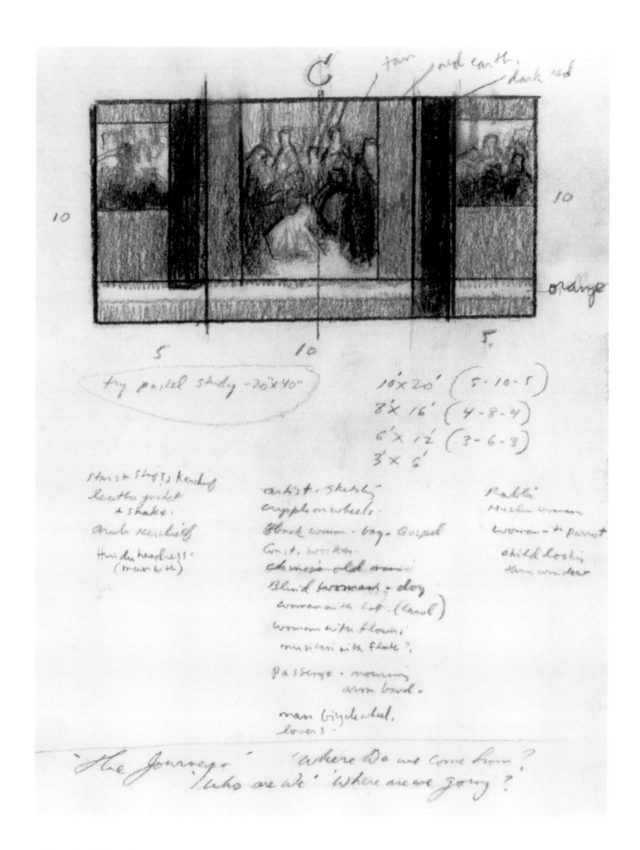

Subway Sketch (2) graphite on paper, 9¼" x 7½", 1995

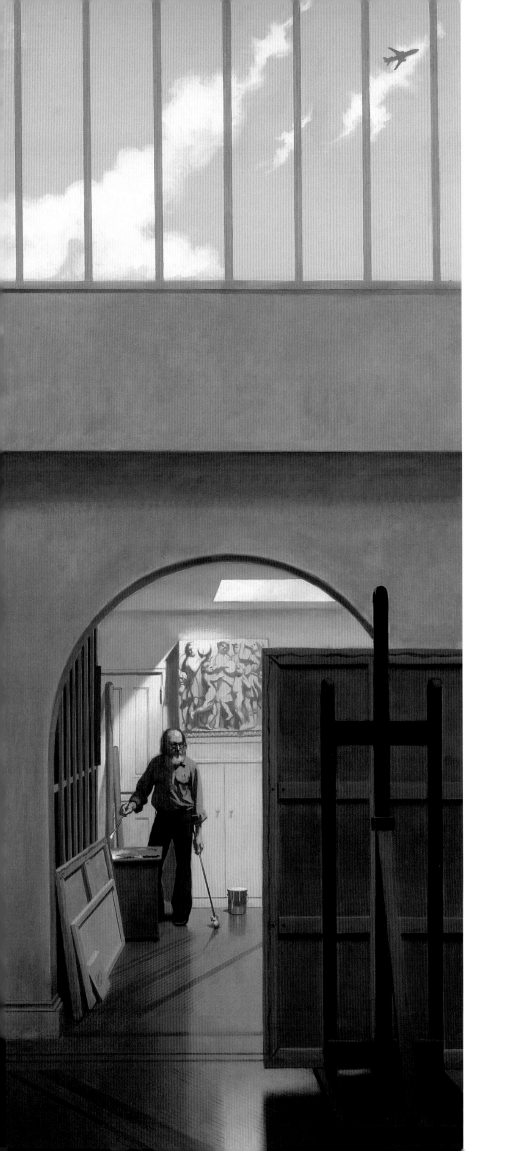

above
Self-Portrait with Plumb Line (Daedalus)
pastel on board, 21¼" x 18¼", 1999

opposite page
Flight Over Brooklyn oil on canvas, 76" x 32", 1997

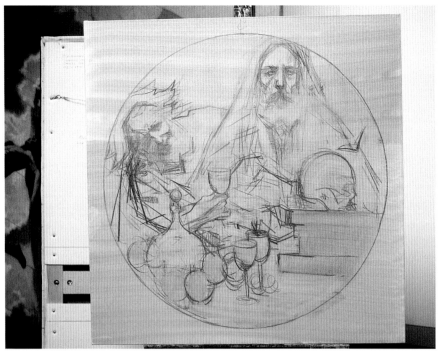

left, top
Joy and Abstinence charcoal lay in on canvas,
36" x 36", 1995

left, bottom
Joy and Abstinence oil underpainting on canvas,
36" x 36", 1995

opposite page
Joy and Abstinence oil on canvas, 36" x 36", 1995
This painting evolved from a literary source. The short
story "Repentence," by I.J. Singer, describes the encoun-
ter between a Chassidic rabbi who celebrates his faith
with food and wine, and another rabbi, his exact oppo-
site, who denies himself the pleasures of this life. When
the painting was exhibited, someone responded to the
image by referring to another narrative—Dionysus and
Apollo in Greek mythology. I really did not anticipate
this reaction, but perhaps the painting evokes the sensi-
bility of many cultures that acknowledge paradoxical
elements inherent in all of us.

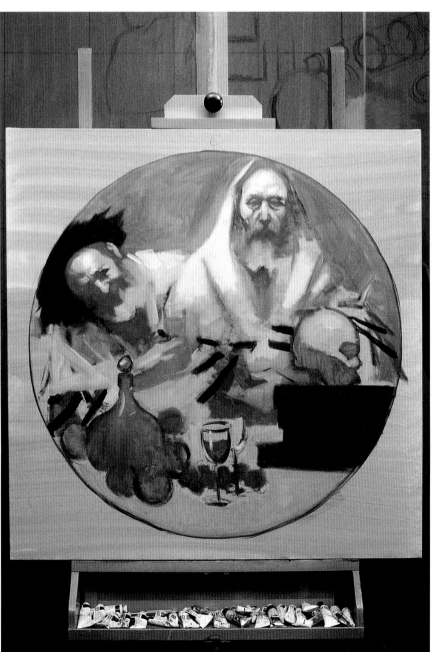

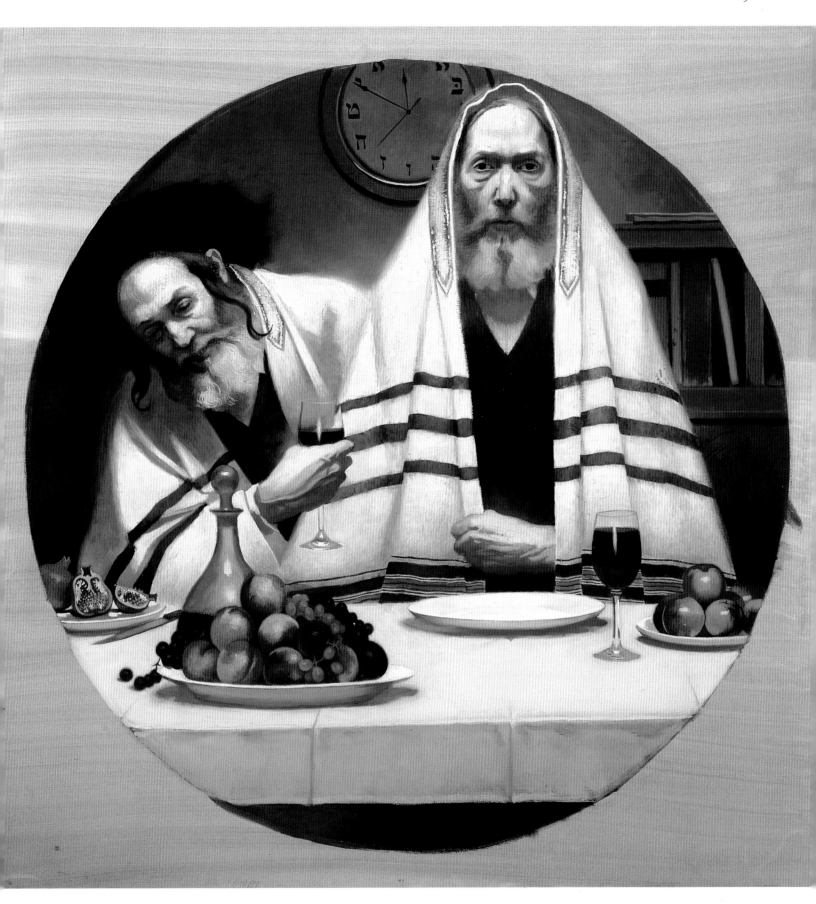

right, top
The Veteran pastel on board, 23⅝" x 18⅝", 1990

right, bottom
Facing the Other pastel on canvas, 56¼" x 60", 1991
The pastel of *The Veteran* was done directly from the
subject, and somehow my thoughts associated it with
the Minotaur legend. I got to thinking about an image
that would bring a contemporary sensibility to the Greek
myth. I imagined an everyman in a kind of labyrinth,
struggling with a mirror image of himself, part human,
part bestial. The scale of the figures is larger than life-
size, to enhance the impact on the viewer.

opposite page
Diana and Actaeon pastel on canvas, 72" x 55", 1990
Reading Ovid's *Metamorphoses*, which includes the
narrative of Actaeon's encounter with Diana, I noted
that the first English translation of the text by George
Sandys was completed in the colony of Virginia in 1626.
The translator refers to an effort that was "Bred in the
New World, of the rudeness whereof it cannot but parti-
cipate; especially having Warres and Timultes to bring
it to light instead of the Muses."

In undertaking this painting, there was some trep-
idation, considering countless images of the subject by
so many artists since the Renaissance. Nevertheless, I
believe the myth reverberates in our time, and I sought
to engage the subject in contemporary visual terms.

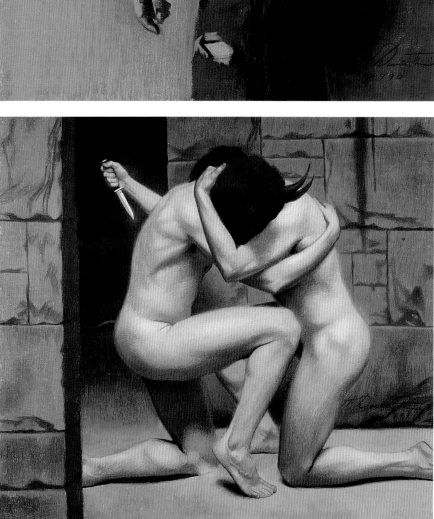

Sundown, The Crossing oil on canvas, 74" x 84", 1999
In the late 1950s, I painted various small studies around
New York harbor, which included a painting of an aban-
doned ferry docked in Staten Island. Four decades later, as
I was reading Walt Whitman's "Crossing Brooklyn Ferry,"
the image of the old ferry reverberated in my imagination
and evoked images related to my perception of the city
today as a vibrant spirit that encompasses past, present,
and future. The poem has a transcendent quality that lifts
my spirit on the bleakest day, and I actually copied the
entire text into a sketchbook that I carry with me when
I draw. At about the same time, I came across a black-
and-white photograph at the Brooklyn Public Library of
a ferry crossing to Ellis Island. A crowd of passengers
on deck suggested interesting staging possibilities for
a figurative composition. The image would not be an
illustration of Whitman's poem but a reflection of my
experience, hopefully related in spirit to the poem. I envi-
sioned a painting that responded with "loving and thirsty
eyes" to the "eternal float of solution" that Whitman
describes, on a scale large enough to accommodate all
the complex elements I was considering.

To develop the crowd of figures across the deck of
the boat, I went back over various paintings, pastels, and
drawings I had done over the years to select individuals
I could include in the painting. They were not arranged
chronologically but composed with an eye to variation
and repetition of shape and color. For example, the carni-
val figure elevated on stilts on the right side related to
the child on her father's shoulder on the left. At the left,
alongside figures taken from images of protest against
the war in Vietnam, which I had done between 1968 and
1970, is a young woman flutist derived from a painting
of a Brooklyn block party done in 1994. Also included is
Frank Fools Crow of Wounded Knee, South Dakota, from
a sketch I had done at the Cathedral of Saint John the
Divine in New York in 1973. In the midst of a group of
West Indian carnival revelers at the right, derived from
pastels I had done in Brooklyn in 1970, there is a
Peruvian musician with a pan flute, sketched also in
Brooklyn, in 1991, and reminiscent of a drawing I had
done of an African American man playing a related
instrument in the streets of Montgomery, Alabama, in
1956. Beside the carnival figure is a man with crutches,
taken from a sketch of a beggar in Paris, done in 1963.

When I needed to adjust the gestures of a figure,
like the Vietnam veteran in a wheelchair at left (that
I had initially painted in 1970), I had a model assume
the pose to depict the figure I was essentially painting
from memory. In some instances, like the family group
alongside, I had the subjects I had painted in the past
pose again for this painting.

I finally settled on a composition with 28 figures
and a monkey. In combining these diverse elements,
I tried to reach for unifying qualities of light, air, and
space, related to overall qualities of the image. (I like
the poet's line, "Every one disintegrated, yet part of
the scheme.")

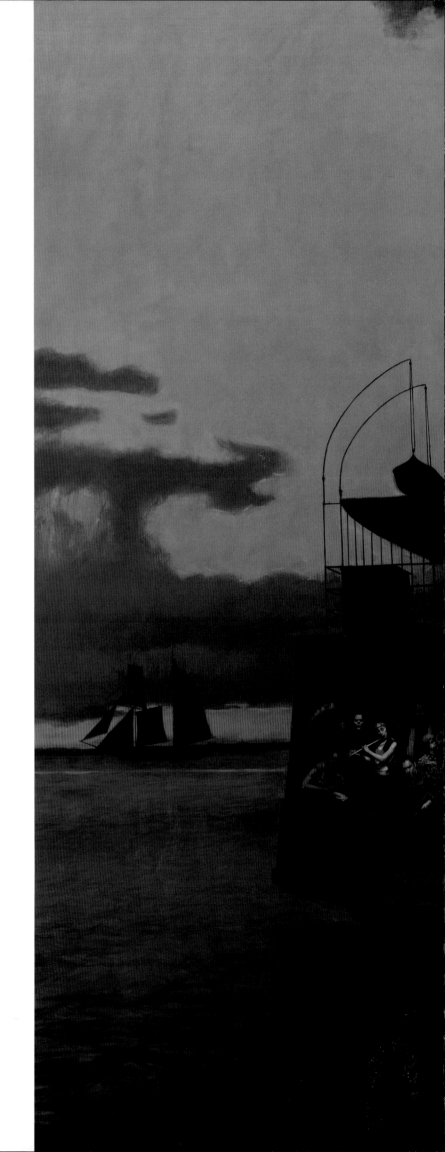

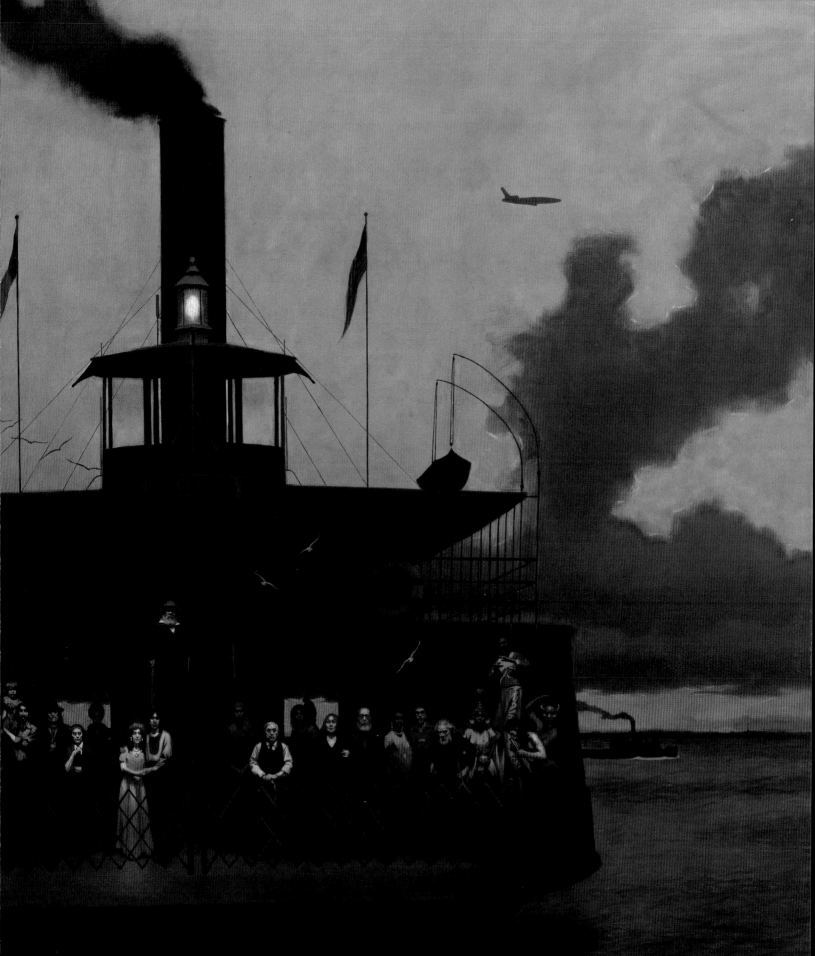

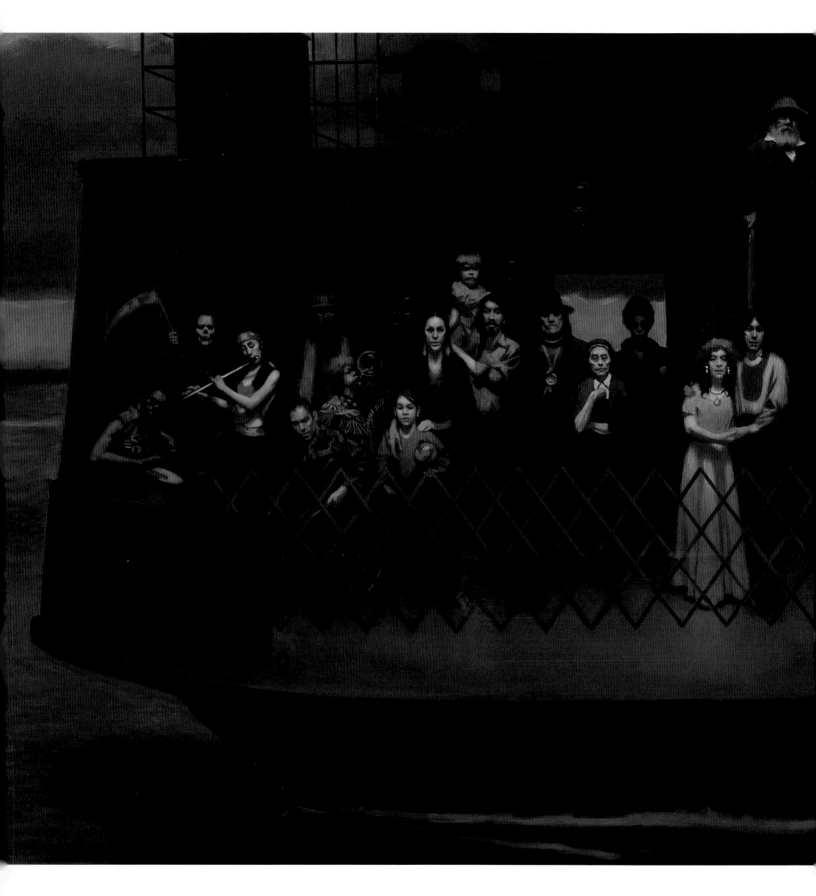

Sundown, *The Crossing* detail oil on canvas, 74" x 84," 1999

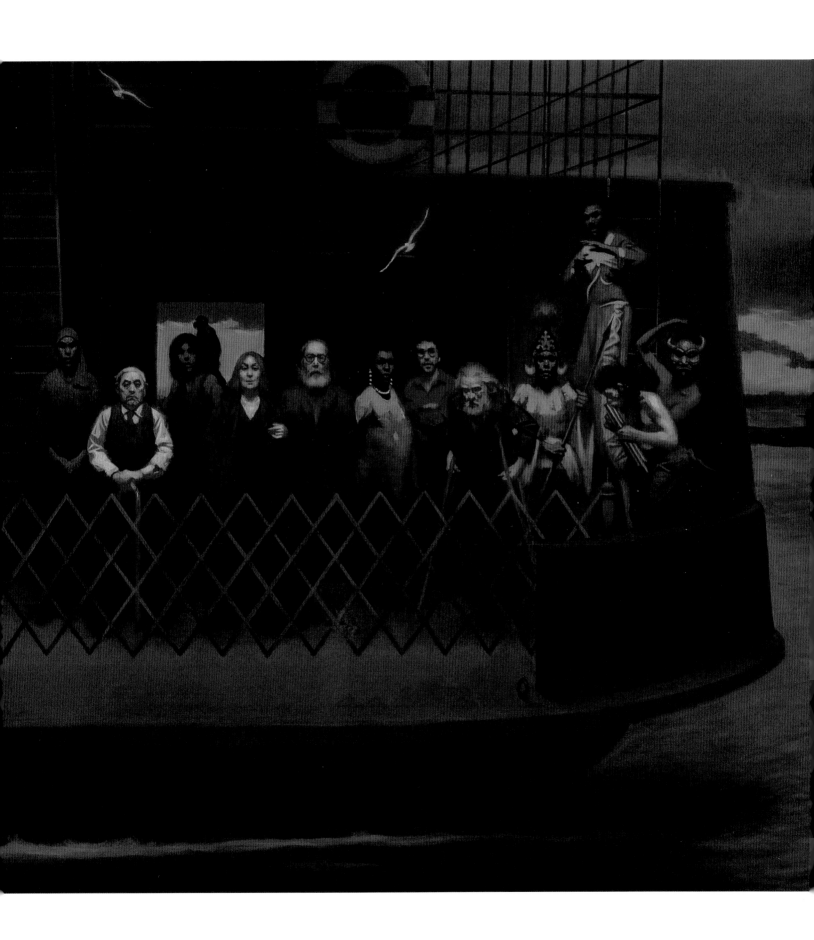

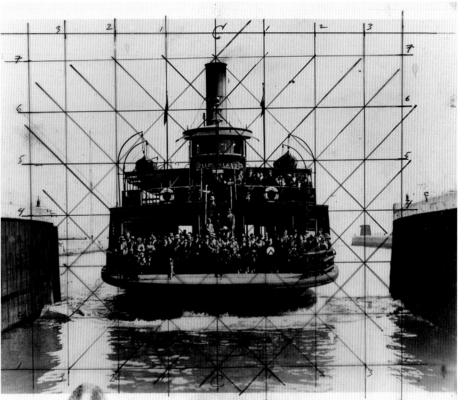

above, top
Abandoned Ferry oil on canvas, 16" x 18¾", 1964

above, bottom
Photograph of Ferry to Ellis Island c. 1930
From the collection of the Brooklyn Public Library

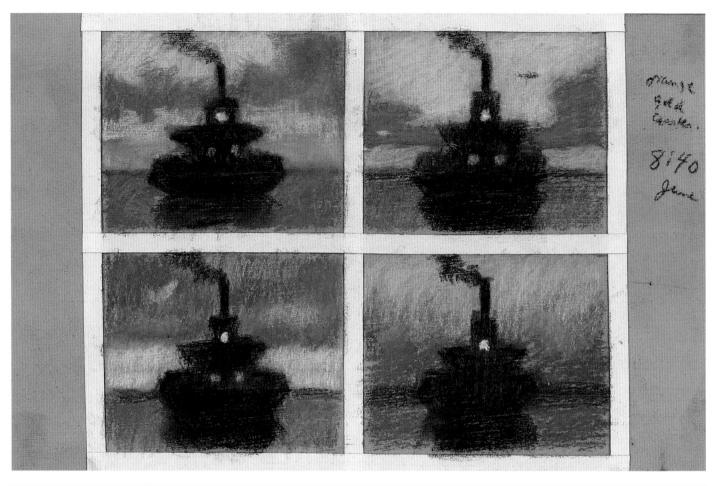

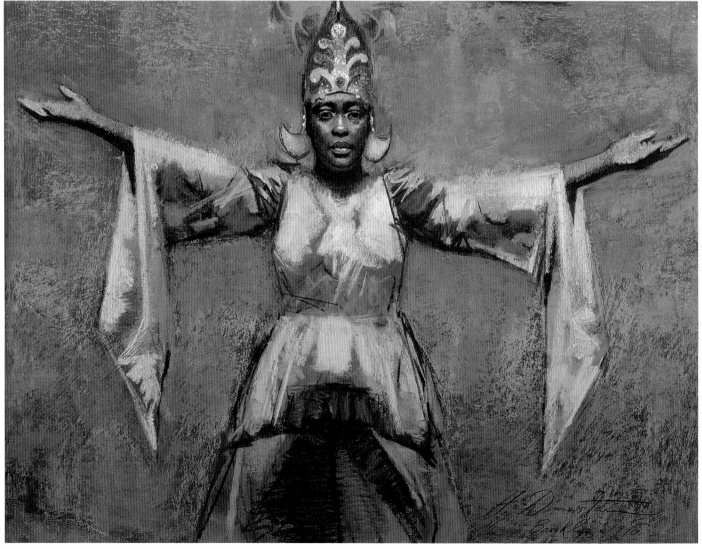

above
Sketchbook pages graphite and pen on paper,
7½" x 8¾", 1990s

opposite page, top
Sky Studies pastel on board, 6" x 9¾", 1999

opposite page, bottom
West Indian Carnival, Brooklyn pastel on board,
20¾" x 27¾", 1990

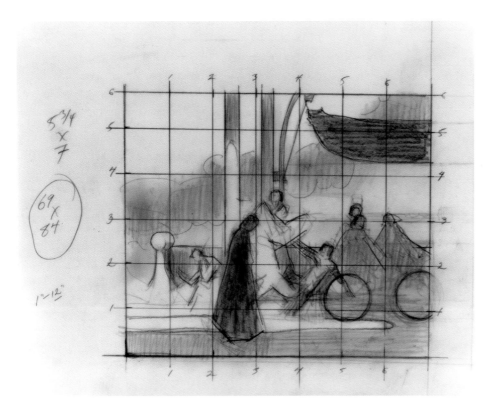

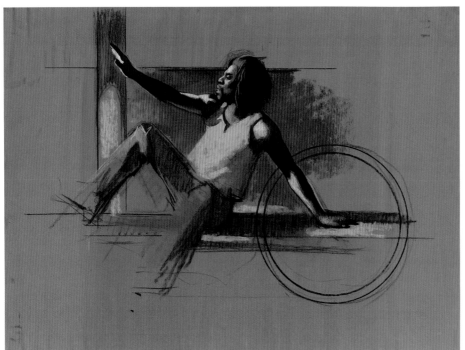

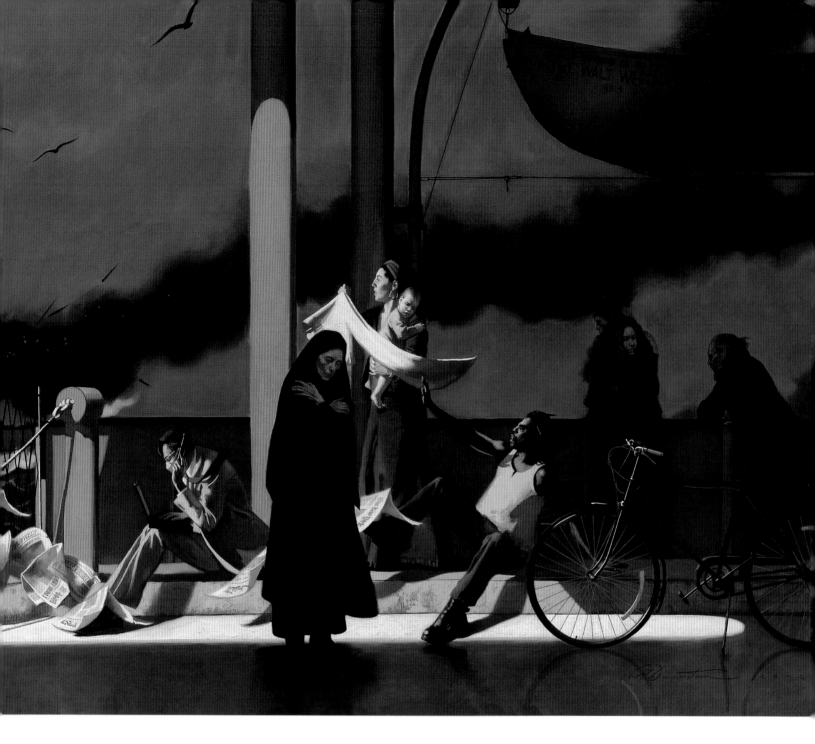

above
Fallout oil on canvas, 69" x 84", 2002

opposite page, top
Composition Sketch for Fallout graphite on paper,
14½" x 17½", 2002

opposite page, bottom
Figure Study for Fallout pastel on board,
25½" x 31½", 2002

When the World Trade Center was attacked, I was involved
with a number of studies of the ferry that crosses the har-
bor between Staten Island and Manhattan. I had done a
sketch in which a blast of sunlight sets up dramatic patterns
of light and shadow, but was still undecided about the
placement of the figures on the lower deck of the boat. Then
it occurred to me that the passengers could be responding
to some unexplained catastrophic explosion out of view.
Incidentally, there is no ferry named after Walt Whitman,
but I was struck with the way so many people found solace
in his poetry at this time and inscribed the lifeboat with
his name.

Candlelight Procession oil on canvas, 51" x 82½", 2003
After the devastating attack on the World Trade Center,
a candlelight procession gathered outside my local fire-
house in Brooklyn. Squad 1 had lost twelve men in the
tragic event. There was a huge gathering of people from
throughout the neighborhood. Working from photo-
graphs, sketchbook notations, and memory, I developed
the composition back in my studio and had models
pose for the individual figures. I placed the candlelight
procession at the epicenter of the collapsed buildings
and gave careful consideration to selecting individuals
that would convey the complex range of reactions to
the event.

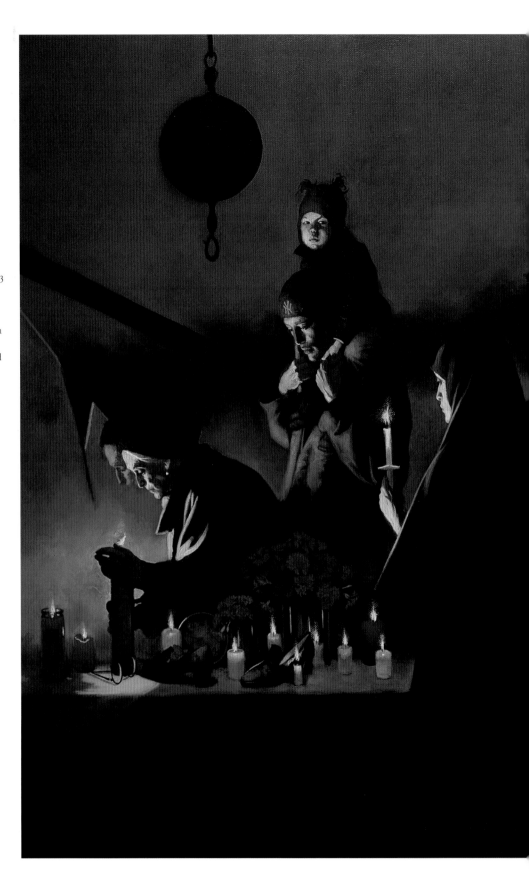

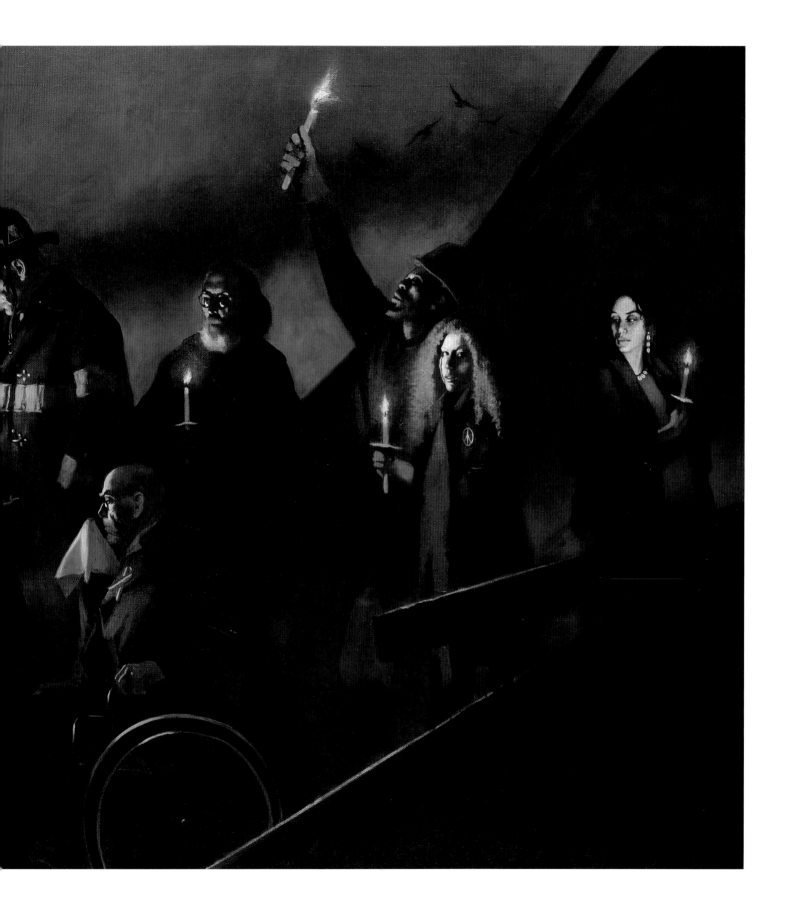

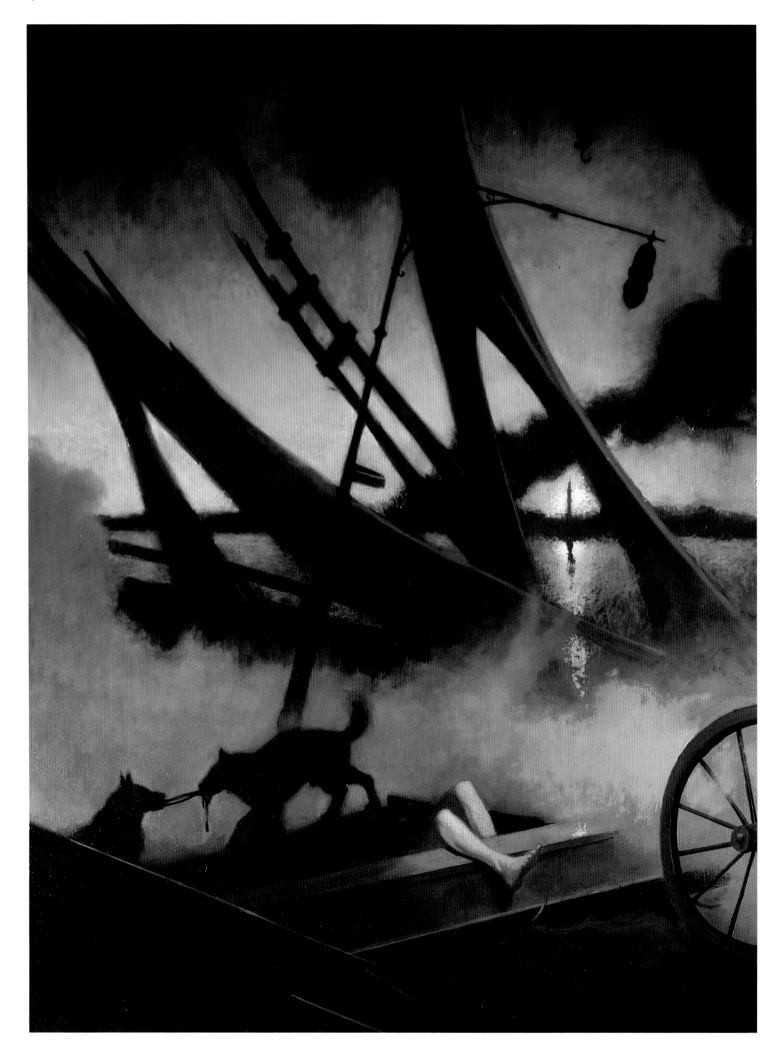

above
Detail of *Aftermath*

opposite page
Aftermath oil on canvas, 41¾" x 31¾", 2001–06

I started this painting in 2001 and worked over the
image for the next five years, mulling over William
Butler Yeats's poem, "The Second Coming," which
now seemed so immediate:
Turning and turning in the widening gyre
The falcon cannot hear the falconer;
Things fall apart; the centre cannot hold;
Mere anarchy is loosed upon the world,
The blood-dimmed tide is loosed, and everywhere
The ceremony of innocence is drowned;
The best lack all conviction, while the worst
Are full of passionate intensity.

Pathology of War

above
Pathology of War pastel on paper, 9 ½" x 11", 2006

opposite page
Sam and Bill pastel on board, 51" x 41", 1997

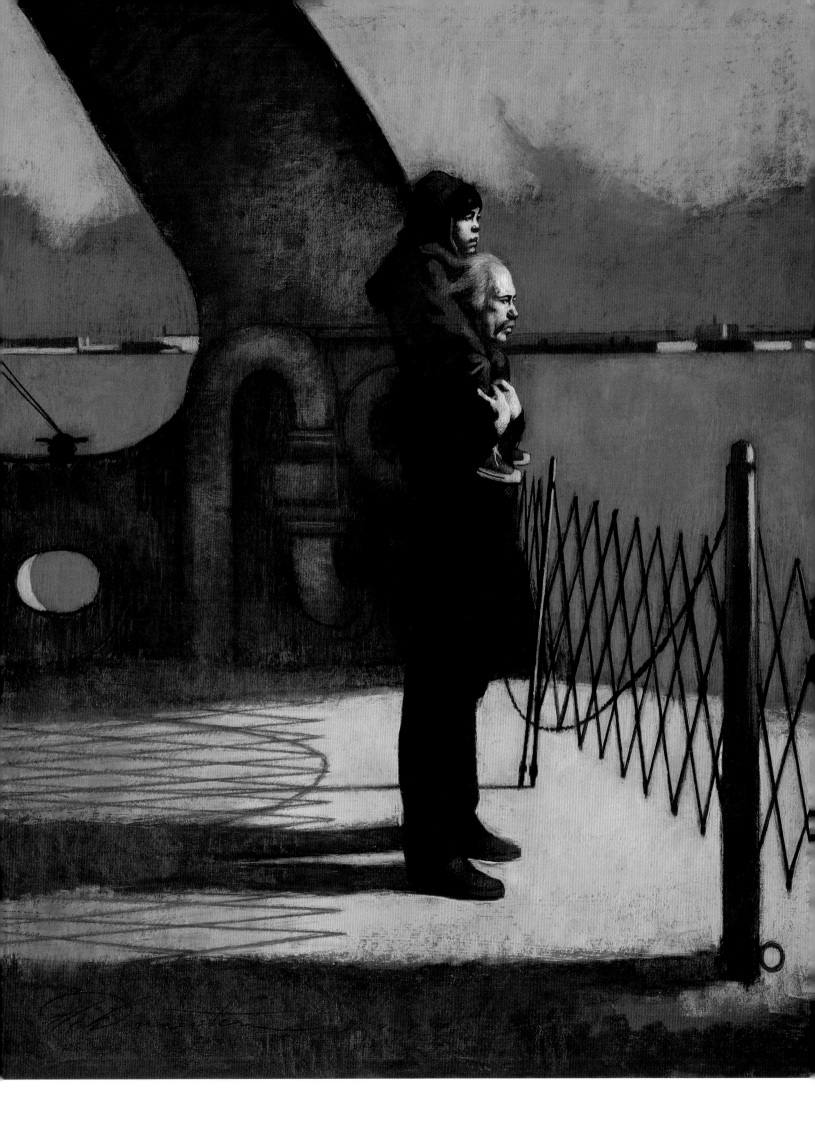

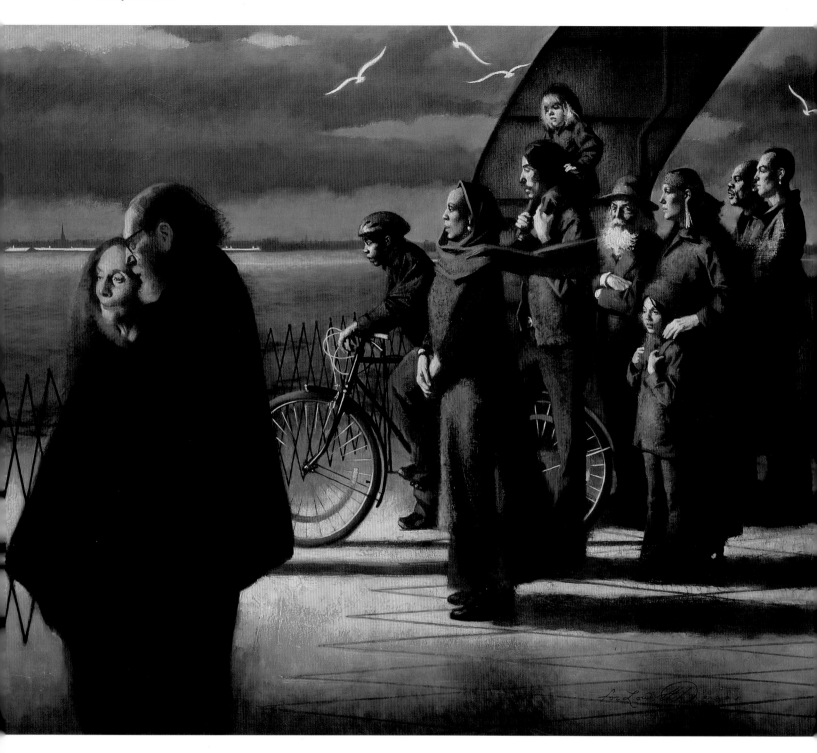

Ferry Crossing, Sunrise oil on canvas, 33" x 40", 2001

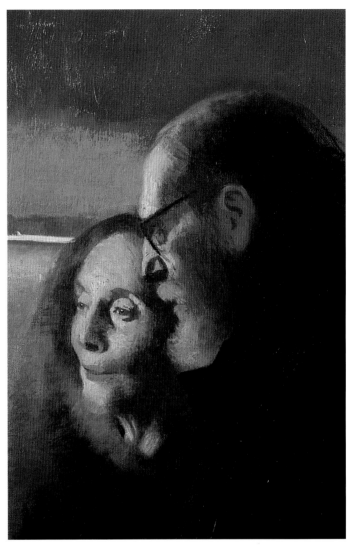

above, clockwise from top left
Study for *Ferry Crossing, Sunrise* charcoal on paper,
15" x 8¾", 2000

Detail of *Ferry Crossing, Sunrise* (Self-Portrait with Lois)

Detail of *Ferry Crossing, Sunrise* (Walt Whitman)
After I had done the painting focusing on the old ferry
in *Sundown, The Crossing,* I thought it would be interest-
ing to paint a contemporary ferry from another point
of view. In the midst of the crowd of passengers on
the lower deck, I placed the old poet, Walt Whitman,
engaging the viewer:
*Who knows, for all the distance, but I am as good as
looking at you now, for all you cannot see me?*

Harvey Dinnerstein Biography

BORN

Brooklyn, NY, 1928

EDUCATION

High School of Music and Art, New York, NY, 1942–46
Studied with Moses Soyer, 1944–46
Art Students' League, New York, NY, with Yasuo Kuniyoshi and Julien Levy, 1946
Tyler Art School, Temple University, Philadelphia, PA, 1947–1950

TEACHING

School of Visual Arts, New York, NY, 1965–1980
National Academy of Design, New York, NY, 1975–1992
Art Students' League, New York, NY, 1980–Present

SOLO EXHIBITIONS

Frey Norris Gallery, San Francisco, CA, 2003, 2005, 2008 (Retrospective)
Gerold Wunderlich & Co., New York, NY, 1997
Butler Institute of American Art, Youngstown, OH, "A Retrospective Exhibition," 1994
Sid Deutsch Gallery, New York, NY, 1989
Sindin Galleries, New York, NY, 1983
Capricorn Galleries, Bethesda, MD, 1980, 1990
Gallery 1199, Hospital Workers' Union, New York, NY, "20 Years of Drawing and Painting," 1976
F.A.R. Galleries, New York, NY, 1972, 1979
Kenmore Galleries, Philadelphia, PA, 1964, 1966, 1969, 1970
Davis Galleries, New York, NY, 1955, 1960, 1961, 1963

PUBLIC COLLECTIONS

Ackland Art Museum, Chapel Hill, NC
Allentown Art Museum, Allentown, PA
Brooklyn Museum, Brooklyn, NY
Butler Institute of American Art, Youngstown, OH
Delaware Art Museum, Wilmington, DE
Everson Museum of Art, Syracuse, NY
JPMorgan Chase Art Collection, New York, NY
Louisiana State University, Anglo-American Art Museum, Baton Rouge, LA
M.H. de Young Memorial Museum, San Francisco, CA
Martin Luther King Jr. Labor Center, New York, NY
Metropolitan Museum of Art (Robert Lehman Collection), New York, NY
Montclair Art Museum, Montclair, NJ
Museum of the City of New York, New York, NY
National Academy Museum and School of Fine Arts, New York, NY
National Museum of American Art, Smithsonian Collection, Washington, DC
National Portrait Gallery, Smithsonian Collection, Washington, DC
New Britain Museum of American Art, New Britain, CT
Norton Museum of Art, West Palm Beach, FL
Palm Springs Desert Museum, Palm Springs, CA
Parrish Art Museum, Southampton, NY
Pennsylvania Academy of the Fine Arts, Philadelphia, PA
Penn State University, Palmer Museum of Art, University Park, PA
Rutgers University, Jane Voorhees Zimmerli Art Museum, New Brunswick, NJ
Stanford University, Iris and Bo Gerald Cantor Center for Visual Arts, Stanford, CA
University of Kansas, Spencer Museum of Art, Lawrence, KS
University of Texas, Harry Ransom Center, Arthur Conan Doyle Collection, Austin, TX
University of Vermont, Robert Hull Fleming Museum, Burlington, VT
The West Collection, West Publishing Company, St. Paul, MN
Whitney Museum of American Art, New York, NY

SELECTED AWARDS & HONORS

Portrait Society of America, Gold Medal Award, 2007
Isaac N. Maynard Prize + Samuel F.B. Morse Medal, National Academy Museum and School of Fine Arts, 2003
Honorary Doctorate, Lyme Academy of Fine Arts, Old Lyme, CT, 1998
Jurors Award, Mid-Year Show, Butler Institute of American Art, 1986
Adolph and Clara Obrig Prize, National Academy Museum and School of Fine Arts, 1986
Arthur Ross Award, The Institute of Classical Architecture & Classical America, Painting, 1983
Art and the Law Purchase Award, West Publishing Co., 1982, 1983
Best Labor Magazine Cover of the Year Award, AFL-CIO International Labor Press Association, 1982
Audubon Artists President's Award, 1978
Gold Medal of Honor, Allied Artists of America, 1977
Henry Ward Ranger Purchase Award, National Academy Museum and School of Fine Arts, 1976
Hassam, Speicher, Betts, and Symons Purchase Award, American Academy of Arts and Letters, 1974, 1978, 1987
Elected Member, National Academy Museum and School of Fine Arts, 1974
Temple Gold Medal, Pennsylvania Academy of the Fine Arts, 1950
Louis Comfort Tiffany Foundation Grant, 1948, 1961

Selected Publications

CD-ROM, Collection of the National Museum of American Art, Smithsonian
 Institution, Washington, DC
"Remembering Marvin Franklin," Harvey Dinnerstein, *Linea*, Summer, 2007
"Harvey Dinnerstein Life Size Portraits," *International Artist*, June/July, 2007
"Contemplating Rubens," Harvey Dinnerstein, *Linea*, Fall/Winter, 2005
"Going Beyond the Moment," *International Artist*, December/January, 2005
"Harvey Dinnerstein Interview," *The Pastel Journal*, September/October, 2003
"Evolution of an Image: Sundown, The Crossing," *American Artist*, September, 2003
"Ingres Portraits," Harvey Dinnerstein, *Linea*, Winter, 2000
"Harvey Dinnerstein At The Millennium," the *Portrait Signature*, Fall, 1999
"Are 19th C. Methods of the Academy and Independent Atelier Relevant for
 Contemporary Figurative Artists?" Harvey Dinnerstein, *Linea*, Summer, 1998
"The Montgomery Bus Boycott, 1955–1957, Volume III of the Martin Luther King Jr.
 Papers Project," University of California Press, 1997
"Beyond Narrative: The Making of Past and Present," *American Artist*, August, 1995
Long Island Landscape Painting in the Twentieth Century, Ronald G. Pisano, Little
 Brown and Co., 1990
"Harvey Dinnerstein on Pastel," *American Artist*, May, 1988
New York Observed: Artists and Writers Look at the City, 1650 to the Present, Barbara
 Cohen, Seymour Chwast, Steven Heller, Harry N. Abrams, 1987
"Diamonds Are Forever: Artists and Writers on Baseball," *SITES Exhibition Catalogue*,
 Chronicle Books, 1987
The Fine Line: Drawing with Silver in America, Bruce Weber, Norton Museum of Art,
 West Palm Beach, FL, 1985
"The Seasons," Harvey Dinnerstein, *American Artist*, August, 1983
Realism and Realities: The Other Side of American Painting, 1940–1960, Greta Berman
 and Jeffrey Wechsler, Rutgers University Art Gallery, New Brunswick, NJ, 1981
Harvey Dinnerstein: Artist at Work, Watson-Guptill, 1978
"An Interview with Harvey Dinnerstein," Heather Meredith-Owens, *American Artist*,
 May, 1973
"Dink Stover in Hell," *Esquire*, September, 1970
Harvey Dinnerstein: A Portfolio of Drawings, Introduction by Moses Soyer,
 Kenmore Press, Philadelphia, PA, 1968
"The Face of Protest," *Esquire*, December, 1968
"The Artist as Buffalo Hunter," Harvey Dinnerstein, *Esquire*, December, 1965
"Ten Cents That Shook America" (The Montgomery Bus Boycott), Rosa Parks,
 drawings by Harvey Dinnerstein and Burton Silverman, *Esquire*,
 December, 1964
"Four Realists" (Harvey Dinnerstein, David Levine, Aaron Shikler, Burton Silverman),
 Frederick Whitaker, *American Artist*, October, 1964
"New Look at Protest, the Eight Since 1908," Harvey Dinnerstein and Burton Silverman,
 ART News, February, 1958

Image Credits

Page 2, Page 137 **Rainy Evening, Lower East Side** from the collection of Jack and Jenny Rootman

Page 6 **Hallway Entrance** from the collection of Elizabeth Barlow and Stephen McClellan

Page 9 **The Studio** from the collection of the Robert Hull Fleming Museum, University of Vermont, Burlington, VT,
 gift of the American Academy of Arts and Letters

Page 16 **Subway Sketch** Private Collection

Page 24 **Self-Portrait, Della Robbia and Baseball** Private Collection

Page 27 **At the Louvre** Private Collection

Page 28, Page 115 **Self-Portrait with Burt Silverman** (with Yiddish inscription: 2 boys from Brooklyn, 50 years later) Private Collection

Page 29, Page 71 **Rosa Parks, Montgomery** from the collection of the Delaware Art Museum, F.V. Du Pont Acquisition Fund, 1993

Page 29, Page 71 **Walking Together, Montgomery** from the collection of the Parish Art Museum, Southhampton, NY

Page 30, Page 60 **Clinton Square, Newburgh** from the collection of Susan Walter

Page 31, Page 78–79 **Parade** from the collection of Dr. and Mrs. Mohammad Khavari

Page 32, Page 109 **Michelene** Private Collection

Page 33, Page 105 **Shaka** from the collection of the Everson Museum of Art, Syracuse, NY

Page 33, Page 104 **Stay Amazed** from the collection of Michael Dinnerstein

Page 33, Page 106 **Linda** Private Collection

Page 33, Page 107 **Mercedes** from the collection of Lyndon and Janine Barrois

Page 34, Page 52 **Self-Portrait with Mr. Meltzer** from the collection of Edward and Maria Gale

Page 35, Page 134 **Demolition, Union Square** from the collection of the Museum of the City of New York

Page 35, Page 130 **Morning Light, Brooklyn** from the collection of Jonathan and Cathy Binder

Page 36, Page 94 **Summer** Private Collection

Page 36, Page 95 **Autumn** Private Collection

Page 36, Page 96–97 **Winter** Private Collection

Page 40, Page 186–187, Page 188–189 **Sundown, The Crossing** from the collection of the Fine Arts Museums of San Francisco,
 gift of Gary and Kathie Heidenreich and Frey Norris Gallery

Page 41, Page 195 **Fallout** from the collection of Gary and Kathie Heidenreich

Page 41, Page 196–197 **Candlelight Procession** from the collection of The Late Jana Thompson and Nancy Sur

Page 42, Page 139 **Crossing Broadway** Private Collection

Page 47 **Self-Portrait** (After the Cataract Operation) from the collection of Rachel and Donald Klein

Page 51 **Sarah** Private Collection

Page 53 **Mr. Melzter** Private Collection

Page 56 **The Passage**

Page 61 **Motorcycle Ride** Private Collection

Page 61 **Foliage Study for Motorcycle Ride** from the Lehman Collection, Metropolitan Museum of Art, New York, NY

Page 62 **Roman Market Women** Private Collection

Page 65 **Garlic Lady** Private Collection

Page 67 **The Gleaner** from the collection of James E. Baer

Page 69 **Mezzonotte, Venezia** Private Collection

Page 70 **Old Woman Walking, Montgomery** from the collection of the Delaware Art Museum, F.V. Du Pont Acquisition Fund, 1993

Page 73 **Hunger's Wall, Resurrection City** Private Collection

Page 73 **Burning Shack, Washington, D.C.** Private Collection

Page 74 **Sick Child** Private Collection

Page 74 **Prophet** Private Collection

Page 76 **Vigil** Private Collection

Page 76 **Carlos and Monkey** from the collection of Dr. and Mrs. Mohammed Khavari

Page 77 **Confrontation at Fort Dix** Private Collection

Page 81 **Parade** (Detail 1) from the collection of Dr. and Mrs. Mohammad Khavari

Page 82 **Parade** (Detail 5) from the collection of Dr. and Mrs. Mohammad Khavari

Page 83 **Parade** (Detail 6) from the collection of Dr. and Mrs. Mohammad Khavari

Page 84 **Parade** (Detail 8) from the collection of Dr. and Mrs. Mohammad Khavari

Page 86 **White Rat** Private Collection

Page 92 **Working in the Park** from the collection of The Hebrew Home for the Aged, Riverdale, NY

Page 94 **Summer** from the collection of National Grid

Page 95 **Autumn** from the collection of National Grid

Page 96 **Winter** from the collection of National Grid

Page 98 **Another Spring** from the collection of National Grid

Page 99 **Spring, Study for the Seasons** from the collection of Daniel Bennett Schwartz

Page 100 **Summer, Nethermead Tunnel** from the collection of the LSU Museum of Art, gift of the American Academy of Arts and Letters

Page 100 **Autumn, Nethermead Tunnel** from the collection of Richard C. Barker

Page 101 **Study for Winter (B)** from the collection of JPMorgan Chase Art Collection, New York, NY

Page 101 **Study for Winter** Private Collection

Page 101 **Study for Winter** (completed pastel, work in progress 2) Private Collection

Page 101 **Study for Winter** (Distant Landscape) Private Collection

Page 107 Detail of left panel of **Mercedes** painting from the collection of Lyndon and Janine Barrois

Page 108 **Michael S.** Private Collection

Page 110 **Ladino Song** Private Collection

Page 111 **Amaryllis** from the collection of the Norton Gallery of Art, West Palm Beach, FL

Page 113 **Sunflower in Brooklyn** Private Collection

Page 114 **The Last Kobilansky** from the collection of Vivian and Neil Bailes

Page 114 **Pavenah** from the collection of Dave Donohue and Ann Jones

Page 116 **Sleepless Night** Private Collection

Page 116 **The Flutist** Private Collection

Page 123 **Dancing Shiva** (Mani and Manisha) from the collection of Tony Mysak and Mary Beth McKenzie

Page 125 **Amina** from the collection of Seven Bridges Foundation

Page 128 **Arraignment Court, Brooklyn** from the collection of Thomson West

Page 129 **Arraignment Court, Brooklyn** (11 sketches) from the collection of Jane Voorhees Zimmerli Art Museum, Rutgers, The State University of New Jersey, Gift of the American Academy and Institute of Arts and Letters

Page 133 **Rainy Evening, Broadway** Private Collection

Page 134 **Rainy Evening, Union Square** Private Collection

Page 138 **Underground Musician** Private Collection

Page 138 **Winter Light, West 57th Street** from the collection of Robert and Kathleen Osmond

Page 141 **Tenor Sax** from the collection of Mary Jo Hartenberger

Page 143 **The Scenic Artist** (Arnold Abramson) from the collection of the New Britain Museum of American Art, New Britain, CT

Page 144 **The Collector** (Philip Desind) from the collection of The Butler Institute of American Art, Youngstown, Ohio

Page 146 **Maggy Buissereth** from the collection of The Butler Institute of American Art, Youngstown, Ohio

Page 156 **The Art Historian** (Lois Dinnerstein) from the collection of Patti and Jerry Sowalsky

Page 157 **The Art Historian** (in door frame with step) from the collection of Patti and Jerry Sowalsky

Page 166 **Underground** Private Collection

Page 166 **D Train to Coney Island** from the collection of Patti and Jerry Sowalsky

Page 168 **The Exile** from the collection of Louise Pearl Greenwald

Page 169 **No. 7 to Flushing** from the collection of P.L. Brown and Kelly L. Peterson

Page 171 **Tosca's Aria** from the collection of P.L. Brown and Kelly L. Peterson

Page 172 **Subway Musician** Private Collection

Page 180 **Flight Over Brooklyn** from the collection of Harry de Winter

Page 181 **Self-Portrait With Plumb Line** (Daedalus) from the collection of Dr. Rona Z. Silkiss and Mr. Neil A. Jacobstein

Page 191 **Abandoned Ferry** from the collection of the Fine Arts Museums of San Francisco, gift of Gary and Kathie Heidenreich and Frey Norris Gallery

Page 191 **Photograph of Ferry to Ellis Island** from the collection of the Brooklyn Public Library

Page 192 **Sky Studies** from the collection of the Fine Arts Museums of San Francisco, gift of Gary and Kathie Heidenreich and Frey Norris Gallery

Page 194 **Compositional sketch for "Fallout"** from the collection of Gary and Kathie Heidenreich

Page 194 **Figure study for "Fallout"** from the collection of Gary and Kathie Heidenreich

Acknowledgments

I would like to note with appreciation, all those people who have posed for me over the years. Family, friends, and chance acquaintances, they are the ultimate source of my work.

Also my gratitude to Raman Frey and Wendi Norris of Frey Norris Gallery for their enthusiastic support of this publication.

Alan Rapp, Bridget Watson Payne, Annabelle Gould, Brooke Johnson, and the staff at Chronicle Books have been most helpful in guiding me through the complexities of the book production.

I am fortunate to have Pete Hamill's vivid description of Brooklyn, past and present, included in the text, along with Gabriel Weisberg's insightful observations on the art historical sources and contemporary relevance of my work.

This book is dedicated to Lois, whose love has sustained me in our journey, together . . .

—H.D.

We are grateful and indebted to a number of people who have made this book on Harvey Dinnerstein a reality. Firstly, thanks go to Alan Rapp, our tireless and patient editor who believed in us and in Harvey—Alan was gracious while we bent his ear over countless lunches and cocktails. Brooke Johnson, Bridget Watson Payne, Doug Ogan, Molly Jones, Tera Killip, Patti Quill, and Annabelle Gould have provided great insight, creativity and organization at every step along the way.

We continue to marvel at the most recent artwork arriving at our gallery from Harvey's studio; he continues to produce some of the strongest art of his career. Our gratitude extends to the art historians, critics, and collectors who have shared our appreciation for his accomplishments. We wish to thank the graceful Lois Dinnerstein for being the steadfast and wise partner behind the scenes. Pete Hamill has been immensely generous and kept us grounded with his exquisite prose and support. And we thank Gabriel Weisberg for helping all of us to contextualize and synthesize the decades of work that span Harvey's career.

We also extend our thanks to our dearest friends Gary and Kathie Heidenreich who have been supportive of our every single venture from the very first day we opened our doors. Our registrar and do-it-all Melissa Bernabei provided flawless support and the most cheerful attitude even into the late fact-checking stages. We also wish to thank the eternal optimist on our staff—the Brooklyn-born Mike Yohay—for all the promotional support.

Most of all, we wish to thank Harvey himself, for granting us the faith and respect required to realize the creation of this book. We hope that *Underground Together: The Life and Art of Harvey Dinnerstein* will become a springboard of investigation for students and admirers of his art for decades to come.

—R.F. and W.N.